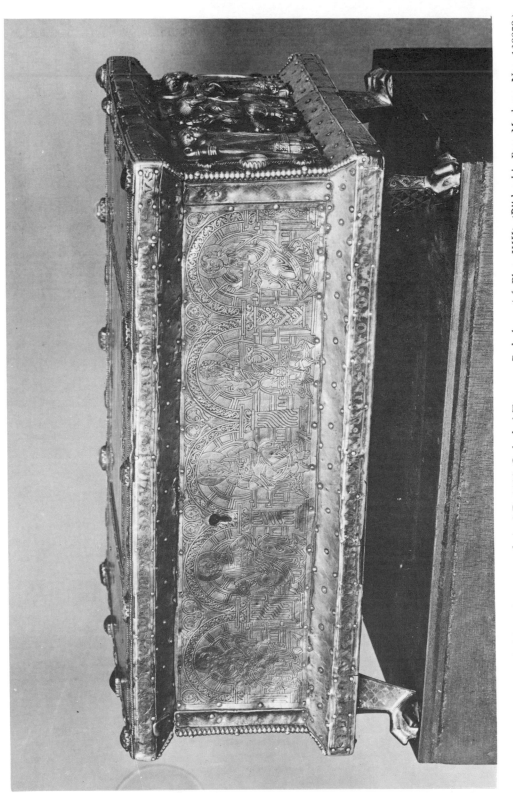

Portable altar by Roger of Helmarshausen, made in A.D. 1100. Cathedral Treasury, Paderborn (cf. Plate XIII). (Bildarchiv Foto-Marburg, Neg. 138889.)

THEOPHILUS

On Divers Arts

THE FOREMOST
MEDIEVAL TREATISE
ON PAINTING,
GLASSMAKING AND METALWORK

TRANSLATED FROM THE LATIN
WITH INTRODUCTION AND NOTES BY

JOHN G. HAWTHORNE
AND
CYRIL STANLEY SMITH

DOVER PUBLICATIONS, INC.
NEW YORK

Published in Canada by General Publishing Company,
Ltd., 30 Lesmill Road, Don Mills, Toronto, Ontario.

This Dover edition, first published in 1979, is an
unabridged and corrected republication of the work
originally published in 1963 by The University of Chicago
Press.

International Standard Book Number: 0-486-23784-2
Library of Congress Catalog Card Number: 78-74298

Manufactured in the United States of America
Dover Publications, Inc.
180 Varick Street
New York, N.Y. 10014

TO

Herbert Maryon, O.B.E.

MASTER OF DIVERS ARTS,

SCULPTOR, GOLDSMITH,

STUDENT, AND WRITER ON

THE HISTORY OF TECHNIQUES

Preface to the Dover Edition

This new edition is dedicated to the memory of my collaborator and good friend John Hawthorne, who died on 9 March 1977. I remember with great pleasure the animated discussions through which we sought to reconcile historical, technical and verbal meanings in two languages. He would have been delighted to see Theophilus once more in print. The *Treatise* is not only an important source for the history of technology. In its pages the art historian will find evidence of the rich human experience that lies behind the paintings and stained-glass windows of the medieval cathedral and the rich metalwork in its treasure vaults. The modern craftsman can not only pick up some useful hints on technique but he will gain inspiration and courage as he talks with this fellow spirit in a workshop of more than three quarters of a millennium ago.

A fine picture of the environment within which Theophilus wrought and wrote is provided by the recently published collection of essays by Lynn White, *Medieval Religion and Technology* (Los Angeles *etc.*, 1978). The book provides a well-documented and illustrated argument for the central importance of technology in medieval life and society, and is essential reading for anyone who wishes to understand either European history or technology.

Some publications relating to Theophilus and the techniques he describes that have appeared since the first edition of this translation are listed in the appendix to the bibliography, page 199. The critical reviews by Lynn White (1964) and Daniel V. Thompson (1967) should particularly be noted. The *Mappae Clavicula*, an important medieval source which preceded Theophilus by some three centuries, is now available in facsimile reproduction of the two principal manuscripts and English translation (Smith and Hawthorne, 1974). The book by Heinz Roosen-Runge (1967) includes many photomicrographs of contemporary paintings and is a valuable source on medieval painting techniques.

Lynn White (1964) saw that the Preface to Book III of the *De diversis artibus* was rather clearly an answer to the attack on lavish ornamentation of Benedictine monastic churches contained in the *Apologia* of Bernard of Clairvaux, and on this basis he suggests that Theophilus was writing between 1122 and 1123. In an article to appear in *Viator,* John Van Engen argues that Theophilus' religious ideas point clearly to the early twelfth century, and are at any rate inconceivable in the German Empire before the year 1100; building upon White's essay, he dates the work to the later 1120's.

M. S. Frinta (1964) has suggested that Theophilus was associated with the Benedictine center at Reichenau. This is plausible because of the high standards and diversity of techniques evident in the products of the ecclesiastical workshops of the Lake Constance region early in the twelfth century. However we have not abandoned our belief that the pseudonymous author of the *Treatise* was the north-German Roger of Helmarshausen.

C.S.S.

Acknowledgments

The translators wish to acknowledge their indebtedness to C. R. Dodwell, Fellow and Librarian of Trinity College, Cambridge, and to Thomas Nelson and Sons, Limited, for making available the page proofs of his edition in advance of publication; our gratitude to Mr. Dodwell is matched only by our admiration for his scholarship. Mr. Herbert Maryon of the Research Laboratory of the British Museum critically read an early draft of Book III and made innumerable helpful suggestions regarding interpretation and terminology. Book II has benefited from the comments of Messrs. Arthur Lane, Rowan LeCompte, W. A. Weyl, W. E. S. Turner, and particularly Messrs. Paul Perrot and R. J. Charleston. For Book I we are indebted both to Professor James Wattrous (University of Wisconsin) and Mr. A. E. A. Werner of the British Museum. On musical instruments, the advice of Messrs. Heinrich Fleischer and E. A. Bowles was sought. Messrs. Robert Randall and Hanns Swarzenski of the Boston Museum of Fine Arts gave some help in the selection of photographs of contemporary work. Our sketches of Theophilus' devices have been skilfully redrawn for reproduction by Mr. William A. Norman. Many others, in correspondence or conversation, have shown their interest and contributed their knowledge to this edition.

Finally, it is a pleasure to acknowledge the support of the work on this translation and other sources for technological history that has been provided through grants by the United States National Science Foundation.

Contents

Plates

following page 58

Figures

Introduction

THE AUTHOR, THE MANUSCRIPTS, AND THE EDITIONS

The work here translated consists of three books in Latin, one each on painting, glass, and metalwork. Each is an outstanding record of the art. The original manuscript has not survived, the earliest known being two copies (perhaps third generation), both written in twelfth-century German hands. Neither the date and place of writing nor the identity of the author is known with certainty.

The author is identified on the earliest manuscripts only as Theophilus Presbyter. The Vienna Manuscript (*V*) has an added title page in a seventeenth-century hand, describing Theophilus as a Benedictine monk, with the word *Benedictini* deleted and the phrase *qui et Rugerus* written in another seventeenth-century hand.[1] A similar identification occurs in other manuscripts, but they are all later. On the basis of this attribution, Ilg (1874)[2] suggested that Theophilus was the historical metalworker Roger of Helmarshausen, who flourished around A.D. 1100 and whose skill is attested by a bejeweled book cover in Nuremberg[3] and two portable altars that are preserved in Paderborn, one of which is shown in our frontispiece. The only record of his life is in the papers by which his monastery conveyed a cross and a reliquary-altar to the Bishop of Paderborn in exchange for a church and its tithes on August 15, 1100 (Fuchs, 1916).

The identification of Theophilus with Roger of Helmarshausen was challenged by Degering (1928) on several grounds: (*a*) the spelling of Roger's name differs (it is *Rogkerus* in the document

[1] A good photographic reproduction of this title page with its corrections is given by Degering (1928).

[2] A date in parentheses following a name should be construed as a reference to the bibliography on page 193, which lists all major works referred to. See also page xxii for a listing of all previous editions of Theophilus' work.

[3] See Plate VIII. The complete cover is illustrated in Plate I of Schnitzler (1959). Details of the two altars are shown in Plates XII and XIII. More views were published in Deckert *et al.* (1932), Vol. II, Plates 240–45 for the Paderborn Franciscan Church altar, Plates 245*b*–50 for the one in the cathedral treasury at the same town.

cited); (*b*) the attribution is not contemporary but was written in the seventeenth century, and Degering believed the earliest manuscript to antedate Roger considerably; (*c*) the work has a Byzantine bias; (*d*) many of the words used by Theophilus were not in use after the eleventh century; and (*e*) Theophilus writes (thinks Degering), not as a practical technician, but as a literary man using old written sources. Degering concluded that Theophilus was a Benedictine monk working in Cologne in the mid-tenth century, perhaps one Bruno at St. Pantaleon monastery, which once owned an early Theophilus manuscript (*G*).

This tenth-century date was unfortunately given prominence in the title of Theobald's important German edition (1933). Dodwell (1961) has shown, however, that the weight of evidence is strongly against this. He points out that all the evidence converges to support the belief that the manuscript was composed between the years 1110 and 1140 and that it was written by the Benedictine monk and metalworker Roger of Helmarshausen. The earliest manuscript dates from the middle of the twelfth century; the spelling of proper names at this time was commonly variable; the supposedly anachronistic words actually were not so; some Byzantine content is to be expected in any medieval treatise on metalwork; and, finally, Degering's claim that Theophilus was not a practical technician will be disbelieved by anyone who has read Book III. Since it is improbable that the seventeenth-century writer had seen an earlier manuscript attributed to Roger, or that he had himself done research on the sources, it seems likely that a verbal tradition that the author of the manuscript was Roger had persisted until it was then written down.

Although Degering's objection should be borne in mind, the evidence seems to be strongly in favor of Roger of Helmarshausen's being the actual author of the *Treatise,* and that, desiring a pseudonym in Benedictine modesty, he chose the Byzantine name of Theophilus in recognition of Byzantium's excellence in the techniques described.

The surviving work by the historic Roger strongly supports this view. Helmarshausen was an important center for all the arts de-

scribed by Theophilus.[4] The book cover attributed to Roger involves the use of beaded wire, cloisonné enamel, and the mounting of gems. His portable altars show pierced metalwork, ring-punching, repoussé, niello, gilding, chasing, and engraving—indeed, Roger carried his use of divers techniques to the point where there was more variety than was aesthetically desirable, and it almost seems as if he wished to illustrate the third book of his pseudonymous work!

There are many manuscripts of different dates and varying accuracy scattered throughout European libraries, most of which have been listed by R. P. Johnson (1938). The paleography of the earliest versions has been critically studied and reviewed by Bischoff (1952–53) and by the editors of previous printed editions, particularly Hendrie (1847), Ilg (1874), Theobald (1933), and Dodwell (1961).

The following list shows the present location of the more important manuscripts of the *Treatise* and gives the sigla by which they will be referred to herein.

LIST OF THE PRINCIPAL MANUSCRIPTS

Twelfth Century

V *Vienna,* National Bibliothek, 2527. *V* (Ilg, Theobald, Dodwell), *W*[1] (Thompson).

> Lacks chapter 38 of Book I and chapters 80–96 of Book III. Following Bischoff (1952–53) and Dodwell this is to be regarded as the earliest. It is textually similar to *G.*

G *Wolfenbüttel,* Herzogliche Bibliothek, 4373 or Cod. Guelph Gudianus lat. 2°69. *G* (Ilg, Theobald, Dodwell), *Wb* (Thompson).

> Textually similar to *V.* Lacks I-38 and III-80 to 96.
> This has commonly been regarded as the oldest; it was once in the monastery of St. Pantaleon in Cologne; probably owned by Georgius Agricola in 1530; basis for texts of Lessing (1781), Ilg (1874), and Theobald (1933).

Thirteenth Century

H *London,* British Museum, Harley 3915. *Ha* (Ilg), *H* (Theobald and Dodwell), *L*[1] (Thompson).

> Lacks prologue to Book I. Of a line of descent different from *V* and *G.* Includes several chapters of Eraclius with continuous numbering and other miscel-

[4] See Jansen (1933) and Meyer (1940, 1944).

laneous extracts. This is the most complete copy of the *Treatise* and was the basis of Hendrie's edition (1847). For a reproduction from this manuscript see Plate I.

C *Cambridge,* University Library MS 1131 (Ee VI 39), part iii. *CC* (Ilg), *C* (Thompson, Dodwell).

Contains Book I and parts of Book III. Copied by Humphrey Wanley in 1699 (British Museum, Sloane 781). Rediscovered by Raspe in 1781; used by Escalopier (1843) for his edition.

E *London,* British Museum, Egerton 840 A. *Ed. R* (Ilg), L^2 (Thompson), *E* (Dodwell).

Contains I-1 to I-30 only. Formerly in the library of Trinity College, Cambridge, where it was found by Raspe and used as basis of his edition of Book I.

Fourteenth Century

L *Leipzig,* Karl Marx Universitäts Bibliothek, 1157 (formerly 1144). *L* (Ilg, Theobald, Dodwell), *Lp* (Thompson).

Contains Books I, II, and parts of Book III.

Fifteenth Century

P *Paris,* Bibliothèque Nationale, Latin 6741. *C.R.* (Ilg, Theobald), *P* (Thompson, Dodwell).

Contains only I-1 to 27 as part of the famous compilation of manuscripts on painting made in and before 1431 by Jean le Bègue.

The bibliographic articles of Johnson (1938) and Thompson (1932) list a large number of other manuscripts, some as late as the nineteenth century. A full discussion of the manuscript tradition is given by Dodwell (1961) in the introduction to his edition (pp. lvii–lxx). Most of the manuscripts were copied as component parts of compilations of information from several different sources and many contain interpolations from other works (principally the *Mappae clavicula* and Eraclius, *De coloribus et artibus Romanorum*) with nothing to indicate the different origin of this material.

The printed editions began in the late eighteenth century with the revival of interest in Theophilus that was precipitated by G. E. Lessing's small book *Vom Alter der Oelmalerey aus dem Theophilus Presbyter* (1774). In this he included some chapters (our chapters I-17 to 20, 23, 25, 27) from manuscript *G* to establish the antiquity

of linseed oil as a painting medium against the claim of Vasari that this was a discovery of the Van Eyck brothers. This was reprinted in 1792 as part of Lessing's *Vermischte Schriften,* and in all subsequent collected editions of Lessing's work. Lessing found the Theophilus manuscript in the library of the Duke of Brunswick at Wolfenbüttel shortly after he had been appointed ducal librarian in 1770. He proceeded to collate the manuscript with the one in the library of the University of Leipzig, and his complete text was printed as part of the sixth *Beitrag* of his *Zur Geschichte und Litteratur aus den Schätzen der herzoglichen Bibliothek zu Wolfenbüttel.* This bears a printer's colophon dated 1780, but it was not actually published until after Lessing's death in the following year. It has an introduction by the editor, Christian Leiste, dated May 5, 1781. The Theophilus text was reprinted in 1839 as part of Karl Lachmann's comprehensive edition of Lessing's works and is included in most later complete editions of the works. It is therefore by far the most widely available Theophilus text, but as it is rarely indexed as such, it is little used. The editors of the later editions, Wendelin von Maltzahn, Franz Muncker, and especially Alfred Schöne, made some minor emendations of the text and corrections of a few of Lessing's (Leiste's?) errors in transcription.

A few years before this, Jacopo Morelli had discovered another manuscript in Venice and published extracts and comments on it in the catalogue of the Nani library in 1776. Meanwhile in England, R. E. Raspe,[5] stimulated by his friend Lessing's article, had found two manuscripts in Cambridge, one in the University Library (*C*), which he was not allowed to publish, and the other in the library of Trinity College (*E*). He published the Latin text of Book I from this in 1781, the same year as Lessing's edition, with com-

[5] Raspe was a colorful character, known to metallurgists for his translation of Born's book on amalgamation, for his igneous theory of basalt, and for his association with Boulton and Watt in their Cornish mining operations. His *Critical Essay on Oil Painting* was seen through the press by Horace Walpole, and he was precariously associated with many of the leading German and English intellectuals of his day. Raspe, the only Fellow of the Royal Society to have been expelled on the basis of character, is more widely known as the author of *Baron Munchausen's Travels* and as the pattern for the charlatan Dousterswivel in Walter Scott's *Antiquary.* There is a fine biography of him by John Carswell (1950).

ments and extracts from Eraclius and other sources pertaining to painting.

In the nineteenth century, editions of the *Treatise* with translations into modern languages began to appear. The first of these was that of Charles de l'Escalopier, who published text and French translation in 1843, with an introduction by Guichard discussing the manuscripts. Escalopier made use of the works of Morelli, Lessing, and Raspe, together with manuscripts *C* and *P.* Shortly after this, the first English translation was published by Robert Hendrie (1847). He owed much to Escalopier, somewhat less to the previous editions, but relied chiefly on manuscript *H,* which he himself had discovered in the British Museum and the Latin text of which he printed opposite the English translation. Hendrie has extensive notes, particularly on Book I, and he frequently quotes other sources for comparison. It was a great contribution and the edition is still useful, although the translation is sometimes faulty because of Hendrie's lack of familiarity with the technical details being discussed.

Hendrie's Latin was reprinted by J. J. Bourassé (1851) in the *Dictionnaire d'archéologie sacrée,* which in turn was part of the *Nouvelle encyclopédie théologique* edited by J. P. Migne. This was accompanied by a new French translation, except for the two chapters on censers (III-50 and 51) which were taken from Escalopier.

In the same year as Hendrie's complete edition (1847) there appeared C. S. Winston's independent English translation of Book II, on glass, which was based upon Escalopier's Latin text. This was reprinted in 1867. Winston's translation was uncritically condensed by S. E. Winbolt (1933), who also included English versions of Månsson's and Agricola's sections on glass. Another translation limited to Book II was that of Georges Bontemps (1876), who made a new French version on the basis of Escalopier's text.

Albert Ilg (1874) provided the only edition before that of Dodwell which made any pretense to a complete collation of the various manuscripts, and he also produced the first translation into German. He made use of all the previous editions and his critical apparatus is extensive. He collated two manuscripts in Vienna which had been noted but not used by Morelli and Hendrie, and he also had

access to the Wolfenbüttel and Leipzig manuscripts; for the others
he relied upon the respective printed editions. Ilg's text is, however,
not good. It is arbitrary, full of errors and misreadings; yet for
seventy years it was the principal basis for scholarly studies of
Theophilus.

In 1880 a Polish translation was published in Kraków by T.
Żebrawski without a Latin text.

The twentieth century has seen three editions: an anonymously
edited reprint of the Escalopier French translation, published in
Paris in 1924 without acknowledgment, introduction, or annota-
tion; and the editions of Theobald (1933) and Dodwell (1961) with
text and translations into German and English, respectively.

Theobald omits most of the first book because his interest was
primarily technological, but he provides the second and third books
together with fine illustrations and copious notes. His text is based
on the Wolfenbüttel manuscript G, supplemented by H for those
chapters in Book III which are lacking in G. There is a brief critical
apparatus appended to each chapter, but Theobald's emendations
are not always warranted. His notes are extensive (sometimes, per-
haps, too elaborate) and are designed to clarify Theophilus' descrip-
tions or to describe the history of the technical processes involved.
Among the illustrations are many most useful drawings showing
reconstructions of details of various tools and pieces of equipment.
The indebtedness of the present translators to Theobald will be
obvious, although disagreement with his interpretation is not in-
frequent.

The most recent edition of the *Treatise* is that of C. R. Dodwell
(1961). It consists of a newly collated Latin text, together with
critical apparatus, an English translation, and an excellent intro-
duction. The text is far superior to that of any previous edition, as
it is based on a critical evaluation of the reliability of the various
manuscripts with proper consideration of technical plausibility.

Dodwell's edition is of such quality that there could scarcely
seem to be need for another to follow so soon. Had the present
translators known in advance of Dodwell's plans, our labor would
have been saved, but when we heard of his work we had already
completed our translation, then based primarily on the printed

texts of manuscripts *G* and *H,* and it awaited only final annotation. We decided to carry on with our edition. Dodwell's great contribution is the long-overdue collation of the Latin manuscripts and his text is definitive, apart from an occasional reading. We—a classicist and a metallurgist in collaboration—envisaged our edition as one that would pay especial attention to the detailed technology that Theophilus describes, the tools, materials, and practical processes. With Dodwell's page proofs before us, we revised our translation to make it conform to his new Latin text, which he freely and gracefully offered to us. In some places, where technical reality demands, we have followed a reading that he discarded, and occasionally we have adopted one of his English phrases when it is obviously closer to the Latin than was our first rendering. Normally, however, we have retained our independent wording, in the belief that two opinions are of more value than one and that the full meaning and color of the original are more closely to be found by diversity of translation and scholarly co-operation. As a complement to Dodwell's philological and historical researches, we have been able to add in our edition drawings of the tools and devices used by Theophilus and photographs of pertinent twelfth-century craftsmanship.

A word is needed to explain our choice of title. Dodwell points out that the phrase *Diversarum artium schedula,* which has commonly been used as a title following Lessing's original adoption of it, is actually only a descriptive phrase in the Prologue. There is no title on either *G, L,* or *H.* The titles of both *V* and *C,* however, read *De diversis artibus,* which was adapted by Dodwell as "The Various Arts," the title of his edition. We have retained the preposition and preferred the slightly archaic word "divers."

A list of the principal printed editions follows.

LIST OF THE PRINTED EDITIONS

An asterisk (*) denotes that only a selected part of the text is included.

*1774 Lessing, Gotthold Ephraim. *Vom Alter der Oelmalerey aus dem Theophilus Presbyter.* Brunswick, 1774. 96 pp. 17 cm.

Reprinted in Lessing's *Vermischte Schriften,* VIII, 287–368. Berlin, 1792, and subsequent editions. A French translation was included in C. F. Soehnée, *Recherches nouvelles sur les procédés de peinture des anciens. . . .* Paris, 1822.

781 ———. "Theophilus Presbyter Diversarum Artium Schedula," in *Zur Geschichte und Literatur aus den Schätzen der herzoglichen Bibliothek zu Wolfenbüttel*, VI. Beytrag, Brunswick, 1781 (colophon 1780), pp. 291–424.

This was edited by Christian Leiste. Although this was omitted from the first edition of Lessing's collected works, it was reprinted, minus the introduction, in Lessing's *Sämmtliche Schriften:* ed. Karl Lachmann (Berlin, 1839), X, 372–463; ed. Wendelin von Maltzahn (Leipzig, 1856), X, 369–461; ed. Alfred Schöne (Berlin, 1877–78), XIII, Abt. 2, 458–552; ed. Franz Muncker (Leipzig, 1898), XIV, 48–125; and others.

781 Raspe, Rudolf Erich. *A Critical Essay on Oil-Painting, proving that the art of painting in oil was known before the pretended discovery of John and Hubert Van Eyck.* . . . London: H. Goldney, 1781. vii+148 pp. 24 cm.

843 Escalopier, Comte Charles de l'. *Theophili presbyteri et monachi libri III. seu Diversarum artium schedula. Opera et studio Caroli de l'Escalopier.* With second title page: *Théophile prêtre et moine. Essai sur divers arts, publié par le Cte Charles de l'Escalopier . . . et précédé d'une introduction par J. Marie Guichard.* Paris: Firmin Didot Frères, 1843. lxxii+315 pp. 27 cm.

847 Winston, Charles S. "A Translation of the Second Book of the *Diversarum artium schedula Theophili Presbyteri et Monachi,* with notes." Forms Appendix A in *An Inquiry into the Difference of Style Observable in Ancient Glass Paintings, Especially in England.* . . . Oxford: J. H. Parker, 1847. 2 vols. xiv+384 pp.; 75 pls. 22.5 cm.

Based upon the Escalopier Latin text. Reprinted without significant change in 1867.

847 Hendrie, Robert. *Theophili, qui et Rugerus, presbyteri et monachi libri III. De diversis artibus: seu diversarum artium schedula.* . . . With second title page: *An essay upon various arts, in three books, by Theophilus, called also Rugerus, priest and monk, forming an encyclopedia of Christian art of the eleventh century. Translated, with notes, by Robert Hendrie.* London, John Murray, 1847. li+447 pp. 22 cm.

Has an added title page in Latin, printed in gold.

851 Bourassé, Jean Jacques. "Essai sur divers arts, en trois livres, par Théophile, prêtre et moine . . . avec traduction et notes. . . ." Occupies columns 729–1014 and 1141–46 in Vol. XII of the *Nouvelle encyclopédie théologique . . .* publiée par [J. P.] Migne. Paris, 1851.

Has a second title page: *Dictionnaire d'archéologie sacrée.* Vol. II. Paris, 1851.

1874 Ilg, Albert. "Theophilus Presbyter Schedula diversarum artium. 1. Band. Revidierter Text, Übersetzung und Appendix," in *Quellenschriften für Kunstgeschichte und Kunsttechnik des Mittelalters und der Renaissance*. VII, 1–374. Vienna, 1874. 22 cm.

*1876 Bontemps, Georges.[6] *Theophili presbyteri et monachi. Diversarum artium schedula Liber Secundus. Translatore Georgio Bontemps. Deuxième livre de l'essai sur divers arts par Théophile, prêtre et moine, traduit par Georges Bontemps*. Paris, 1876.

1880 Żebrawski, Teophil.[6] *Teofila kaplana i zakonnika o sztukach rozmaitych ksiąg troje przelożyl z lacinskiego T. Żebrawski*. Kraków, 1880.

1924 [Anon.]. *Traité des divers arts par Théophile, prêtre et moine*. Paris: Émile Paul Frères, 1924. 129 pp. 19 cm.

 A reprint of Escalopier's 1843 edition, without the Latin and without acknowledgment, introduction, or annotation.

1933 Theobald, Wilhelm. *Technik des Kunsthandwerks im zehnten Jahrhundert des Theophilus Presbyter Diversarum artium schedula, in auswahl neu herausgegeben, übersetzt und erläutert*. . . . Berlin: V.D.I. Verlag, 1933. xxxi+533 pp. 30 cm.

 Omits most of Book I.

*1951 Smits van Waesberghe, J. "Cymbala. Bells in the Middle Ages," *Studies and Documents* (American Institute of Musicology, Rome), Vol. I. 1951.

 Contains the chapters on bells only, translated on the basis of manuscripts *H* and *P* and Theobald's edition.

1961 Dodwell, C. R. *Theophilus, De diversis artibus. Theophilus, The Various Arts. Translated from the Latin with Introduction and Notes by C. R. Dodwell, Fellow and Librarian, Trinity College, Cambridge*. London and Edinburgh, etc.: Thomas Nelson & Sons, Ltd., [1961]. lxviii pp.+171 double pp. 21 cm.

 Part of Nelson's Series of Medieval Texts.

1963 Hawthorne, John G., and Smith, Cyril Stanley. *On Divers Arts. The Treatise of Theophilus. Translated from the medieval Latin with introduction and notes by John G. Hawthorne and Cyril Stanley Smith*. Chicago: University of Chicago Press, 1963.

 The present edition.

 [6] We have not seen Bontemps and Żebrawski. The titles are from the British Museum catalogue and the Library of Congress Union Catalog.

TABLE OF CONCORDANCE OF THE MAJOR EDITIONS*

BOOK I

HS, D	L	H, B	E, A	I	T
1–17	1–17	1–17	1–17	1–17	. . .
18	. . .	18	18	18	. . .
19	. . .	19	19	19	. .
20	18	20	20	20	. . .
21	19	21+22	21	21	. . .
22	20	23	22	22	. . .
23	21	24+25	23+24	23+24	23
24	22	26	25+26	25+26	25+26
25	23	27	27	27	. . .
26	24	28	28	28	. .
27	25	29	29	29	. . .
28	26	30	30	30	30
29	27	31	31	31	. . .
30	28	32	32	32	. . .
.	33	33	33
.	34	34	. . .
.	35	35	35
.	36	36	36
.	37	37	37
31	29	33	38	38	. . .
32	30	34	39	39	. . .
33	31	35	40	40	. . .
34	32	36	41	41	. . .
35	33	37	42	42	. . .
36	34	38	43	43	. . .
37	35	39	44	44	. . .
38	. . .	40	45	45	. . .

BOOK II

Chapters 1 to 31 are identical in all editions, except for Lessing's, which has two chapters numbered 6, his 7–10 are 8–11 of other editions, and 12–31 are without numbers.

BOOK III

HS, D	L	H, B	E, A	I	T
1–15	1–15	1–15	1–15	1–15	1–15
16	16p	16	16	16	16
17	16p	17	17	17	17
18	17	18	18p	18	18
19	18	19	18p	19	19
20	19	20	19	20	20

* There is some variation in the numbering of and division into chapters among the different printed versions of the *Treatise*. The following concordance is designed to facilitate comparison.

Key: HS, this edition (1963); D, Dodwell (1961); L, Lessing (1781, 1839, etc.); H, Hendrie (1847); B. Bourassé (1851); E, Escalopier (1843); A, Anon. (Paris, 1924); I, Ilg (1874); T, Theobald (1933); p, part of chapter.

HS, D	L	H, B	E, A	I	T
21	20	21	20	21	21
22	21	22	21	22	22
23	22	23	22	23	23
24	23	24	23	24	24
25	24	25	24	25	25
26	25	26	25	26	26
27	26	27	26	27	27
28	27	28	27	28	28
29	28	29	28	29	29
30	29	30	29	30	30
31	30	31	30	31	31
32	31	32	31	32	32
33	32	33	32	33	33
34	33	34	33	34	34
35	34	35	34	35	35
36	35	36	35	36	36
37	36	37	36	37	37
38	37	38	37	38	38
39	38	39	38	39	39
40	39	40	39	40	40
41	40	41	40	41	41
42	41	42	41	42	42
43	42	43	42	43	43
44	43	44	43	44	44
45	44	45	44	45	45
46	45	46	45	46	46
47	46	47	46	47	47
48	47	48	47	48	48
49	48	49	48	49	49
50	49	50	49	50	50
51	50	51	50	51	51
52	51	52+53	51	52	52
53	52	54p	52	53p	53p
54	53	54p	53	53p	53p
55	54	55	54	54	54
56	55	56	55	55	55
57	56	57	56	56	56
58	57	58	57	57	57
59	58	59	58	58	58
60	59	60	59	59	59
61	60	61	60	60	60
62	61	62	61	61	61
63	62	63	62	62	62
64	63	64	63	63	63
65	64	65	64	64	64
66	65	66	65	65	65
67	66	67	66	66	66
68	67	68	67	67	67
69	68	69	68	68	68
70	69	70	69	69	69

Book III—*Continued*

HS, D	L	H, B	E, A	I	T
71	70	71	70	70	70
72	71	72	71	71	71
73	72	73	72	72	72
74	73	74	73	73	73
75	74	75	74	74	74
76	75	76	75	75	75
77	76	77	76	76	76
78	77	78	77	77	77
79	78	79	78	78	78
80	75(ii)	80	79	79	79
81	76(ii)	81	80	80	80
82	. . .	82	. . .	81	81
83	. . .	83	. . .	82	82
84	. . .	84	. . .	83	83
85	. . .	85	. . .	84	84
86	. . .	86(i)	. . .	85	85
87	. . .	86(ii)	. . .	86	86
88	. . .	87	. . .	87	87
89	. . .	88	. . .	88	88
90	. . .	89	. . .	89	89
91	. . .	90	. . .	90	90
92	. . .	91	. . .	91	91
93	. . .	92	. . .	92	92
94	. . .	93	. . .	93	93
95	. . .	94	. . .	94	94
96	. . .	95	. . .	95	95
.	96–111

THE PLACE OF THE TREATISE
IN THE LITERATURE OF THE PRACTICAL ARTS

Theophilus needs no introduction to those concerned with art history. He has been intensively studied for the light that he throws on medieval painting and glassmaking, and, somewhat less thoroughly, in connection with metalwork. In addition, however, since the material-working crafts constituted the most advanced branch of technology in the Middle Ages, Theophilus' discussion of them provides a most valuable source for its study.

The monuments of Romanesque metalwork that can be seen in our museums today were made by Theophilus and his fellow smiths, and the appearance of the works themselves should be borne in

mind while reading the *Treatise,* for the design and the techniques are inseparable. It is actually the first substantial written record of techniques that is available to supplement the evidence that can be derived from examining surviving objects.

This twelfth-century work of Theophilus far excels other early literary sources on technological history, for it is the first European writing in which there is realistic detail on a wide range of complex technical processes. Many of the techniques themselves can be traced in surviving examples of ceramics and metalwork from the third millennium B.C. and even earlier. Illiteracy did not prevent the employment and enjoyment of the diverse properties of matter by artisans who long ago learned to associate fire, tool, material, form, and function in a balanced relationship, but it did deprive us of a useful record. Artisans, if they wrote at all, at best only jotted down partial reminders and recipes, records which had little chance of survival, for literary men did not regard such material as suitable for their pens or even for preservation in their libraries.

There are, of course, innumerable encyclopedic, alchemical, and even practical manuscripts that are earlier than this *Treatise* of Theophilus, but their information value is slight. The special terminology generally used by the alchemists obscures whatever technical knowledge may have been contained in their writings. The compilers of encyclopedias—of whom Pliny is outstanding—provided much interesting information but never on the basis of personal acquaintance with technical matters. The early collections of technical recipes which have survived provide material for philological study and for fascinating technico-historical detective work, but they reflect only feebly the technology of their times; the rare technical manuscript that did get accepted by scholars was thereafter copied and recopied without further contact with the workshop and with an inevitable increase of informational entropy.

The earliest written records of Theophilus' arts are the Assyrian cuneiform clay tablets discussed by R. C. Thompson (1925, 1936). The first of these date from the seventeenth century B.C. and describe in an intelligible way the ingredients for making glass. Even

better are the Nineveh tablets of the seventh century B.C. which tell
of the making of pigments, the construction of glass furnaces, and
the composition of the batches for clear and colored glass, and con-
tain some information on solders and other alloys.[7] The substance
of many of the Assyrian recipes appears unchanged in the famous
Egyptian papyri, dating from the third century A.D., now in Leiden
and Stockholm (see Berthelot, 1885; Caley, 1926, 1927). These were
elegantly written in Greek on good papyrus, probably by someone
on the fringes of technical operations rather than a practitioner.
They contain recipes for dyeing, for color-making, and for a number
of alloys. Some of these are realistically practical, but many involve
improbable and complex compositions which bear little relation to
the materials used in such contemporary metalwork as has survived.

The same manuscript tradition continued unbroken down to
Theophilus' day, when it existed as two separate series—best rep-
resented by the *Mappae clavicula* (see Phillips, 1847; Johnson, 1935)
and the manuscript at Lucca, *Compositiones variae* (commonly
known as *Compositiones ad tingenda musiva*) (see Hedfors, 1932;
Burnam, 1920). The continuity and interrelationship of the various
manuscripts are discussed by R. P. Johnson (1939). The later ones
include many of the items of the Leiden papyrus essentially without
change. The Lucca manuscript contains several usable alloy recipes,
descriptions of making gold leaf and mineral pigments, as well as
the coloring of glass for use in mosaics. It was written at the end
of the eighth century. The *Mappae clavicula* was compiled very
early in the ninth century, although the earliest surviving manu-
script is of the tenth century. It was followed by many others with
considerable variation. The *Mappae clavicula* has a number of
recipes identical with those in the *Compositiones* but it lays greater
emphasis upon the coloring and multiplication of gold, and its
twelfth-century copies contain additional paragraphs on the testing
of gold by weighing in water, on measuring the height of buildings,
and on various incendiary compositions. Although the *Mappae*

[7] Thompson's magnificent work on these tablets, extending technological history by over a millennium, is marred by his incorrect identification of some of the substances. See, for example, the comments of Turner (1956).

clavicula contains more technical information than the *Composi-tiones,* it has attracted far less critical attention and has not been translated into any modern language.

There is little doubt that a continuously connected sequence of copied and recopied manuscripts extended perhaps from Assyrian, certainly from Greco-Egyptian, antiquity to the twelfth century A.D. and beyond. There is even a traceable connection with the printed *Kunstbüchlein* and the Books of Secrets of the sixteenth century and later. It has not, however, generally been realized that these relationships decrease the value of the sources as evidence for contemporary practice. Theophilus' manuscript is completely out-side this literary circuit and hence of incomparably greater value. Literary scholars have tended to group it with the others because it names some of the same substances and because many of the later copies of Theophilus include sections lifted from them and vice versa. Theophilus unmistakably wrote directly from his own experi-ence in Book III and from intimate observation and critical inquiry of his fellow artisans in his first two books. Moreover, Theophilus aimed to write a detailed and well-balanced manual for the express purpose of disseminating information and instructing youth: some-thing very different from the old recipe collections. Though the processes he described had their roots deep in the past, the infor-mation had been transmitted as the living, growing practical tradi-tion in the workshops themselves, not as words passing perilously through scriptoria. Theophilus himself could not avoid the deg-radation inevitable at the hands of copyists, but, when first written, his *Treatise* had a comprehensiveness and originality, a down-to-earth quality that makes it far superior to any other technological manuscript for some centuries to come. The very fact that he did not appropriate the older recipes and their errors verbatim would be distinction enough, even if he had limited himself to the same things. Actually he covered a much wider field, and, unlike the others, he wrote with the obvious intent that readers should share his delight in the use of materials and techniques for making beau-tiful things.

The importance of Theophilus' work was quickly recognized and, as we have seen, many copies of it were made. Their existence did

not prevent the continuation of the older recipe collections or even the writing of a better new one, *De coloribus et artibus Romanorum,* by Eraclius (twelfth century). This work was added to by later writers, and by the fifteenth century it contained considerable information on compositions for the manufacture of colored glass. There was no work that showed any significant improvement over Theophilus as a source for the arts he describes until the books by Cennini (1437) on painting, Månsson (*ca.* 1520) on glass, and Biringuccio (1540) on almost everything but painting.

Against this background let us survey the principal contributions of Theophilus to the record of technology.[8] The best-known part of the *Treatise* is the discussion of painting, which consists mostly of instructions on the mixing of pigments and their use on various surfaces. He mentions a variety of materials as vehicles for pigments, including linseed oil, which he remarks was tedious to use (which it must have been, since no dryer was used), egg white or yolk, lime, and some vegetable resins or juices. He gives little chemical information on the pigments themselves, although the manufacture of lead-white, minium, two kinds of copper-green, and vermilion is described on a scale appropriate to a small factory. The manufacture of gold leaf is described (using "Byzantine parchment," which is perhaps the first European reference to paper), and also the preparation of gold powder inks for chrysography.

Theophilus describes a relatively large plant for making glass in the form of windows, vessels, mosaic tesserae, and glazes. The general scale of operations suggests the employment of at least twelve workmen, perhaps more. He mentions a number of special tools—the blowpipe for the first time—and describes the manipulation of glass in some detail. The chemistry of the process is again rather lightly treated. To obtain glass of different color for windows, he evidently depended on the incidental presence of manganese in the beechwood ashes and iron in the sand and refractories that were

[8] No one who reads Theophilus should fail to read *Medieval Technology and Social Change* by Lynn White, Jr., published after the present work was completed. Showing how erroneous is the view of history that depends only on written records, White discusses the lively technological ferment in the Europe of Theophilus' time, citing several waves of technological innovation which produced changes in society and in man's outlook.

used, for there is no suggestion of any added metallic oxides or other
coloring matter, except in compounding the pigment to be applied
superficially on painted windows.

The intimate detail in Book III of the *Treatise,* on metalwork,
leaves no doubt that Theophilus was himself a practicing worker
in metal and many of his descriptions convey vividly the feel of the
material and the appearance of the activity in the workshop. He
begins with the construction of a high spacious building specifically
for these operations, with a large room for the casting and working
of base metals, with two smaller ones for gold and silver, each with
their special workbenches and forges. It is to be noted that he uses
a number of simple machines, such as drills, lathes, and a special
tool for swaging beaded wire, which must have greatly accelerated
the production of the decorative filigree that was so popular at the
time. He describes stamps and dies for the repetitive production of
designs on thin sheet metal for use as borders. There is an ingenious
little machine for cutting grounds for damascening. Theophilus
several times refers to an instrument called a *runcina,* which is
probably a normal cylindrical grindstone for preparing smooth
surfaces. Despite this range of simple machines and specialized tools,
most of the important vessels that he describes were made or finished
by the standard methods of punching, raising, sinking, repoussé,
engraving, and chasing, all of which depend less on mechanical aid
than on the skill of the craftsman using the simplest tools. The
variety of shapes of hammers, anvils, punches, etc., is hardly ex-
ceeded in a modern shop. Some degree of skill in mechanical design
is involved in the simple machines mentioned above, as well as in
the organ with its many valves and air channels, but most of
Theophilus' ingenuity in design seems to have been in the aesthetic
realm. Nowhere in the book is there a suggestion of the use of
mechanical power to replace human muscle, and there are no large
machines, not even a crane to handle the mold for large bells, al-
though suitable hoisting devices were in use in building construction
at the time.

To put metals or alloys into form for subsequent working,
Theophilus cast metal into ingot molds or built-up slab molds. He
gives a detailed description of the *cire perdue* casting of handles for

a chalice in precious metal and an elaborate brass censer with tier upon tier of symbolic architectural forms. Of particular interest is the chapter on the casting of bells, which is replete with both technical and organizational detail. The bell metal, melted in a kind of cupola, was run through a channel into the mold buried in a pit in the earth. The mold was made of clay on a lathe, with a turned pattern of tallow, which was melted out as the mold was heated in a temporary furnace built in the pit. Theophilus' description of the appearance of the metal, of the foreman running back and forth between mold and furnace, and of the strong disciplined men carrying the pots of hot metal is vivid. Like the glassmaking operations, the casting of bells required many men and a considerable degree of technological organization, although most of Theophilus' work required only one man and a boy.

All the operations described by Theophilus are intimately dependent on the quality of the raw materials used. It is apparent that there was a considerable trade in pigments, for there are many which he uses without any discussion of their preparation. His discussion of glassmaking, on the other hand, begins with the cutting of the beechwood logs and the washing of the sand. Among the metals, iron and steel were just taken and used, although Theophilus tells the reader how to harden steel tools and how to case-harden iron. The precious metals fare a little better, because they needed more working and reworking locally, but their winning is poorly described. The refining of both silver and gold (by cupellation and cementation, respectively) is given in some detail, but there is not a word on the origin of silver, and the chapters on the origin of gold (except for one on Rhenish alluvial gold washing) smack more of an alchemist's writings than of the elsewhere practical Theophilus.

Theophilus evidently obtained his copper in a crude metallic form, although he gives a tantalizing description of its smelting in which he mentions the separate melting-out of lead. This is a most unlikely happening, and it may be a garbled report of the liquation process for desilverizing copper, which is commonly supposed to be a much later invention.

Sources of heat are of major concern to any metalworker. Theophilus most commonly used a simple charcoal fire urged by a bellows,

but his design of the cupola for melting bell metal, his large rever-
beratory furnaces for glass melting and annealing, and the well-
designed wind furnace for making brass incorporate among them
the principles of all metallurgical furnaces prior to the introduction
of gas and electricity.

The range of refractory materials was limited to natural stones,
sand, and clay, and many operations were done in ordinary pots.
Glass vessels are rarely mentioned. Theophilus does not describe the
alloying of gold and silver. He employs the pure metals for his
ecclesiastical vessels, the amount of material available determining
the size of the work to be produced. Nor is there any information
on assay methods, although malleability tests for quality are men-
tioned several times. The number of alloy compositions used by
Theophilus was limited, consisting only of brass, bell metal, and the
various alloys used for solders (tin-lead, copper-silver, and copper-
gold) each of which, however, was made in a composition which
modern thermometric measurements have shown to be approximate-
ly that of lowest melting point.

Since Theophilus was not concerned with the manufacture of
arms and armor, agricultural tools, textiles, or buildings, his *Trea-
tise* throws little light on contemporary problems of technological
organization. It is an account primarily of individual craftsmanship,
not of integrated industry. Some of the methods that he describes
are used almost unchanged in today's decorative arts, but, a few
centuries after he wrote, there was to develop a parallel material-
working industry which was more concerned with quantity than
with quality and which had to satisfy vastly wider markets. The
automated industries of today, in which instruments sense the prop-
erties that Theophilus felt with his fingers and in which mechanical
power replaces his muscles, have their roots in the simple operations
that he describes and depend upon exactly the same properties of
matter. It was in workshops like those described by Theophilus that
the principal characteristics of metals, alloys, and other materials
were uncovered, properties which had to be explained by the phi-
losopher and eventually by the scientist.

Theophilus was neither a scientist nor an engineer nor an indus-
trialist in the modern sense. He was a craftsman, making things

mostly for their beauty, and, though he used many tools and some simple machines, he thought little about labor-saving devices and had no desire for large-scale production. His knowledge of matter was the directly sensed, intuitive understanding that comes from constantly handling divers substances under various conditions, not the intellectual knowledge that comes from considering them within a theoretical framework. It was sound knowledge, nevertheless, and the *Treatise* provides a very realistic picture of what was definitely known at the time. It has its place in any study of the development of science and technology, as well as in the history of religion and art.

THE TREATISE

List of Chapters

THE SECOND BOOK: THE ART OF THE WORKER IN GLASS / 45

THE FIRST BOOK

The Art of the Painter

Prologue

Theophilus, a humble priest, servant of the servants of God, unworthy of the name and profession of monk, to all who wish to avoid and subdue sloth of mind and wandering of the spirit by useful occupation of the hands and delightful contemplation of new things: the recompense of heavenly reward!

We read in the account of the creation of the world that man was created in the image and likeness of God and was given life by the breathing-in of the Divine breath; that by the excelling quality of such distinction he was preferred above all other living creatures, so that, capable of reason, he might participate deservedly in the wisdom and skill of God's design, and that, endowed with freedom of choice, he should respect the will and revere the sovereignty of his Creator alone. But, although he lost the privilege of immortality through the sin of disobedience, being pitifully deceived by the cunning of the devil, nevertheless he transmitted to the generations of posterity his distinction of knowledge and intelligence, so that whoever devotes care and attention to the task can acquire, as by hereditary right, the capacity for the whole range of art and skill.

Holding this purpose before it, human ingenuity, in its varied activities in pursuit of gain and pleasure, brought this purpose through the waxing of time eventually to the predestined era of the Christian religion. So it came to pass that a people devoted to God converted to His worship that which His own ordinance had created for the praise and glory of His name.

Wherefore the pious devotion of the faithful should not neglect what the ingenious foresight of their predecessors has transmitted to our present age, and man should embrace with avid eagerness the inheritance that God bestowed on man and should labor to acquire it. Let no one after acquiring this glorify himself in his own heart as though it had been received from himself and not from elsewhere. But let him be humbly thankful in the Lord from whom and through whom all things are and without whom nothing is. Let him not hide

11

his gifts in the purse of envy nor conceal them in the storeroom of a
selfish heart but, thrusting aside all boasting, let him simply and
with a cheerful mind dispense to those who seek. Let him also fear
the judgment in the Gospel on that merchant who failed to return
the talent to his master with interest and went without thanks, and
by the evidence of his own mouth deserved the epithet, "thou
wicked servant."[1]

Fearing to incur this judgment, I, an unworthy human creature,
almost without name, offer freely to all who desire in humbleness to
learn the gifts that God, who gives abundantly and undemandingly
to all, has deigned to grant freely to me. I admonish them to see
exemplified in me the blessed kindness of God and to wonder at His
ample generosity. I urge them to believe unquestioningly that the
same is there for them if they will add their own efforts. For just as
it is wicked and hateful for a man through evil ambition to grasp at
a forbidden thing that is not his due or to take possession of it by
theft, so also it must be ascribed to laziness and to folly if he leaves
without trial or treats contemptuously a rightful inheritance from
God the Father.

Therefore, whoever you are, dearest son, whose heart God has in-
spired to investigate the vast field of the divers arts and to apply
your mind and attention to gather from it whatever pleases you, do
not disparage any costly or useful thing just because your native soil
has spontaneously and unexpectedly produced it for you. For he is a
foolish merchant who suddenly comes across a treasure while dig-
ging the soil and neglects to gather it up and save it. If your common
shrubs should produce myrrh, frankincense, and balsam, if your
local springs should pour forth oil, milk, and honey, if spikenard,
cane, and various aromatic herbs should grow in place of nettles,
thistles, and other garden weeds, would you despise all these as
cheap local products and travel over land and sea to procure foreign
ones that are no better and are perhaps of less value? Even in your
own judgment this would be a great folly. For although men nor-
mally accord highest rank to, and guard with the greatest care, every
precious thing that has been sought after with much sweat and ac-
quired at extreme expense, yet if now and then similar or better

[1] Matt. 25:26.

things turn up or are found for nothing, they are guarded with similar or even greater vigilance.

Therefore, most gentle son—whom God has wholly blessed in that there are freely offered to you things which many obtain only after intolerable effort, plowing the waves of the sea at the greatest danger to their lives, constrained by the necessities of hunger and cold, or wearied by long servitude to the professors, and yet remain unflagging in their desire for learning—gaze covetously and avidly upon this treatise on divers arts, read it through with tenacious memory, and embrace it with an ardent love.

If you study it diligently you will find here whatever kinds of the different pigments Byzantium[2] possesses and their mixtures; whatever Russia has learned in the working of enamels and variegation with niello; whatever Arab lands adorn with repoussé or casting or openwork; whatever decoration Italy applies to a variety of vessels in gold or by the carving of gems and ivories; whatever France loves in the costly variegation of windows; and whatever skillful Germany applauds in the fine working of gold, silver, copper, and iron, and in wood and precious stones.

When you have read this again and again and entrusted it to your tenacious memory, you will repay your instructor for his pains if every time you have made good use of my work, you pray for me that I may receive the mercy of almighty God who knows that I have written what is here systematically set forth neither out of love for human praise nor from desire for temporal reward, and that through envious jealousy I have neither stolen anything precious or rare nor silently reserved anything for myself alone, but rather that I have given aid to many men in their need and have had concern for their advancement to the increase of the honor and glory of His name.

[2] See Book II, chap. 13, n. 1.

Chapter 1. The Mixture of Pigments for Nude Bodies

The pigment called flesh-color, with which faces and nude bodies are painted, is prepared thus. Take ceruse (i.e., the white which is made from lead) and put it without grinding, just as it is, dry, into a copper or iron pot; set it on blazing coals and burn it until it turns a yellowish tan color.[1] Then grind it and mix white ceruse and cinnabar[2] with it until it looks like flesh. Mix these pigments to suit your fancy: for example, if you want to have red faces, add more cinnabar; if white, put in more white; if pallid, put in a little *prasinus* instead of cinnabar.[3]

[1] Cf. Book I, chap. 37 (hereafter book and chapter of this *Treatise* are cited as "I-37," etc.). This change of color is due to the conversion of ceruse, $PbCO_3$, to the oxides, massicot and minium, PbO and Pb_3O_4.

[2] In I-34 it will be seen that by *cenobrium* Theophilus actually means the artificial pigment vermilion.

[3] We list below all of the pigments and vegetable colors that are referred to by Theophilus, together with a brief identification. In preparing this we have leaned heavily upon D. V. Thompson (1936) and S. Waetzoldt (1952–53).

RED

Burnt Ocher, the red iron oxide (*rubeum:* I-1, 3, 11, 12, 13, 14, 16, 23; II-17). Although "red that is burnt from ocher" is specified in I-3 and I-23, it is possible that red used elsewhere was sometimes a natural red earth, ground without firing. Red iron oxide (rouge) for polishing gold was made by calcining green vitriol (III-40).

Cinnabar, a popular pigment which to Theophilus was artificial mercury sulphide, later known as vermilion. Preparation described in I-34 (*ceno-brium:* I-1, 3, 4, 8, 14, 15, 16, 20, 29, 34).

Minium (red lead, Pb_3O_4), made by roasting ceruse as in I-37 (*minium:* I-4, 14, 20, 25, 29, 30, 32, 37).

Carmine, mentioned without description except for comparison of color with minium or cinnabar. It is probably the coloring matter derived from the eggs of the cochineal insect, *kermococcus vermilio* (*carmin:* I-24, 32, 33).

Folium, a vegetable juice which was red in its natural acid state (*folium:* I-14, 16, 33). See I-33, n. 1.

Madder, used only on bone (*rubrica:* III-94).

YELLOW

Ocher, a natural yellow earth consisting mostly of hydrated iron oxides and clay mineral (*ogra:* I-3, 10, 11, 14, 15, 16).

Orpiment, yellow arsenic sulphide, also used in a mixture with cinnabar (*auripigmentum:* I-14).

Saffron yellow, from the dried stigma of the saffron plant or crocus. Theophilus uses the pigment mostly for staining the surface of tin to represent gold, but the term is also applied to

the color of a clear yellow glass (II-7, 12, 21, 23, 28) (*croceum:* I-16, 24, 30).

GREEN

Green and dark green pigments, otherwise unidentified but supposedly earth greens (*viride:* I-2, 14, 15).

Spanish green (*viride Hispanicum:* I-25, 32, 36) and *salt green* (*viride salsum:* I-32, 35), both of which types of verdigris are basic copper acetates, the latter perhaps with some chlorides. Their manufacture is described in some detail.

Prasinus is hard to identify, and we have not followed Dodwell in translating it as "earth green" (see I-2, n. 1) (*prasinus:* I-2, 3, 7, 11, 15).

Sucus is supposedly sap green (probably that made from buckthorn berries) which owes its color to chlorophyll (*sucus:* I-14, 15, 16, 25). Other vegetable juices that are mentioned are those of iris, cabbage, and leek (*sucus gladioli vel caulae vel porri:* I-32, elderberry juice (*sucus sambuci:* I-14), and the material *folium* (see under red and blue pigments).

BLUE

Azure is the only mineral blue mentioned. Probably this was the mineral azurite, basic copper carbonate, $Cu_3(CO_3)_2OH_2$, but Theophilus could have known other natural or artificial blue pigments, including ultramarine (which was prepared by a kind of flotation process) although he does not specifically mention them (*lazur:* I-14, 15, 16). See Raft (1968).

Indigo, the vegetable color imported from the Orient (*indicum:* I-14).

Folium, the red vegetable juice which became purple or violet when made alkaline with urine and wood ash, or blue when made still more alkaline with lime (*folium:* see I-33, n. 1).

Menesc, a vegetable pigment of uncertain nature, but probably violet or dark blue, since it was used as an alternative to indigo or elderberry juice in robe painting (I-14) and as a complementary color to cinnabar or ocher in the rainbow (I-16). The word is of obscure origin but Kissling (quoted by Waetzoldt) suggests that it is derived from the Persian *banaschi* (violet) (*menesc:* I-14, 16). Merrifield (1849) believed that it may have been madder, for *mnitsch* is the Indian name for this plant.

VIOLET

Menesc (see above).

Folium (see above).

Violet, an undescribed pigment or mixture of pigments, used as a robe color on a wall (*violaticum:* I-14).

BLACK

A pigment frequently mentioned by Theophilus, though he nowhere describes its preparation. The best blacks of the period were lampblacks or ground charcoal made from vine, ground grapevine shoots being preferred (*nigrum:* I-2, 6, 10–16).

Ink (*incaustum*), made from thornwood extract and green vitriol (I-38). Theophilus uses the word *atramentum,* which in classical Latin was a black pigment, only in places where the chemical context calls unmistakably for green vitriol and he certainly does not mean any of the carbon blacks as Waetzoldt has supposed. Vitriol was classically *atramentum sutorium,* shoemaker's black, but the term was often applied to blue vitriol and to astringent crystalline substances generally.

WHITE

Ceruse is the principal named white pigment, basic lead carbonate, the manufacture of which is described in I-37 (*cerosa:* I-1, 5, 12, 14, 25, 32, 37).

White pigment without fuller specification was probably ground bone ash, whiting, calcium carbonate, or lime (*album:* I-6, 9, 14, 16).

Gypsum or *chalk,* ground and mixed with glue, was used as a ground for painting, the mixture later known as

Chapter 2. The Pigment "Prasinus"

This *prasinus* is, as it were, a special preparation with a resemblance to green and black.[1] Its nature is such that it is not ground on a stone, but, when it is put into water, it disintegrates and it is then strained carefully through a cloth. It is very serviceable for use as green on a new wall.

gesso. It is interesting that Theophilus refers to both gypsum, the typical gesso of southern Europe, and chalk, which was the basis of northern ground (I-19, 22).

COMPOUND PIGMENTS

Veneda, gray, mixed from black and white as in I-6 (*veneda:* I-6, 13, 15, 16).

Exudra, brown, mixed from black and burnt ocher, for use as a shadow pigment on faces, etc. (*exudra:* I-13).

Shadow pigments, mixed from ocher, green, cinnabar, etc., used for dark flesh shades (*posc:* I-3, 5, 7, 15; II-21).

Flesh-colored pigments, mixed from massicot, ceruse, and cinnabar (*membrana:* I-3, 4, 5, 15).

Light brown pigments, for highlighting flesh, are mixed as for *membrana* but with more ceruse (*lumina:* I-5, 9, 15).

Rose is the basic flesh color plus cinnabar and minium (*rosa:* I-4, 8, 11, 13, 15).

It should be noted that Theophilus refers to mixed pigments very frequently, although D. V. Thompson (1936) believes that among medieval painters "the prevailing fashion was to use a palette of frank, definite colors."

METALLIC COLORS

Gold leaf (*petula auri:* I-23).

Tin leaf (*petula stagni*), either dyed yellow to imitate gold or used directly as a white reflecting background for applied painting (*pictura translucida:* I-27).

Milled gold (made as in I-28) used both as a paint, usually burnished, and as an ink for chrysography. Silver, brass, and copper powders were also ground and used in the same manner as gold: they must have been very subject to tarnish. Burnished tin powder would be better, whether dyed or not (I-30).

Theophilus usually refers only to the use of his pigments, not to their manufacture. The exceptions are cinnabar, Spanish green, salt green, ceruse, and minium, the preparation of which is described almost as an afterthought at the end of Book I; these are perhaps copied from another source, although they do not appear in either the *Mappae clavicula* or the Lucca manuscript.

See I-25 for note on pigment vehicles and I-21 for note on varnishes and resins.

[1] *Prasinus* is usually regarded as earth green and Dodwell so translates. However, the easy disintegration of the material in water would be a characteristic of a soluble or finely crystalline substance, not an earthy one, hence we have preferred not to translate the word. *Prasinus* is perhaps related to the leek-green gem *prasitis* (Theophrastus) or *prasius* (Pliny).

Chapter 3. The First Shadow Pigment

When you have mixed the flesh-color pigment and have laid in the faces and nude bodies with it, mix with it *prasinus,* the red that is burnt from ocher, and a little cinnabar, and so make shadow pigment. With this you should delineate the eyebrows and eyes, the nostrils and mouth, the chin, the hollows round the nostrils, the temples, the wrinkles on the forehead and neck, the roundness of the face, the beards of young men, the fingers and toes, and all the distinctive limbs of the nude body.

Chapter 4. The First Rose Pigment

Then mix a little cinnabar and a little less minium with the plain flesh-color pigment, to make the pigment that is called rose. With this redden both checks, the mouth, the lower part of the chin, the neck and the wrinkles of the forehead slightly; also each side of the forehead above the temples, the length of the nose, above the nostrils on each side, the fingers and toes, and the other limbs of the nude body.

Chapter 5. The First Highlighting Pigment

After this mix ground ceruse with the plain flesh-color pigment and prepare the pigment which is called the highlighting pigment. With this paint highlights on the eyebrows, the length of the nose, and above the openings of the nostrils on each side, the fine lines round the eyes, the lower part of the temples, the upper part of the chin, close to the nostrils, each side of the mouth, the upper part of the forehead, slightly between the wrinkles of the forehead, the middle of the neck, around the ears, the outside of the fingers and toes, and the middle of all the roundnesses of the hands, feet, and arms.

Chapter 6. "Veneda," To Be Put on the Eyes

Then mix black with a little white. This pigment is called *veneda*. Lay in the pupils of the eyes with it. Add still more white to it and lay in each side of the eyes. Paint plain white between the pupil and [the areas covered by] this pigment, and wash it with water.[1]

Chapter 7. The Second Shadow Pigment

Next, take the above-mentioned shadow pigment and mix more *prasinus* and red with it to make a darker shade of the former pigment. Lay in the intermediate space between the eyebrows and the eyes and in the center below the eyes, close to the nose, between the mouth and chin, the down or slight beards of adolescents, the half of the palms facing the thumb, the feet above the smaller toes, and the faces of boys and women from the chin up to the temples.

Chapter 8. The Second Rose Pigment

Then mix cinnabar with rose, and with it paint along in the middle of the mouth so that the former [rose] shows above and below. Draw fine lines over the former rose on the face, neck, and forehead. Delineate with it the lines in the palms, the joints of all the limbs, and the nails.

Chapter 9. The Second Highlighting Pigment

If the face turns out to be dark so that one coat of highlighting pigment is not sufficient, add more white to it and draw fine lines with it all over the first highlights.

[1] The intent is to soften the contrast between the white and the *veneda* by working over the junction with a wet brush.

Chapter 10. The Hair of Boys, Adolescents, and Young Men

After this mix a little black with ocher, and lay in the hair of boys and outline it with black. Add more black to the ocher and lay in the hair of adolescents and paint the highlights with the first highlighting pigment. Add still more black and lay in the hair of young men and paint the highlights with the second highlighting pigment.

Chapter 11. The Beards of Adolescents

Mix *prasinus* and red and, if you wish, a little rose and lay in the beards of adolescents. Mix ocher, black and red and lay in the hair; paint the highlights with ocher mixed with a little black and draw black lines on the beard with the same mixture [as for the hair].

Chapter 12. The Hair and Beards of Senile and Old Men

Mix a little black with ceruse and lay in the hair and beards of senile men. Add more black and a little red to the same pigment and draw the lines with it, and paint the highlights with plain ceruse. Mix still more black with ceruse and lay in the hair and beards of old men, and draw the lines with the same pigment but with more black and a little red mixed with it. Paint the highlights with the pigment you used to lay in the [hair and beards of] the senile men. In the same way make the hair and beards still blacker, if you wish.

Chapter 13. "Exudra" and the Other Pigments for Faces

Then mix a little black with red to give a pigment called *exudra*, and with it draw the lines round the pupils of the eyes and along in

the middle of the mouth and make fine lines between the mouth and the chin. After this make the eyebrows with plain red and draw fine lines between the eyes and eyebrows, below the eyes, and on the right side of the nose when in full face; also paint above the nostrils on each side, below the mouth, round the forehead, inside the cheeks of old men, round the fingers of the hands and inside the toes of the feet, and in front round the nostrils when the face is in profile. On the eyebrows of old and senile men you should use the *veneda* with which you laid in the pupils. Use plain black for the eyebrows of young men (in such a way that a little red shows through above [the eyebrows]), also for the upper part of the eyes, the holes of the nostrils, each side of the mouth, around the ears, the outside of the hands and fingers, and for the toes and the other lines of the body. Draw all the lines round nude bodies with red, and delineate the nails with rose pigment on the outside.

Chapter 14. The Mixture [of Pigments] for Robes on a Ceiling Panel[1]

Mix *menesc* with folium or black and a little red and lay in a robe. Also mix in a little black and draw the lines [for the folds]. Then mix azure with a little *menesc* or with folium or with the same pigment that you [used for] laying in [the robe] and paint the first high-

[1] The best reading of the chapter heading and the one which fits its content is that chosen by Dodwell on the basis of *G* and *H*, "De mixtura vestimentorum in laqueari." *V* reads *muro* ("wall") for *laqueari*, while *P* and *G* read simply, "De mixtura diversorum colorum." *Laquearia* were wooden ceiling panels. They are discussed at length by Clemens (1916), who provides several illustrations of panels with motifs similar to Theophilus' description.

Although there is not a thing in the chapter to suggest that vellum or parchment is the base under consideration, and the illumination of manu-

scripts is treated elsewhere (I-29 to 32), this chapter has been erroneously taken to refer to that art. The trouble started with the copyist who produced the manuscript *E*, originally at Trinity College, Cambridge, now at the British Museum. In the text he correctly entitles the chapter "De mixtura diversorum colorum," but in the list of chapters preceding Book II he added gratuitously, ". . . in vestimentis que fiunt in parchameno." Raspe transposed this erroneous interpolation, properly in parentheses, to the heading of the chapter in his printed transcription (1781). This reading was adopted by Ilg, who

lights; then paint the second highlights with pure azure. After this mix a little white with azure and draw fine lines, but only a few.

Lay in a robe with red and if the red is pale,[2] add a little black. Then mix more black with the same [red] and draw the lines. Then mix a little red with cinnabar and paint the second highlights.

Lay in a robe with cinnabar and mix a little red with the same [pigment] and draw the lines. Then mix a little minium with cinnabar and paint the first highlights. After this paint the [second] highlights with plain minium. Finally mix a little black with red and make the shadow along the outside.

Mix pure green with ocher so that there is more ocher, and lay in a robe. Add to the same pigment a little *sucus* and a little less red and draw the lines. Mix white with the same pigment that you used for laying in [the robe] and paint the first highlights. Add more white and paint the outer highlights. Mix also with the above shadow pigment more *sucus* and red and a little less green and make the shadow along the outside.

Mix the juice of folium with ceruse and lay in a robe. Add more folium and draw the lines. Add more ceruse and paint the highlights. After this [paint the second highlights] with plain ceruse. Finally mix a little ground-up folium and a little cinnabar with the first shadow pigment and make the [shadow along the] outside.

Lay in another robe with the same pigment. Add more folium and cinnabar to it and draw the lines. Add ceruse and a little cinnabar to the same pigment that you used for laying in, and paint the first highlights. Add more ceruse and paint the second highlights. Finally mix a little red with the first shadow pigment and make the shadow along the outside. From this assortment of pigments you can make three kinds of robes: one purple, another violet, and a third white.

Mix green with *sucus* and add a little ocher and lay in a robe. Add

transcribed it as "De mixtura diversorum colorum in vestimentis imaginum quae fiunt in pergameno" with no indication that the mention of parchment was a parenthetical hypothesis. Thence it became incorporated into the German mainstream of comment to produce untold confusion. The error was perpetuated by Berger (1897) and even in the recent detailed studies of The-ophilus that have been made from the standpoint of the painter, by Waetzoldt (1952–53) and by Roosen-Runge (1952–53), both of whom uncritically follow Ilg's carelessly composed text. However, see Roosen-Runge (1967), Vol. I.

[2] I.e., if the red lacks covering power or chromatic strength.

more *sucus* and draw the lines. Also add a little black and make the shadow along the outside. Add more green to the laying-in pigment and paint the first highlights. Paint the outer highlights with pure green and, if necessary, add a little white to it.

Mix a little cinnabar with orpiment and lay in a robe. Add a little red and draw the lines. Make the shadow along the outside with plain red. Add more orpiment to the laying-in pigment and paint the first highlights. Paint the outer highlights with plain orpiment. This is not to be used for a robe on a wall.

Mix orpiment with indigo or with *menesc* or with elderberry juice and lay in a robe. Add more juice or *menesc* or indigo and draw the lines. Add a little black and make the shadow along the outside. Add more orpiment to the laying-in pigment and paint the first highlights. Paint the second highlights with plain orpiment. Orpiment and anything in which it is mixed are no good on a wall.[3]

Mix *menesc* with folium and lay in a robe. Add more folium and draw the lines. Also add a little black and make the shadow along the outside. Paint the first highlights with plain *menesc;* add a little white and paint the second highlights.

Mix ocher with black and lay in a robe. Add more black and draw the lines. Add still more and make the shadow along the outside. Add more ocher to the laying-in pigment and paint the first highlights. Add still more and paint the second highlights. Do the same with ocher and red.

Mix white and green and lay in a robe. Draw the lines with plain green. Add a little *sucus* and make the shadow along the outside. Add more white to the laying-in pigment and paint the first highlights. Paint the second highlights with plain white.

Mix a little black and a little less red with white and lay in a robe. Add more red and a little black and draw the lines. Add still more black and red and make the shadow along the outside. Add more white to the laying-in pigment and paint the first highlights. Paint the outer highlights with plain white. Mix *menesc* with white in the

[3] Orpiment is a reactive pigment which turns black with pigments based on copper or lead, and seems to have a corrosive effect on binding media (D. V. Thompson, 1936, p. 178). It is supposed, however, to be stable on a plaster wall.

same way as above. Similarly mix black with white. In the same way mix ocher with white and add a little red for shadows to be made of it.

Chapter 15. The Mixture [of Pigments] for Robes on a Wall

On a wall, however, lay in a robe with ocher, after adding a little lime[1] to it for the sake of its brilliancy. Make the shadows in it either with plain red or with *prasinus* or with a shadow pigment which should be made from the same ocher and green. The flesh-color pigment for use on a wall should be mixed from ocher, cinnabar, and lime, and its shadow pigment, rose pigment, and highlighting pigment should be made as above.

When figures or likenesses of objects are portrayed on a dry wall, the wall should first be sprinkled with water until it is completely soaked. All the pigments that are to be put on underneath[2] should be painted on while it is still wet and they should all be mixed with the lime and allowed to dry with the wall itself, so that they stick to it. For the ground beneath azure and green, the pigment called *veneda,* mixed from black and lime, should be laid. When it is dry, a thin coat of azure, tempered with the yolk of an egg mixed with plenty of water should be laid in place, and over this again a thicker coat to make it more beautiful. The green may also be mixed with *sucus* and black.

Chapter 16. The Band Which Represents the Appearance of the Rainbow

The band which represents the appearance of the rainbow is made from the juxtaposition of [a pair of graded areas based on] two different pigments, namely: cinnabar and green; cinnabar and *menesc;*

[1] I.e., aged lime putty or lime plaster, which will both lighten the color and serve as a binding medium. Later in this chapter, when lime is to be added to pigments as undercoats on a wall, it is possible lime water would be used.

[2] Follows *supponendi* as in *V, G, C,* and *H,* not *superponendi* as Dodwell.

green and ocher; green and folium; folium and ocher; *menesc* and
ocher; or cinnabar and folium. These are put together in this way.
Two strips of equal width are drawn, one red [the other green]. The
red, mixed with lime, should be painted as an undercoat for cinnabar
on a wall, so that barely a fourth [of the mixture] is red. On a ceiling
panel, however, cinnabar itself [is used], mixed in the same way but
with chalk-white. The other strip, the green one, is mixed in the
same way, without *sucus*. Make a white stripe between these two
strips. Then mix as many shades of pigment as you wish from cinna-
bar and chalk-white, so that the first contains only a little cinnabar,
the second more, the third even more, the fourth still more, until you
reach [the fifth], plain cinnabar. Then mix a little red with this.
Then use plain red. After this mix red with black. Finally use black.
In the same way make shades of pigment by mixing together green
and white, until you reach plain green. Then mix a little *sucus* with
it. Mix it again adding more *sucus*. After this put in a little black;
then more; finally use plain black.

[If you use the other pigment pairs listed at the beginning] you
should make the shadings of ocher with red, finally with black
added; the shadings of *menesc* with folium, finally with black added;
the shadings of folium with red, finally with black added. These
shades of pigment should be put on in such a way that the stripes are
paler starting from the center and deepen into black on the outside.

There can never be more than twelve of these [graded] stripes for
each color. If you want as many as this, so temper the mixtures as to
put the plain pigment in the eighth[1] place. If you want nine, put the
plain pigment in sixth place. If you want eight or seven, put the
plain pigment in fifth place. If you want six, in fourth place. If five,
in third place. If four or three, do not put a plain pigment between
them, but instead of it take the one that should be applied before it,
and blend the shading from this to black, along the outside.[2]

By this work [i.e., the successive gradation of colors] round and
four-cornered thrones are made, and strips around borders,[3] also tree
trunks with their branches, columns, round towers, seats, and any-
thing to which you want to give a round appearance. Arches on

[1] *Octavo;* following *G, E,* and *P.*

columns in houses are painted by the same procedure, but with only one pigment base, shading from white on the inside to black along the outside. Round towers are made with ocher with a white stripe in the center and extremely pale ocher extending on each side, gradually taking in saffron yellow pigment up to the second-from-the-last stripe, with which a little red, then a little more, should be mixed. Do this in such a way that neither plain ocher nor plain red is to be seen. In the same way and with the same [graded] mixtures towers and columns are also made from black and white. Tree trunks are made with a mixture of green and ocher with a little black and *sucus* added. Earth and mountains are also painted with this mixture of pigments. In addition, earth and mountains are made from green and white, without *sucus,* so the center is pale and the edges take on shadows that are mixed with a little black.

All pigments which underlie others on a wall should be mixed with lime to set them. *Veneda* should lie underneath azure, *menesc,* and green; red under cinnabar. Under ocher and folium use the same pigments mixed with lime.

[2] The sequence of colors in the representation of the rainbow is:

Black

Burnt ocher plus black
Plain burnt ocher
Cinnabar plus burnt ocher

Plain cinnabar

White plus yet more cinnabar
White plus still more cinnabar
White plus more cinnabar

Plain white

White plus a little green
White plus more green
White plus still more green
White plus yet more green

Plain green

Green plus *sucus*
Green plus more *sucus*
Green and *sucus* plus a little black
Green and *sucus* plus more black

Black

Instead of using cinnabar and green as the basis, the other pairs of colors listed in the first sentence may be used, with the different terminal shadings to black that are later mentioned. Notice that in each case the middle strip is white and the plain pigments on which the short and long wave-length halves of the spectrum are based occur about two-thirds of the way out (actually 3/5 to 5/7 depending on the number of stripes) shaded to white in the center, black at the outside. The central white line may be an empirical use of the enrichment of colors that results from the presence of a white "cue" (see Karp, 1959).

[3] Reading *limbos* with *E* and *P.*

Chapter 17. Panels for Altars and Doors; and Cheese Glue

The individual pieces for altar and door panels are first carefully fitted together with the shaping tool that is used by coopers and vat-makers. Then they should be stuck together with cheese glue, which is made in this way.

Cut soft cheese into small pieces and wash it with hot water in a mortar with a pestle, repeatedly pouring water over it until it comes out clear. Thin the cheese by hand and put it into cold water until it becomes hard. Then it should be rubbed into very small pieces on a smooth wooden board with another piece of wood, and put back into the mortar and pounded carefully with the pestle, and water mixed with quicklime should be added until it becomes as thick as lees. When panels have been glued together with this glue, they stick together so well when they are dry that they cannot be separated by dampness or by heat. Afterwards they should be smoothed with a planing tool [i.e., a drawknife] which is curved and sharp on the inside and has two handles so that it can be drawn with both hands. Panels, doors, and shields are shaved with this until they become completely smooth. Then the panels should be covered with the raw hide of a horse or an ass or a cow which should have been soaked in water. As soon as the hairs have been scraped off, a little of the water should be wrung out and the hide while still damp laid on top of the panels with cheese glue.

Chapter 18. Glue from Hide and Stag Horns

When this has been carefully dried out, take some cuttings of the same hide, similarly dried, and cut them up into pieces. Then take stag horns and break them into small pieces with a smith's hammer on an anvil. Put these together in a new pot until it is half full and fill it up with water. Cook it on the fire without letting it boil until a third of the water has evaporated. Then test it like this. Wet your fingers in the water and if they stick together when they are cold, the

glue is good; if not, go on cooking it until your fingers do stick to-
gether. Then pour this glue into a clean vessel, fill the pot again with
water, and cook as before. Do this four times.

Chapter 19. Whitening Hide and Wood with Gypsum

After this take some gypsum burned in the fashion of lime (or some
of the chalk-white with which skins are whitened) and grind it care-
fully on a stone with water. Then put it in an earthenware pot, add
some hide glue soaked [in water], and place it on the fire so that the
glue melts. [Stir] and spread it over the hide very thinly with a
brush. When it is dry, spread a little on more thickly; if necessary,
spread on a third coat. When it is completely dry, take the grass
called shave-grass, which grows up like a rush and is knobby. You
should gather this in the summer and dry it in the sun. With it rub
the white [surface] until it is completely smooth and bright.

If you lack hide for covering the panels, they may be covered with
medium-weight new cloth with the same glue.[1]

Chapter 20. How To Redden Doors; and Linseed Oil

If you want to redden doors, get linseed oil which you should make
in this way.

Take some flax seed and dry it in a pan over the fire without water.
Then put it in a mortar and pound it with a pestle until it becomes a
very fine powder. Put it back in the pan, pour in a little water, and
heat it strongly. Afterwards wrap it in a new cloth and put it in the
press where oil is usually pressed from olives, nuts, and poppy seeds,
and press out this oil also in the same way. Grind some minium or
cinnabar with this oil on a stone without water, spread it with a

[1] Dodwell puts this paragraph at the
end of chapter 17. It does not seem out
of place here at the end of the three
chapters dealing with hide (as in *P*).

brush on the doors or panels that you want to redden and dry them in the sun. Then coat them a second time and dry them again. Finally spread on top of it the gluten[1] called varnish, which is made in this way.

Chapter 21. The Gluten [Called] Varnish

Put some linseed oil into a small new pot and add some very finely ground resin,[1] which is called *fornis,* and which looks like very clear frankincense except that when it is broken up it has a higher lustre. After putting it on the fire, cook it carefully without letting it boil, until a third of it has evaporated. Beware of flame, because the varnish is extremely dangerous and, if it should catch fire, difficult to extinguish. Every painting that is coated with this gluten is made bright, beautiful, and completely lasting.

Another method.[2]—Set up four stones which can withstand fire without spalling, and place a raw pot on them. In the pot put some

[1] *Gluten* is a word used for any adhesive substance. We have translated it as "glue" when common glue is obviously meant, but have retained the cognate for materials not easily soluble in water.

[1] The varnishes and organic vehicles for pigments mentioned by Theophilus are hard to identify, for several different materials are referred to under a single name. The term *gummi,* which we have translated resin, is in this chapter certainly a true resin, for it can be mixed with linseed oil. However, the material used for the first recipe was probably a soft resin, which dissolves easily in boiling linseed oil, unlike the one in the second recipe (whose position in the manuscript and the title suggest that it may have been a later addition) which had to be "run" before mixing and was therefore a hard resin like copal. Both of these resins are quite distinct from the water-soluble substance (supposedly a true

gum) mentioned as reinforcement to a fish glue in I-31 and as a temper for pigments in I-32, although all bear the same name, *gummi.* In I-25 and 26 *gummi* is used for the exudations of a cherry or plum tree, which are water soluble, and which we have there translated as "gum resin." It is different from the material in this chapter, which is likened to very clear incense, a resin with which Theophilus would be familiar. Note that it is first called *fornis,* a word supposedly related to the German *Fürniss,* and then, "*fornis* which is called *glassa* in Roman." Hendrie believed that *gummi* was sandarach, but this substance would not dissolve in linseed oil under the conditions described by Theophilus. One can only agree with Werner (1958) that there is "need for caution in attempting to identify with certainty the resins mentioned in many old varnish recipes."

[2] Among the manuscripts only *H* begins a new chapter (22) here.

of the above-mentioned resin, *fornis,* which is called *glassa* in Roman. Over the mouth of this pot place a smaller one with a little hole in the bottom. Smear some paste around it so that no air can escape between the two pots. Then build a fire carefully beneath it until the resin melts. You should also have a thin iron rod fitted into a handle, with which you can stir the resin and feel when it becomes completely liquid. You should also have a third pot on the fire close by, with hot linseed oil in it. When the resin is thoroughly liquid so that, when you take out the iron rod, a sort of thread is trailed behind it, pour the hot oil into it, stir with the rod, and cook them together without letting them boil. Occasionally take out the rod and smear a little on a piece of wood or a stone to test its consistency. Take care that there are two parts of oil and a third part of resin by weight. When you have cooked it carefully to your satisfaction, take it off the fire, uncover it, and let it cool.

Chapter 22. Horse-Saddles and Carrying Chairs

Horse-saddles and eight-man carrying-chairs, that is, curtained seats, and footstools and the other objects which are carved and cannot be covered with leather or cloth, should be rubbed with shave-grass as soon as they have been scraped with an iron tool; then covered with two coats of white [gesso] and, when they are dry, smoothed again with shave-grass. After this measure them with compasses and a rule and arrange your work, namely, figures or animals or birds and foliage, or whatever you want to portray. After doing this, if you want to embellish your work, apply gold leaf, which you should make in the following way.

Chapter 23. Gold Leaf

Take some Byzantine[1] parchment, which is made from flax fiber,[2] and rub it on both sides with the red pigment that is made by burn-

[1] *Graecam.* See II-13, n. 1.
[2] *Quae fit ex lana lini* is the preferred reading. (In P this is followed by *id est papirum,* identifying it with paper. Both G and C read *ex lana ligni* in place of *ex lana lini,* which could be

ing very finely ground and dried ocher. Then polish it very carefully with the tooth of a beaver, a bear, or a boar, until it becomes bright and the pigment sticks fast as a result of the friction. Then cut this parchment with scissors into square pieces, four fingers wide and equally long.

After this make a sort of pouch of the same size out of calf vellum and sew it together firmly. Make it large enough to be able to put a lot of pieces of the reddened parchment into it. After doing this take pure gold and thin it out with a hammer on a smooth anvil, very carefully, so as not to let any break occur in it. Then cut it into square pieces, two fingers in size. Then put a piece of the reddened parchment into the pouch and in the middle on top of it a piece of gold, then another piece of parchment and again a piece of gold, and continue doing so until the pouch is filled and there is always a piece of gold interleaved in the center. Then you should have a hammer cast from brass, narrow near the handle and broad at the face.[3] Hammer the pouch with it on a large flat smooth stone, lightly, not heavily. After frequent inspections you will decide whether you want to make the gold completely thin or moderately thick. If the gold

translated as "from wood fiber," "vegetable fiber," or "bast.") Hendrie translates this as "linen cloth," and Dodwell as "linen rags," but we believe that a woven textile is neither specifically implied in the Latin nor needed in practice. Paper was just beginning to be introduced into Europe early in the twelfth century and the uncertainty of the scribe is understandable. Though made in Egypt and Damascus and commonly known as *charta Damascena,* paper arrived in Europe principally via Constantinople, hence the name Theophilus uses for it. The manufacture of paper was brought into Christian Europe from Spain, crossing the Pyrenees in 1157. (See Carter and Goodrich, 1955, chap. 13, "Paper's Thousand Year Journey from China to Europe.") Most surviving samples of early paper seem to have been made from hemp, not linen.

The process of making gold leaf is of great antiquity and is illustrated in Egyptian tomb paintings. (See Theobald, 1912 and 1933, and Hunter and Whiley, 1951.). It depends not only on the prodigious malleability of the metal, but also on the very subtle qualities of compressibility and surface characteristics of the sheets of material in which the gold is enfolded during beating. Membranes from various parts of animals have usually been used, although metal plates for the purpose are referred to by Pliny, the *Mappae Clavicula* and Porta. Paper has continued in use in the Orient and is the preferred material of the gold-beaters in Kyoto to this day.

[3] Jost Amman (1568) includes a drawing of a hammer of this shape; modern hammers for this purpose are two-faced.

spreads too much as it is thinned and projects out of the pouch, cut it off with small light scissors made for this purpose alone.

This is the recipe for making gold leaf. And when you have thinned it out according to your liking, with the scissors cut as many pieces of it as you want, and with them ornament the halos around the heads of figures, stoles, hems of robes, etc., as you like.

In laying on [the gold] take glair, which is beaten out of the white of an egg without water, and with it lightly cover with a brush the place where the gold is to be laid. Wet the point of the handle of the brush in your mouth, touch a corner of the leaf that you have cut, and so lift it up and apply it with the greatest speed. Then smooth it with the brush. At this moment you should guard against drafts and hold your breath because, if you breathe, you will lose the leaf and find it again only with difficulty. When this piece has been laid on and has dried, lay another piece over it in the same way, if you wish, and also a third, if necessary, so that you can polish it all the more brightly with a tooth or a stone. If you wish, you can also lay this leaf in the same way on a wall or a ceiling panel. If you do not have gold, you may use tin leaf, which you should make in this way.

Chapter 24. Tin Leaf

Thin out the purest tin carefully with a hammer on an anvil, making as many and as thin pieces as you want. When they begin to be thinned out a little, clean them on one side with a woolen cloth and with very finely ground dry charcoal. Then beat them again with the hammer and again rub them with the cloth and the charcoal. Continue doing this alternately until you have completely thinned them out. After this rub them gently with a boar's tooth on a flat smooth wooden board until they become bright.

Then fit these same pieces together on the board, one next to the other, and stick each piece to the wood with wax so that it cannot be moved, and with your hand smear them over with the above-mentioned gluten varnish [I-21], and dry them in the sun. Afterwards

take some shoots of alder buckthorn,[1] which you should have cut in April, split down the center, and dried over smoke. Take off the outer portion of the bark and scrape the inner portion, which is yellow, into a clean pan, adding a fifth part of saffron to it. Pour plenty of old wine or beer over it and after it has stood like this for the night, heat it next morning on a fire until it is warm. Put in sheets of tin one by one; lift them out frequently until you see that they have taken on enough golden color. After this stick them again to the wooden board, smear the gluten on them as before, and, when they have been dried, you have leaves of tin which you may lay on your work as you wish with hide glue.

Then take the pigments that you want to apply, grind them carefully with linseed oil without water, and make the mixtures for faces and robes just as you made them with water above.[2] Vary the animals or birds or foliage each with their proper colors, as you please.

Chapter 25. Grinding Pigments with Oil and Resin

All the kinds of pigments can be ground with this same oil and laid on woodwork, but only on things that can be dried in the sun, because, whenever you have laid on one pigment, you cannot lay a second over it until the first has dried out. This process is an excessively long and tedious one in the case of figures.[1]

If, however, you want to speed up your work, take the gum resin

[1] Follows Theobald's interpretation of *Faulbaum* for *lignum putridum.* Theophilus seems to be describing two distinct processes—one with varnish and the other with a yellow dye, the description of which begins here.

[2] In chapters 13 and 14, wherein water is not specifically mentioned as the medium, since its use would be taken for granted.

[1] Theophilus uses a variety of media for pigments: linseed oil is used on wood (I-20, 21, 25) and on metal sur-

faces (I-24, 25, 27), but since it contains no drier it was tedious to use. Water extracts of cherry or plum resin (gum) were used for quicker work (I-25), and an unidentifiable water-soluble resin was used for pigments in books, i.e., for illuminated manuscripts (I-32). Glair, made by beating the white of egg and taking the clear liquid that runs out, was a high-grade binder for use with gold leaf or gold powder pigment (I-23, 29, 32). The yolk of egg is once mentioned (I-15)

which comes out of a cherry or plum tree; cut it into small pieces and put it in an earthenware pot, pour in plenty of water and place it in the sun (or, in winter, over a fire) until the gum resin melts, and stir it carefully with a round stick. Then strain it through a cloth and grind the pigments with it and lay them on. All pigments and their mixtures can be ground and laid on with this gum resin, except minium, ceruse, and carmine, which should be ground with, and laid on with, glair. Spanish green which is to be covered with gluten should not be mixed with *sucus,* but should be laid on by itself with resin. You can make another mixture if you wish.

Chapter 26. How Many Times the Same Pigments Should Be Applied

On wood you should apply all pigments, whether ground with oil or with gum resin, three times. When the painting is finished and dried, carry the work into the sun and carefully coat it with the gluten varnish. When the heat makes it begin to flow, rub it lightly with your hand. Do this three times and then leave it until it is thoroughly dried out.

Chapter 27. Translucent Painting

There is also made on wood a type of painting called translucent.[1] By some it is called aureola. You should make it in this way.

Take some tin leaf, not coated with gluten or colored with saffron,

for use on a wall. Lime or lime water provided the binder for paints on plaster walls (I-15), and some pigments for such use contained the vegetable juices, *sucus* or folium, that would be good binders. Most of the wall pigments are referred to without mention of any medium, supposedly because water alone would have been used. The practical painter will find numerous references to the compatibilities and incompatibilities of various pigments and media throughout this book.

[1] *Translucida,* painting on a burnished metal base which shows through the pigments. In the Cloisters, New York, there is an early thirteenth-century wooden statue of the Virgin (No. 25.120.214) that seems to have been finished with this technique, although there is no trace of the joints or folds that would have been expected from foil. A fine-grained tin powder may have been used, as described by Theophilus in I-30.

but just plain and carefully polished, and with it cover the place you want to paint in this fashion. Then very carefully grind the pigments that are to be applied with linseed oil and when they are very thin draw them on with a brush and so let them dry.

Chapter 28. Milling Gold for Books; and Casting the Mill

When you have outlined figures or letters in books take pure gold, file it very fine into a very clean bowl or basin and wash it with a brush into a tortoise-shell or a shell taken out of water. Then you should have a mill with its pestle, each of them cast from an alloy of copper and tin mixed in the proportions of three parts of pure copper to a fourth part of lead-free tin. When all this has been arranged in this way, the mill should be cast in the shape of a small mortar and its pestle cast around a piece of iron like a knop, in such a way that the iron projects above it, a finger thick and slightly more than half a foot long. A third [of the length] of the iron should be fastened into a carefully turned piece of wood, about a cubit long and drilled absolutely straight [axially]. On the lower part of this, however, at a distance of four fingers from the end, there should be a revolving wheel of either wood or lead. In the center of the upper part [of the spindle] a thong should be fastened which can be pulled and which by the [continued] rotation pulls itself back again. Next, the mill should be put in a hollow in a bench suited to the purpose, between two wooden posts that are firmly fastened into the bench itself. There should be another wooden bar on top of these, fitted into them so that it can be taken out and put back in again. Underneath in the center of the bar there should be a hole in which the pestle of the mill may rotate.

When you have arranged all this, put carefully cleaned gold into the mill, add a little water, put in the pestle, and fit the upper bar into place. Then pull the string and let it wind back; pull it again, and again let it wind back; and do this for two or three hours. Then remove the upper bar and wash the pestle in the same water with a

brush. Lift out the mill and with the brush stir the gold with the water right to the bottom and leave it for a moment until the coarser part settles. Quickly pour off the water into a very clean basin; whatever gold comes out with the water is milled. Again put in water, set the pestle and the upper bar in position, and mill again in the same way as before until all [the gold] comes out with the water. Silver, brass, and copper should be milled in the same way. Gold,

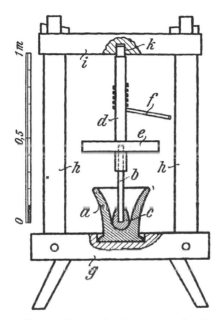

Fig. 1.—The mill for grinding gold powder. Reconstruction by Theobald (1933) based on Theophilus' description. (V.D.I. Verlag.)

however, being softer than the other metals, should be milled more carefully and you should pull gently and inspect it more often to see that it does not happen to stick to the mill or the pestle and form lumps on them.[1] If this does happen through carelessness, the lumps should be scraped off and taken out, and the rest milled until it is finished. After doing this pour the supernatant water with the scum

[1] The *Mappae clavicula* recommends mixing the gold with rock salt and a little sulphur, which would make it easier to avoid the welding together of the gold particles into lumps. It also includes a good description of making a powder of gold amalgam and then very carefully driving off the mercury with heat. Theophilus (III-35) later describes the making of gold amalgam, but he uses it only for gilding.

out of the basin and carefully wash the gold into a clean shell. Then pour water over it and stir it with a brush. Hold it in your hand for an hour, then pour the water into another shell and preserve the very fine gold which comes out with the water. Put water in again and heat it over the fire; stir it and, as before, pour out the fines with the water. Continue doing this until you have thoroughly cleaned it. Next, wash the fines again in the same way a second and a third time, and add whatever gold you collect to the first. Wash silver, brass, and copper in the same way.

Now take the bladder of the fish called sturgeon, wash it three times in warm water, cut it up in pieces, put them into a very clean[2] pot with water, and let them soften overnight. On the next morning cook them over the fire without letting them boil, and test with your fingers to see if they stick together. When they stick fast, the glue is good.

Chapter 29. How Gold and Silver Are Applied in Books

Next, take pure minium, add a third part of cinnabar to it, and grind it on a stone with water. When it is carefully ground, beat the glair out of the white of an egg (in summer with water, in winter without water). When this is pure, put the minium into a horn and pour the glair over it. Put in a stick and stir it a little. Then, using a brush, cover with it all those places on which you want to apply gold.

Put a little pot with [sturgeon-bladder] glue on the fire and, when it melts, pour it into the shell containing the gold and wash the gold with it. Then pour it out into the other shell in which you kept the skimmings. Pour hot glue in again, hold the shell in the palm of your left hand, and stir carefully with a brush. Apply [the mixture] as thickly or thinly as you wish, but do not use too much glue, because, if there is too much, the gold blackens and will not acquire brilliance. After it has dried, polish it with a tooth or a bloodstone that has been carefully cut and polished on a smooth, shining horn

[2] Reading *purissimam* with most of the manuscripts.

tablet. If carelessness should result in failure to cook the glue well, so that the gold becomes powder on rubbing, or rises [i.e., flakes away from the page] because [the glue] is too thick, you should have at hand some old glair, beaten without water, and immediately smear a little of it with a brush lightly over the gold. When it is dry, rub it again with the tooth or the stone. In the same way apply silver, brass, and copper in their proper places and rub them.

Chapter 30. How Paintings in Books Are Embellished with Tin and Saffron

If you have neither of these [i.e., gold or silver] and still want to embellish your work in some way, take pure tin, scrape it very fine, mill it, and wash it as you did the gold. Then, with the same glue, apply it on letters or other places that you wanted to ornament with gold or silver. After polishing it with a tooth, take some of the saffron with which silk is dyed, pour glair without water over it, and let it stand overnight. On the following day cover with a brush [dipped in this medium] those places you wanted to gild; leave the rest [of the tin bare] to take the place of silver. Then, using a quill, draw fine lines with minium around the letters, foliage, scrollwork, materials of robes, and the other places to be ornamented.

Chapter 31.[1] All the Kinds of Glue for Gold Painting

If you do not have a bladder [of sturgeon],[2] cut up thick calf vellum and wash and cook it in the same way. You may also cook in the same way the bladder of an eel, after it has been very carefully

[1] One manuscript (*E*) contains an interpolation, before this chapter, of five additional chapters which describe the methods of making and applying gold and other metal powder pigments. These were borrowed mostly from the *Mappae clavicula*. Escalopier and Ilg, while admitting their probable spuriousness, include them, bracketed, as chapters 33–37 of Book I in their editions. Theobald published four of them for the sake of their technical interest.

[2] As referred to in chapter 28.

scraped, cut, and washed. You may also three times cook the bones of the head of a dried pike, after they have been carefully washed in hot water. Whichever one of these you have cooked in this way, add to it a third part of the very transparent resin and cook it lightly; then you will be able to keep it as long as you wish.[3]

Chapter 32. How Pigments Should Be Tempered for Use in Books

After finishing all this, make a tempering medium of the very transparent resin and water as above, and temper all pigments [with it] except green, ceruse, minium, and carmine. Salt green is not good in a book. You can temper Spanish green with pure wine and, if you want to make shadows, add a little juice of an iris, a cabbage, or a leek. Temper minium, ceruse, and carmine with glair. Prepare all the mixtures of pigments for a book as above, if you need them for painting figures. In a book all pigments should be applied twice, first very thinly, then more thickly; but only once for letters.

Chapter 33. The Kinds of Folium and Their Tempering Media

There are three kinds of folium, one red, another purple, and a third blue, which you should temper like this.

Take some ashes, sift them through a cloth, pour a little cold water over them and make small rolls out of them like loaves of bread. Then put them into the fire and leave them until they are completely red-hot. After they have been red-hot for a very long time and then have cooled, put some of them in an earthenware pot, pour

[3] The *gummi* in this and the next chapter is different from the very transparent resin defined in chapter 21, which would not mix with these aqueous adhesives. See I-21, n. 1.

urine over them, and stir with a stick. When the mixture has settled and is clear, pour [the supernatant liquid] over red folium, grind it lightly on a stone and add to it a fourth part of quicklime. When it is ground and sufficiently moistened, strain it through a cloth and with a brush draw wherever you wish, [first] thinly, then more thickly.[1]

[1] Folium is frequently mentioned under this and other names in medieval craft literature (see Merrifield, 1849). It was a colored substance obtained from the plant turnsole, which, like a chemist's indicator, changed color depending on the degree of acidity or alkalinity of its environment. (Indicators are a class of organic substances, usually weak acids or bases, that can exist in dissociated and undissociated structural forms of different color: the equilibrium between the two is reversibly displaced in favor of one or the other form according to the concentration of hydrogen ion in the solution, of which a visible indication is therefore provided.)

Turnsole, which Merrifield identifies as *crozophora tinctora*, was gathered particularly in southern France, and the seeds, which form in clusters of three, were squeezed to obtain the juice. To preserve it for the use of an illuminator, the juice was soaked up by little pieces of linen cloth and dried. Merrifield conjectures (not very convincingly) that the storage of the dried clothlets between the pages of a book gave rise to the name. In most manuscripts where folium is described, mention is made of the fact that its color can be changed from red to violet or blue by treatment with lime or urine— the latter, when stale, providing a readily available source of mild alkali (ammonia), which has been exploited since antiquity for use as a detergent and otherwise.

It is tempting to see in the controlled modification of the color of folium a precursor of the indicators which in later times played a prominent part in the development of both technical and theoretical chemistry. However, the essential property of reversibility, though possessed by folium, is not noted by Theophilus or other early writers, and the distinction was not made between its preparation and that of other colored substances such as mordants and lake pigments, which depend on a quite different chemical mechanism, the formation of relatively stable organometallic compounds. Perhaps, indeed, reversibility could not have been observed, for the ancient acids were all weak organic ones and the mineral acids were not known until later (nitric acid in the fourteenth century, sulphuric and hydrochloric in the sixteenth and seventeenth centuries, respectively). The complementary nature of acids and alkalies began to be discussed in the sixteenth century in terms of ideas regarding nature as organism and not yet resembling a system of chemical constitution. A theory of acid, base, and salt was not rationalized until the eighteenth century.

Robert Boyle in his *Experimental History of Colours* (1664) and *Reflections upon the Hypothesis of Alcali and Acidum* (1675) mentions the reversible color changes of more than a dozen extracts of berries, fruits, flowers, and woods, including our turnsole and also litmus, which was later to become so well known. He hinted at a quantitative alkalimetry based on measuring how much alkali was needed to discharge the color produced by acid in

If you want to make a representation in purple folium of a cloak on a page, moisten it with the same tempering medium but with the omission of lime. Then, first, with a quill draw on the page itself scrollwork or circles, and inside them birds, animals, or foliage; and when it is dry, paint a thin coat of red folium all over it, then a thicker one, and a third one, if necessary. Afterwards, spread over it thinly some old glair, beaten without water.

You should not grind purple or blue folium, but moisten it in a shell with the same tempering medium without lime, and stir it with a stick. Let it stand overnight; on the next morning apply it however you wish and coat it with glair. Robes and everything that you have painted with folium and carmine should also be coated with glair. You can keep the burnt ashes that are left over for a long time provided that they are dry.

Chapter 34. Cinnabar

If you want to make cinnabar, take sulphur (of which there are three kinds: white, black, and yellow), break it up on a dry stone, and add to it two equal parts of mercury, weighed out on the scales. When you have mixed them carefully, put them into a glass jar. Cover it all over with clay, block up the mouth so that no fumes can escape, and put it near the fire to dry. Then bury it in blazing coals and as soon as it begins to get hot, you will hear a crashing inside, as the mercury unites with the blazing sulphur. When the noise stops, immediately remove the jar, open it, and take out the pigment.

lignum nephriticum, but the method was not effectively applied to a technical titration until a century later, in 1760, by William Lewis. Thus, although the observation and elucidation of the reversibility of the color change lay in the future, the folium of Theophilus' day never left the chemical scene until the work of Boyle and others gave color change a primary place in chemical science. (The translators are grateful to Mr. Frank Greenaway of the Science Museum, South Kensington, for an unpublished short essay on which this note is based.)

[1] This, of course, is artificial cinnabar, usually called vermilion to distinguish it from the natural mineral.

Chapter 35. Salt Green

If you want to make a green pigment, take a piece of oakwood, as long and as wide as you wish, and hollow it into the shape of a little chest. Then take some copper and thin it out into sheets of any desired width but of a length sufficient to span the [inside] width of the chest. After this take a flat pan full of salt and, pressing the salt down firmly, put the pan in the fire and cover it with [glowing] coals for the night. Next morning grind the salt very carefully on a dry stone. Get some thin twigs and place them in the above-mentioned chest in such a way that two thirds of the cavity are beneath [the twigs] and the other third is above them. Smear the copper sheets on both sides with pure honey and sprinkle the ground salt on them. Then lay them next to each other on the twigs and cover them carefully with another piece of wood, fitted for the purpose, so that no vapors can escape. Next, in the corner of this piece of wood drill a hole through which you can pour in heated vinegar or hot urine until a third of [the chest] is filled; then block up the hole. Put this chest in a place where you can pile dung all over it. After four weeks pry off the lid, scrape off whatever you find on the copper, and keep it. Put [the copper] back again and cover it as above.

Chapter 36. Spanish Green

Now if you want to make Spanish green, take thinned-out copper plates, scrape them carefully on both sides, moisten them with pure hot vinegar without honey or salt, and lay them together in a smaller wooden chest in the same way as above. After two weeks inspect and scrape them, and continue doing this until you have enough pigment.

Chapter 37. Ceruse and Minium

If you are going to make ceruse, thin out some lead plates and lay them together, dry, in a wooden chest in the same way as the copper

above. Then pour in hot vinegar or urine to cover them. After a
month pry off the lid and remove whatever white there is and replace
[the plates] as before. When you have enough ceruse and want to
make minium out of it, grind it on a stone without using water, put
it into two or three new pots, and set them on blazing coals. You
should also have a slender curved iron tool, one end of which is fitted
into a wooden [handle] while the other end is broad, and with it you
can stir the ceruse and mix it from time to time. Keep on doing this
until the minium becomes completely red.

Chapter 38. Ink

When you are going to make ink,[1] cut some pieces of [haw]thorn
wood in April or in May, before they grow blossoms or leaves. Make
little bundles of them and let them lie in the shade for two, three, or
four weeks, until they are dried out a little. Then you should have
wooden mallets with which you should pound the thorn on another
hard piece of wood, until you have completely removed the bark.
Put this immediately into a barrel full of water. Fill two, three, four,
or five barrels with bark and water and so let them stand for eight
days, until the water absorbs all the sap of the bark into itself. Next,
pour this water into a very clean pan or cauldron, put fire under it
and boil it. From time to time also put some of the bark itself into
the pan so that, if any sap has remained in it, it will be boiled out.
After boiling it a little, take out the bark and again put more in.
After this is done, boil the remaining water down to a third, take it
out of that pan and put it into a smaller one. Boil it until it grows
black and is beginning to thicken, being absolutely careful not to
add any water except that which is mixed with sap. When you see it
begin to thicken, add a third part of pure wine, put it into two or

[1] The ink would be composed most-
ly of iron tannate or gallate. The acids
are extracted from the partially decom-
posed bark and, after drying for stor-
age, are freshly mixed for use with
wine and green vitriol. The ink could
be made blacker by adding iron or iron
oxide directly. It was commonly added
as metallic filings, but the method of
quenching an iron rod as recommended
by Theophilus will also work, as it
will produce a reactive oxide scale.

three new pots, and continue boiling it until you see that it forms a sort of skin on top.

Then take the pots off the fire and put them in the sun until the black ink purges itself from the red dregs. Next, take some small, carefully sewn parchment bags with bladders inside, pour the pure ink into them, and hang them in the sun until [the ink] is completely dry. Whenever you want, take some of the dry material, temper it with wine over the fire, add a little green vitriol[2] and write. If it happens through carelessness that the ink is not black enough, take a piece of iron a finger thick, put it into the fire, let it get red-hot, and immediately throw it into the ink.

[2] *Atramentum.* See 1-1, n. 3.

THE SECOND BOOK

The Art of the Worker in Glass

Prologue

In the preceding Book, dearest brother, through a feeling of sincere affection, I did not hesitate to urge on you how much honor and advancement there is in avoiding idleness and subduing indolence and sloth, and how sweet and delightful it is to expend your efforts on the practice of divers useful arts after the words of a certain orator who said: "To know something is to merit praise; to be unwilling to learn is to merit blame."[1] Nor should anyone be slow to draw near to the man of whom Solomon said: "He that increaseth knowledge, increaseth labor,"[2] because if he thinks carefully about this, he will be able to see how much advancement of the soul and body arises therefrom. For it is as clear as day that anyone who indulges in idleness and frivolity also spends his time in empty gossip and in slander, idle curiosity, drinking, drunkenness, brawling, fighting, murder, riotous living, thieving, sacrilege, perjury, and other things of this kind which are repugnant in the eyes of God, who looks with favor on a humble quiet man working in silence in the name of the Lord and obedient to the precept of the blessed apostle Paul: "But rather let him labour, working with his hands the thing which is good, that he may have to give to him that needeth."[3]

Therefore, longing to be an imitator of this man, I drew near to the forecourt of holy Wisdom[4] and I saw the sanctuary filled with a variety of all kinds of differing colors, displaying the utility and nature of each pigment. I entered it unseen and immediately filled the storeroom of my heart fully with all these things. I examined them one by one with careful experiment, testing them all by eye and by hand, and I have committed them to you in clarity and without envy for your study. Since this method of painting [on glass] cannot be obvious, I worked hard like a careful investigator using

[1] *Disticha Catonis* iv. 29. 2.

[2] Eccles. 1:18. The Authorized Version translates *laborem* as "sorrow."

[3] Eph. 4:28.

[4] *Agiae Sophiae.* It is tempting to take this as the Hagia Sophia, the famous Byzantine building, as Theobald and others have done without real support, but the phrase is symbolic.

47

every means to learn by what skilled arts the variety of pigments could decorate the work without repelling the daylight and the rays of the sun. By devoting my efforts to this task I have come to understand the nature of glass, and I see that this effect can be achieved by the use of glass alone and in its variety. I have made it my concern to hunt out this technique for your study as I learned it by looking and listening.

Chapter 1. Building the Furnace for Working Glass

If you have the intention of making glass, first cut many beechwood logs and dry them out. Then burn them all together in a clean place and carefully collect the ashes, taking care that you do not mix any earth or stones with them. After this build a furnace of stones and clay, fifteen feet long and ten feet wide, in this way.

First, lay down foundations on each long side, one foot thick, and in between them make a firm, smooth, flat hearth with stones and clay. Mark off three equal parts and build a cross-wall separating one third from the other two. Then make a hole in each of the short sides through which fire and wood can be put in, and building the encircling wall up to a height of almost four feet, again make a firm, smooth, flat hearth over the whole area, and let the dividing wall rise a little above it. After this, in the larger section, make four holes through the hearth along one of the long sides, and four along the other. The work pots are to be placed in these. Then make two openings in the center through which the flame can rise. Now, as you build the encircling wall, make two square windows on each side, a span[1] long and wide, one opposite [each] of the flame openings, through which the work pots and whatever is placed in them can be put in and taken out. In the smaller section also make an opening

[1] The units of measurement used by Theophilus are given below. Approximate modern equivalents of the commoner units are also given in centimeters and inches (see *Lübkers Reallexikon,* Berlin, 1914). Exact equivalents of all measurements are impossible, chiefly owing to their intrinsic nature and to the lack of any commonly accepted standard of measurement in medieval Europe. The palm, the width of the hand, and four fingers were apparently equivalent for Theophilus, although he distinguished between *palma* and *palmus*. Here Latin usage was, and

has been, quite confused. We have preferred palm for the feminine *palma* and span for the masculine *palmus,* the latter being equivalent to twelve fingers' width. This interpretation follows Varro (*De re rustica* 3, 7) and Pliny (12. xxviii. 48) and hence is closer to classical than medieval Latin, but it does less violence to the manuscript readings of Theophilus and conforms more closely to the measurements and proportions that are technically required. It should be noted that Theophilus normally uses the foot and cubit as units of length, the little and

[for the flame] through the hearth close to the cross-wall, and a window, a span in size, near the short wall, through which whatever is necessary for the work can be put in and taken out.

When you have arranged everything like this, enclose the interior

middle fingers as units of both width and length, and the remainder as units of either width, thickness, or diameter.

	cm.	inch
digitus: finger	1.85	0.73
pollex: thumb	2.54	1.00
palma: palm	7.40	2.91
palmus: span	22.20	8.73
pes: foot	29.60	11.65
ulna: cubit	44.40	17.48

Other words or phrases used to indicate dimensions in a general way are:

bracchium: arm (i.e., forearm)
digitus minor (*minimus*): little finger
digitus medius (*maior, longior*): middle finger
digiti duo (*tres, quattuor*): two (three, four) fingers
festuca: straw
hasta lanceae: shaft of a lance
latitudo manus: width of the hand

[Footnote continued on p. 51]

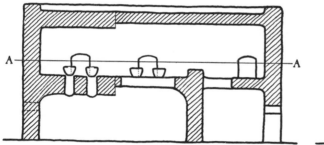

Section BB

Section CC

0 1 2 3m

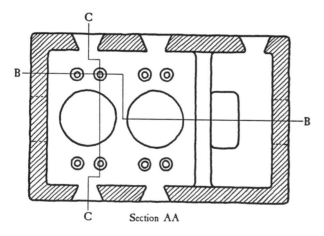

Section AA

Fig. 2.—The furnace for fritting and melting glass. Translators' reconstruction based on Theophilus' description.

with an outer wall, so that the inside is in the shape of an arched vault, rising a little more than half a foot, and the top is made into a smooth, flat hearth, with a three-finger-high lip all around it, so that whatever work or implements are laid on top cannot fall off. This furnace is called the work furnace.[2]

pugnus: fist
tibia: shinbone
ungula minor: little fingernail
ungula maior: large fingernail

[2] *Clibanus operis.* This is an unusual use of *clibanus,* which commonly means a griddle. The same word appears at the end of the next chapter, but in the chapter headings and in referring to furnaces of all types elsewhere, Theophilus uses the common word *furnus.*

Figure 2 shows our attempt to reconstruct the appearance of the furnace from Theophilus' description. This follows the previous reconstruction by Theobald (Fig. 3) in general outline, but differs therefrom in some important details. The relationship of the various holes and windows is not clearly stated in the text, but we have assumed that the windows are opposite each of the fire holes (not the holes for the individual pots) and that two pots

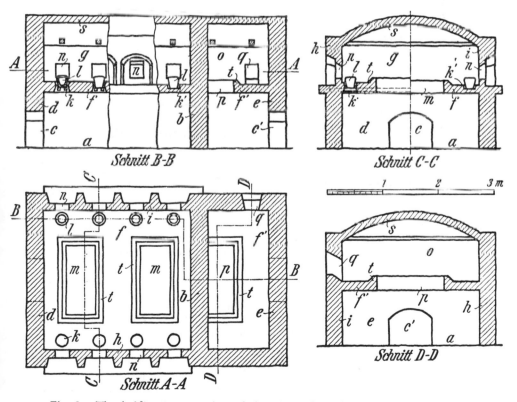

Fig. 3.—Theobald's reconstruction of the glassmaking furnace (V.D.I. Verlag)

Chapter 2.[1] The Annealing Furnace

Now build another furnace, ten feet long, eight feet wide, and four feet high. Then make a hole in one of the faces for putting in wood and fire, and in one side make a one-foot window for putting in and taking out whatever is necessary. Inside, make a firm, smooth, flat hearth. This furnace is called the annealing furnace.[2]

Chapter 3. The Furnace for Spreading Out [the Glass] and the Implements for the Work

Now build a third furnace, six feet long, four feet wide, and three feet high, with a [fire] hole, a window and a hearth, as above. This furnace is called the furnace for spreading out and flattening.

The implements needed for this work are an iron [blow] pipe, two cubits long and as thick as your thumb, two pairs of tongs each hammered out of a single piece of iron, two long-handled iron ladles, and such other wooden and iron tools as you want.

Chapter 4. The Mixture of Ashes and Sand

When you have arranged all this, take beechwood logs completely dried out in smoke, and light large fires in both sides of the bigger furnace. Then take two parts of the ashes of which we have spoken before, and a third part of sand, collected out of water,[1] and care-

are worked through each window. The pots are shown with a considerable taper to conform to the description and to enable them to rest in a reasonable fashion upon the holes in the siege (see Fig. 4). The rooftop is shown flat, with a lip around it. The reasons for our not following Theobald on these points will be apparent in the text. See also below, II-5, n. 1.

[1] For reproduction of manuscript of this and following chapters see Plate I.

[2] Literally "cooling furnace."

[1] That is, clean, from a river bed. It may be, however, that Theophilus refers to a lixiviation or other washing process to clean the sand.

In an excellent series of articles W. E. S. Turner (1956) summarizes the available information on the various materials used in making ancient glass, citing both old descriptions of glass operations and modern analyses of archeological finds. There is considerable uncertainty regarding the nature

fully cleaned of earth and stones. Mix them in a clean place, and when they have been long and well mixed together lift them up with the long-handled iron ladle and put them on the upper hearth in the smaller section of the furnace so that they may be fritted. When they begin to get hot, stir at once with the same ladle to prevent them from melting from the heat of the fire and agglomerating. Continue doing this for a night and a day.

Fig. 4.—Shape of glass-melting pot. Based on drawing by Chambon (1958)

Chapter 5. The Work Pots; and Melting White Glass

Meanwhile take some white pottery clay, dry it out, grind it carefully, pour water on it, knead it hard with a piece of wood, and make your pots. These should be wide at the top, narrowing at the bottom, and should have a small in-curving lip around their rims.[1] When they

of the ingredients in the earliest recipes, but Turner convincingly shows that they are all composed essentially of sand and various kinds of vegetable ashes alone. The use of separated alkali is not mentioned in the literature until the sixteenth century, and prior to that time the bases that were unwittingly present in the ashes, in addition to soda and potash, played an important role. The usual compositions, when using unpurified ashes, were 1 of sand to 2 or 3 of ashes, but with purified alkali, the use of which was first recommended by Biringuccio (1540), the ratio became 2 of sand to 1 of *sal alkali*. Agricola, who in the main copied Biringuccio's account, adds that if you cannot get soda, use 1 of sand to 2 of unpuri-

fied ash with a little salt. The fritting of the ingredients as a precursor of melting is extremely ancient and has the effect of minimizing gas evolution during melting.

[1] There is some uncertainty as to the shape of the pots referred to by Theophilus. It seems likely that they were bowl-shaped in order to rest firmly without sticking on the holes through the siege in which they were to rest (II-1). It is quite possible, however, that these holes supported the sides of a pot with an enlarged belly such as is shown by Agricola or that they have been completely misinterpreted. J. A. Knowles (1922), in an interesting but technically misleading article on medieval glass-

are dry, pick them up with the tongs and set them in the red-hot furnace in the holes made [in the hearth] for this purpose.[2] Pick up the fritted mixture of ashes and sand with the ladle and fill all the pots [with it] in the evening. Add dry wood all through the night, so that the glass, formed by the fusion of the ashes and sand, may be fully melted.

Chapter 6. How To Make Sheets of Glass

At the first hour next morning, if you want to make sheets of glass, take the iron blowpipe, put its end in a pot full of glass, and when the glass sticks to it turn the pipe in your hand until as much glass as you want agglomerates around it. Take it out at once, put it to your mouth, and blow gently; then take it immediately out of your mouth and hold it near your cheek, lest by chance you should suck the flame into your mouth when you draw in a breath. You should also have

making, sketched his interpretation of Theophilus' furnace showing pots with straight tapered sides wedged into the holes. This impractical design was followed in the model of Theophilus' furnace (made in 1929 on the basis of the best evidence then available) that is currently on view in the Science Museum at South Kensington. Winbolt (1933) describes archeological studies of some glasswork sites in the southeast of England which have rectangular furnaces not unlike those described by Theophilus. Most of the crucibles found were nearly square in profile, about 12 inches high and the same in diameter. Two of the pots, from the thirteenth century, had in-curving lips as described by Theophilus, which are supposedly to restrain froth and prevent its running down the sides. One crucible found was round-bottomed, "like half a big coconut," about 2.6 inches high and 4.25 inches in diameter at the top. This was found let into a round hole in the siege. R. J. Charleston, however (private communication,

February, 1961), believes that the bowls were simply to hold a limited quantity of metal for special purposes and were probably set over the pots holding the main supply of melted glass.

Chambon (1958), in a note discussing the evolution of the shape of glass-melting pots, gives the section shown in Fig. 4 as typical of pots excavated from various sites in the Low Countries during the eleventh and twelfth centuries. This is almost exactly the shape of the pot (shown in Fig. 2) which we had independently designed as one that would rest firmly but not immovably in the hole cut in the siege and would conform to Theophilus' description of a larger top than bottom, and an in-turned lip. Third- to tenth-century pots reported by Chambon had more elaborately shaped rims and were somewhat wider in relation to their height; later ones progressively increased in size and were taller in proportion.

[2] The pots would normally have been thoroughly fired before the frit was put in.

a smooth, flat stone in front of the window, on top of which you should gently strike the glowing glass, so that it hangs down equally on all sides. At once blow quickly and repeatedly, taking it out of your mouth each time. When you see it hanging down like a long bladder, put the end into the flame and as soon as it melts, [when you blow] a hole will appear. Then take a round piece of wood made for the purpose, and make the hole as wide as the middle [of the cylinder]. Then join together the upper and lower parts of the rim so that an opening appears on each side of the join. Immediately touch the glass close to the pipe with a wet stick, shake it a little, and it will be separated. Then heat the blowpipe in the flame of the furnace until any glass sticking to it melts, and quickly put it on the two [parts of the] rim of the glass where they are joined together and it will stick to them. Pick up the glass at once and put it in the flame of the furnace, until the hole where you previously separated it from the pipe melts. Take the round piece of wood and widen this hole like the other. Then, enfolding the rim in the middle [at the other end] with a wet stick, separate [the cylinder] from the pipe. Then give it to a boy who will carry it on a piece of wood inserted through one of its holes to the annealing furnace, which should be moderately hot. This kind of glass is pure and white [i.e., clear]. In the same way, by the same sequence of operations, work similar pieces of glass until you have emptied the pots.

Chapter 7. Saffron Yellow Glass

If you see [the glass in] a pot changing to a saffron yellow color, heat it until the third hour and you will get a light saffron yellow.[1] Work up as much as you want of it in the same way as above. And if you wish, let it heat until the sixth hour and you will get a reddish saffron yellow. Make from it what you choose.

[1] The sequence of colors which Theophilus describes as a simple result of holding the molten glass for periods up to about six hours is surprising until one realizes that there is a considerable quantity of manganese in the beechwood ashes that he specifies, and the exact color would depend on the state of oxidation of this and the other metal oxides, such as iron, that are in-

variably present in the charge or are picked up from the clay pot. This was first pointed out by C. H. Clark in 1878 (quoted by James Fowler, 1880). Subsequent analyses (summarized by W. E. S. Turner, 1956) show MnO contents in beech ashes from 1 per cent to an amazing 11 per cent. Although there is good evidence for the intentional introduction of manganese to glass for improving its color, at least in Roman times, its presence in old glass revealed by analysis does not necessarily mean that it was a purposeful addition until after the time that purified alkalis were used. Biringuccio (1540), for example, used purified potash from saltwort or fern, and specifies manganese additions.

The Third Book of Eraclius (in the part which was probably a twelfth- or thirteenth-century French addition to the original manuscript), after describing the making of colorless glass from fern ashes, goes on to say that purple and flesh-colored glasses are made by using the ashes of the beech tree: "On melting it will turn to a purple color which you can use and make whatever you like with it until it begins to turn pale and thereafter it changes to another color, called *membrum* or flesh-color." Theophilus' sequence of colors is the inverse of this—from white through flesh to purple—indicating that his furnace atmosphere must have been oxidizing, for the purple color only occurs under these conditions. The initial reducing material could easily have come from a residue of charcoal in the wood ashes. Note, however, that Theophilus prepares for two eventualities: the freshly melted glass which is white may turn on further heating in the furnace either to saffron, which becomes redder with time (II-7), or, alternatively, it may turn a tawny color which deepens to a reddish purple (II-8). He writes as if there was no control over this behavior, which supposedly resulted from variations in

the amount of manganese and other metals in the glass and their state of oxidation. The initial white (colorless) glass results from the now well-known effect of the purple color of the manganese being overshadowed by the complementary color of ferrous ion present. However, this depends very critically upon the state of oxidation, and it is surprising that Theophilus' glass was initially colorless. The beech ashes certainly would contain some carbonaceous material and the fire would naturally be more reducing during the initial heating-up period than later. Subsequently the atmosphere of the furnace would tend to be more oxidizing, and the impurities would slowly oxidize. W. A. Weyl (private communication, January 9, 1961) remarks: "The iron is the first element to change from Fe^{++} into Fe^{+++}. Both Fe^{+++} and Mn^{++} are yellow in a silicate melt. (Mn^{++} is pink only in the hydrated state.) This accounts for the formation of the saffron yellow with time. Further oxidation changes some Mn^{++} into Mn^{+++} and the latter is deep purple. The tawny flesh color is a mixture of the saffron yellow with some of the purple. As the oxidation proceeds the purple color of the Mn^{+++} ion will dominate the color of the glass because it is very intense."

W. E. S. Turner (private communication, September, 1960) believes that the color would be almost unpredictable since both iron and manganese oxide independently give color to silicate glasses, the former giving rise to a whole range of colors from blue through green-yellow to olive-brown according to concentration, temperature, time, and oxidation potential of the glass (which is affected by the alkali ion), while manganese yields browns and purples. Jointly, the color range may be extended or the two melts may, within certain limits of concentration, "decolorize" one another.

Chapter 8. Purple Glass

But [alternatively] if you see [the glass in] any pot happening to turn a tawny color, like flesh, use this glass for flesh-color, and taking out as much as you wish, heat the remainder for two hours, namely, from the first to the third hour and you will get a light purple. Heat it again from the third to the sixth hour and it will be a reddish purple and exquisite.

Chapter 9. Spreading Out the Glass Sheets

When you have worked as much as you can from these colors and the glass has been cooled in the furnace, take out all your work together and kindle a large fire in the furnace where it is to be spread out and flattened [II-3]. When the furnace is red-hot, take a hot iron, split the glass [muff] along one side and put it on the hearth of the red-hot furnace. When it begins to soften, take iron tongs and a smooth, flat piece of wood, and opening it up on the side where it is split, spread it out and flatten it with the tongs as you want it. When the glass is completely flat, immediately take it out and put it in the annealing furnace, which should be moderately hot, in such a way that the sheet does not lie down but stands up against the wall. Next to it put another sheet, flattened out in the same way, and a third, and all the rest. When they are cooled, use them in laying out windows, by splitting them into pieces of whatever kind you wish.

Chapter 10. How Glass Vessels Should Be Made

When you want to make vessels, prepare the glass in the way described above. When you have [taken on the blowpipe and] blown the amount of glass you want, do not make a hole in the base as you did above, but separate it intact from the pipe using a flat piece of wood that has been dipped in water. Quickly heat the pipe and immediately stick it to the base. Now lift up the vessel, heat it in the

flame, and with a round piece of wood enlarge the hole whence you separated the pipe. Shape its rim and enlarge it as much as you like. You will also widen the base round the pipe so as to be concave underneath.

If you want to make handles on it by which it can hang, take a slender iron rod and dip it right to the end in a pot of glass; when a little of the glass has stuck to it, take it out and put [a stringer of glass forming a handle] on the vessel wherever you wish and, as soon as it sticks, heat it so that it adheres firmly. Make as many of these handles as you wish, between whiles holding the vessel close to the flame so that it may be hot but does not melt. Also, take a little glass out of the furnace in such a way that it trails a thread behind itself and lay this on the vessel in the place you have selected. Turn it around close to the flame so that the thread adheres. After doing this, detach the blowpipe as usual and put the vessel in the annealing furnace. In this way work up as much as you want.

Chapter 11. Long-necked Flasks

If you want to make long-necked flasks, do as follows. When you have blown the hot glass into the shape of a large bladder, block up the mouthpiece of the blowpipe with your thumb so that no wind can escape, and swing the pipe with the glass hanging to it over your head as if you were going to hurl it. Then, as soon as its neck is elongated, raise your hand high up and let the blowpipe with the vessel hang down, so that the neck does not become bent. Then separate it with a wet stick and put it in the annealing furnace.[1]

[1] In most manuscripts the list of chapter headings to Book II includes the following titles after chapter 11, although the chapters themselves are not extant: "The Pigments That Are Made from Copper, Lead, and Salt"; "Green Glass"; "Blue Glass"; and "The Glass Called *Gallien*."

The *Mappae clavicula* and Eraclius contain recipes for a green glass made by adding copper to a lead glass composed of two parts of lead oxide and one of sand; blue glass from *saphireum* or zaffre; and *gallien,* which was a deep red glass colored by copper. Dodwell (p. xvii) translates the Eraclius text on these glasses and discusses the missing chapters. It has been suggested that the omission of the chapters was the result of some glassmaker's desire to keep this process secret, which may well be true, though it is hard to see why these particular chapters should be selected for such treatment.

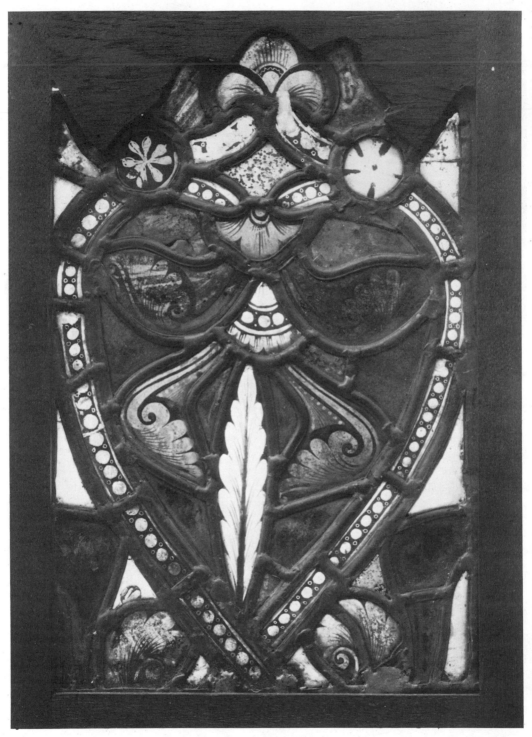

Plate II.—Fragment of stained glass window from St. Denis. French, twelfth century. For discussion see Grodecki (1952). (Metropolitan Museum of Art.)

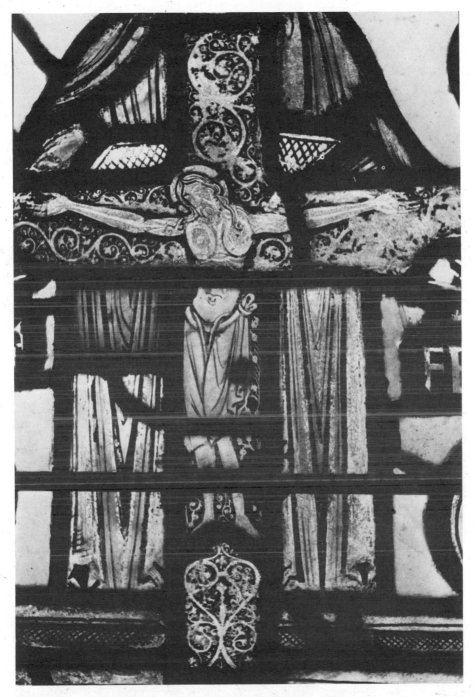

Plate III.—Stained glass window from St. Denis. French, twelfth century. Shows grisaille details achieved by both application of pigment and also by its local removal as referred to by Theophilus. For discussion see Grodecki (1960). (Photo Jean Lafond, courtesy of Jacques Dupont.)

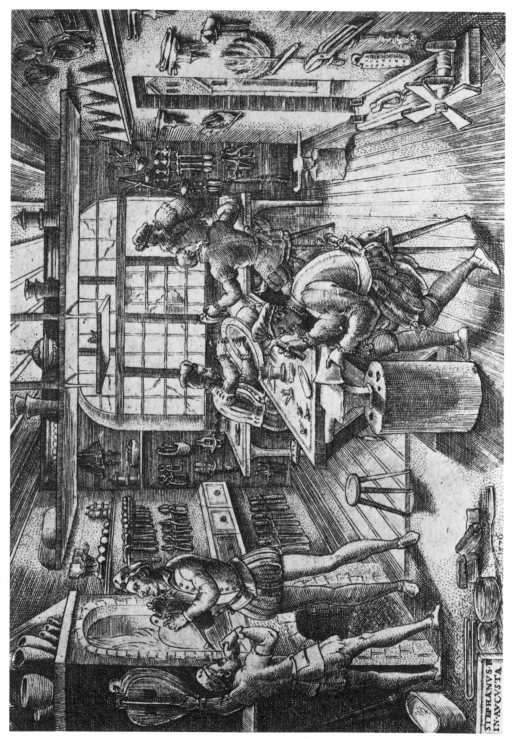

Plate IV.—View of a sixteenth-century goldsmith's shop. Engraved by Stephanus, 1576. (British Museum Print Room; courtesy of H. Maryon.)

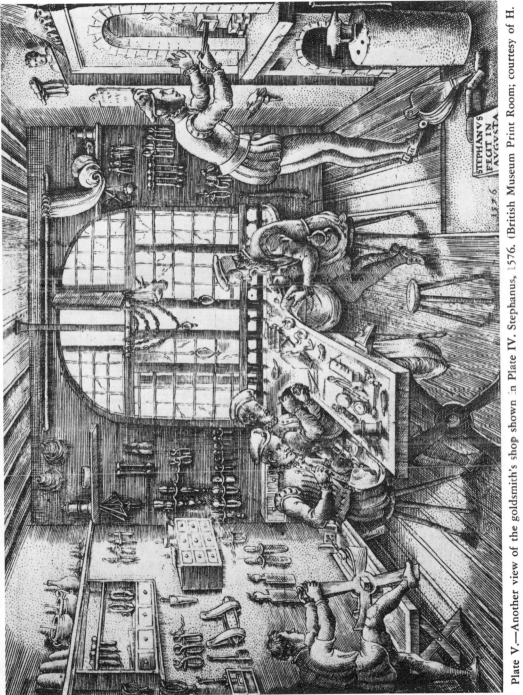

Plate V.—Another view of the goldsmith's shop shown in Plate IV. Stephanus, 1576. (British Museum Print Room; courtesy of H. Maryon.)

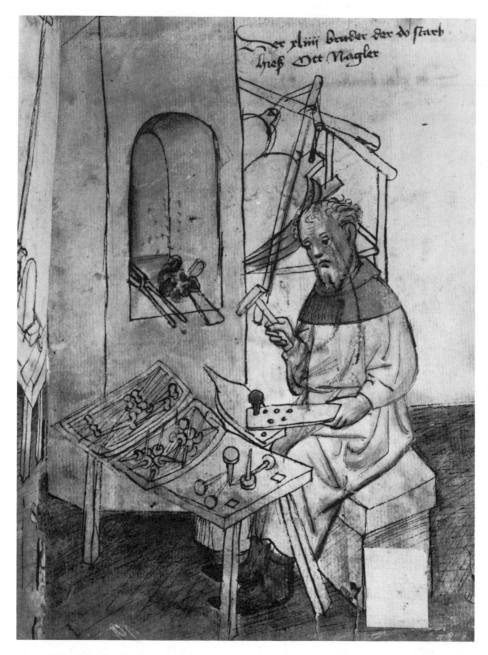

Plate VI.—The nailmaker and his tools, 1425. From the *Hausbuch* of the Mendel Brothers (Stadtbibliothek, Nürnberg). (Photograph, Hauptamt für Hochbauwesen, Nürnberg).

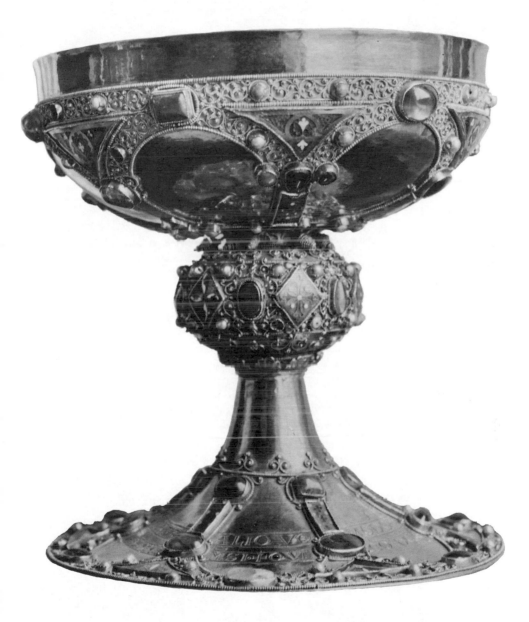

Plate VII.—The Rheims Chalice (eleventh century). This has been heavily restored, but the knop with its enamel plaquettes, pearls, gems, and filigree (such as described by Theophilus) is believed to be original. (Photograph, Monuments Historiques, France 45.F.176.)

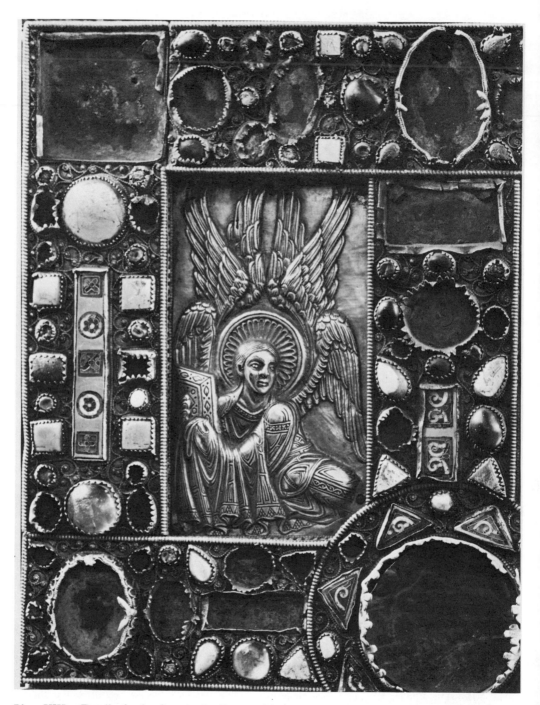

Plate VIII.—Detail of a book cover by Roger of Helmarshausen, showing use of enamel plaques, gems, filigree, and beaded wire as described by Theophilus. Cathedral Treasury, Trier. (Bildarchiv Foto-Marburg, Neg. 58675.)

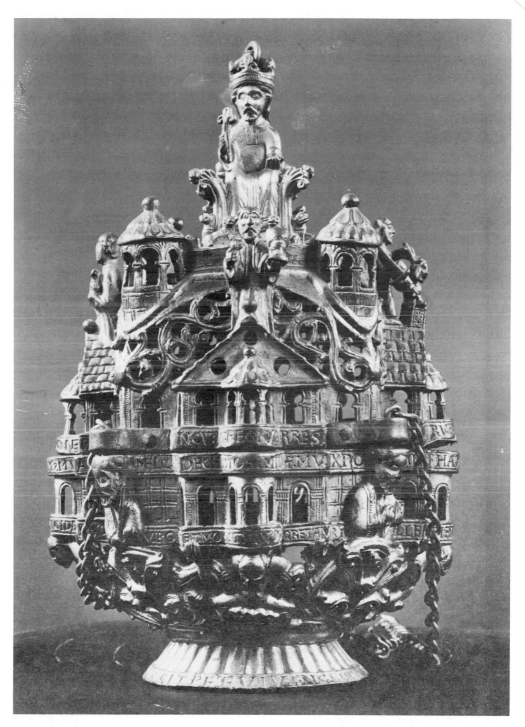

Plate IX.—Cast bronze censer representing the Temple of Solomon. Cathedral Treasury, Trier. (Bildarchiv Foto-Marburg, Neg. 58569.)

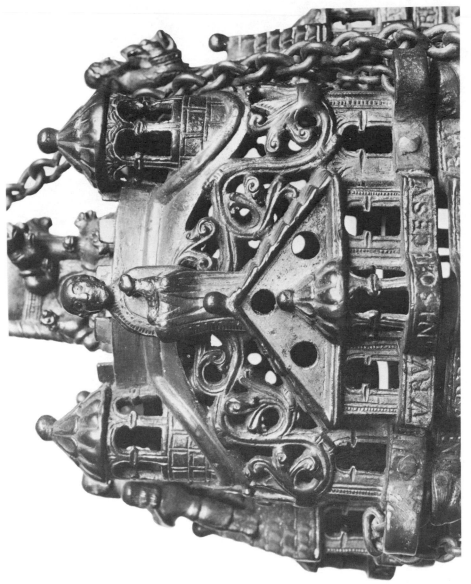

Plate X.—Detail of the Trier censer shown in Plate IX. (Bildarchiv Foto-Marburg, Neg. 19815.)

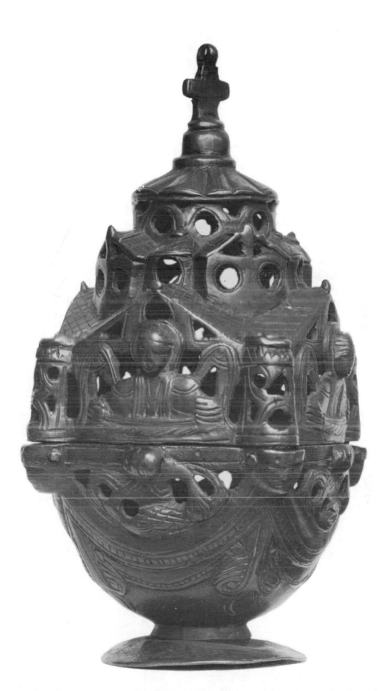

Plate XI.—Cast bronze censer. German, twelfth century. This shows angels with scrolls, architectural details, and perhaps the four rivers of paradise as suggested by Theophilus, and was clearly made essentially by the method he describes. (British Museum, Neg. 1919 7010.5.)

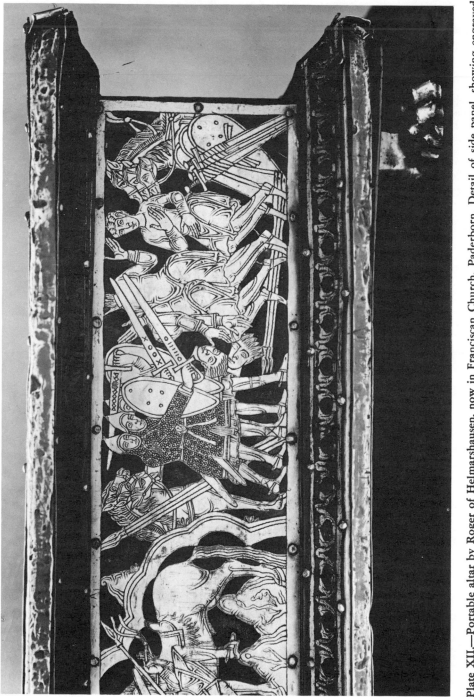

Plate XII.—Portable altar by Roger of Helmarshausen, now in Franciscan Church, Paderborn. Detail of side panel, showing engraved openwork and ring punching. (Bildarchiv Foto-Marburg, Neg. 138911.)

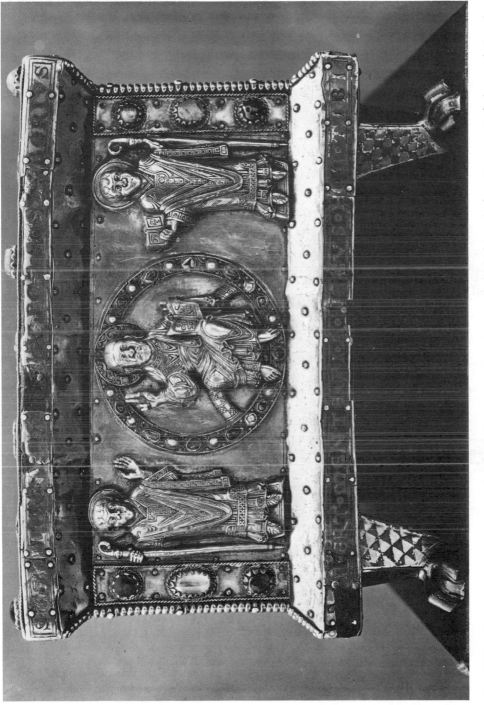

Plate XIII.—The end panel of the portable altar by Roger of Helmarshausen, now in the Cathedral Treasury, Paderborn (cf. Frontispiece). Figures of St. Kilian and St. Liborius in repoussé sheet metal, filigree, beaded wire, gem settings, and niello. (Bildarchiv Foto-Marburg, Neg. 138899.)

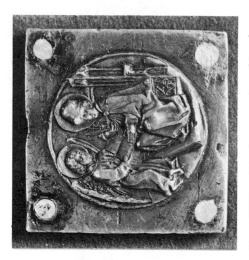

Plate XIV*a*.—Die for stamping thin sheet metal. Fourteenth century. Basle Historisches Museum. (Photograph courtesy of Robert Randall.)

Plate XIV*b*.—Strip of gilded copper sheet with die-stamped design. German, twelfth century. Cologne, Kunstgewerbe Mu-

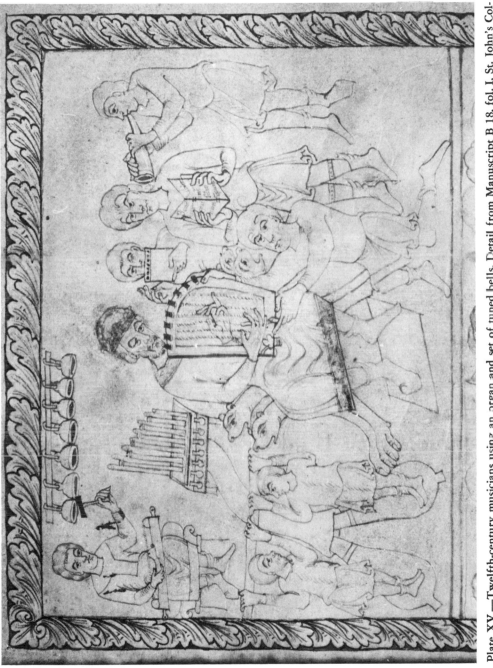
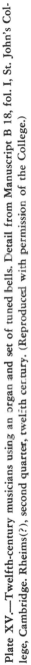

Plate XV.—Twelfth-century musicians using an organ and set of tuned bells. Detail from Manuscript B 18, fol. I, St. John's College, Cambridge. Rheims(?), second quarter, twelfth century. (Reproduced with permission of the College.)

Plate XVI.—Reliquary, carved bone openwork mounted over gilded copper. Italian, tenth century. (Metropolitan Museum of Art, The Cloisters Collection, Neg. 154775.)

Chapter 12. Various Colors of Non-translucent Glass

Different kinds of glass, namely, white, black, green, yellow, blue, red, and purple, are found in mosaic work in ancient pagan buildings. These are not transparent but are opaque like marble, like little square stones, and enamel work is made from them on gold, silver, and copper, about which we shall have enough to say in the proper place [III-54]. There are also found various small vessels in the same colors, which are collected by the French, who are most skilled in this work. They even melt the blue in their furnaces, adding a little of the clear white to it, and they make from it blue glass sheets which are costly and very useful in windows. They also make sheets out of their purple and green glass in the same way.

Chapter 13. Glass Goblets Which the Byzantines Embellish with Gold and Silver

The Byzantines[1] also make costly drinking goblets out of the same blue stones, embellishing them with gold in this way. They take gold leaf, about which we spoke above [I-23], and from it shape representations of men, birds, animals, or foliage. Then they apply these on the goblet with water, in whatever place they have selected. This gold leaf must be rather thick. Then they take glass that is very clear, like crystal, which they make up themselves and which melts soon after it feels the heat of the fire. They grind it carefully on a porphyry stone with water and apply it very thinly all over the gold leaf with a brush. When it is dry, they put [the goblet] in the kiln in which painted glass for windows is fired and about which we shall speak later [II-22]. Underneath they light a fire of beechwood that has been thoroughly dried in smoke; and when they have seen the flame penetrating the goblet long enough

[1] *Graeci:* We have used the term *Byzantine* throughout, to distinguish this characteristic art from that of ancient Greece.

for it to take on a slight reddening, they immediately throw out the wood and block up the kiln until it cools by itself. This gold will never come off.

Chapter 14. More on the Same

They also make these by another method. Taking milled gold (and similarly silver), like that which is used in books, they mix it with water and with it make circles and in them figures, animals, or birds, in varied work, and coat them with the very clear glass about which we spoke above. Then they take pieces of the white, red, and green glasses which are used in enamel work, and individually grind them carefully with water on a porphyry stone. With these they paint little flowers, scrollwork, or any other tiny things they want, in varied work between the circles and the scrollwork and a border around the rim. They apply this rather thickly and then fire [the goblet] in the kiln in the above way. They also make goblets of purple or light blue, and flasks with a fairly wide neck, winding threads made of white glass around them and putting handles of the same glass on them. They also give variety to their diverse workmanship with other colors as they please.

Chapter 15. Byzantine Glass Which Embellishes Mosaic Work

They also make glass sheets in the same way that windows are made, out of the clear white glass, a finger thick. They split them with a hot iron into tiny square pieces and cover them on one side with gold leaf, coating them with the very clear ground glass, as above.[1] Then they lay them side by side on an iron plate, about which we shall speak a little later [II-23], covered with lime or

[1] Theophilus' description is questionable: it is doubtful whether he had seen the process. It seems more likely that the gold was spread on plates of glass and its coating fused on *before* cutting into tesserae.

ashes, and fire them in the window-glass kiln as above. Glass of this kind, interspersed in mosaic work, embellishes it very beautifully.

Chapter 16. Earthenware Vessels, Painted with Different Colored Glazes

They also make earthenware platters, small boat-shaped vessels[1] and other earthenware pots and paint them in this way. They take pigments of all kinds and grind each one separately with water. To each pigment they mix a fifth part of glass of the same color that has itself been very finely ground with water. With this they paint circles, semicircles or rectangles and in them animals or birds or leaves or whatever else they want. After the vessels have been painted in this way, they put them in the window-glass kiln and light a fire of dry beechwood underneath, until the vessels are surrounded by flames and become red-hot. Then they take out the wood and block up the kiln. If you wish, the same vessels can also be embellished in places with gold leaf or with milled gold or silver, in the way described above.

Chapter 17. Laying Out Windows

When you want to lay out glass windows, first make yourself a smooth flat wooden board, wide and long enough so that you can work two sections of each window on it. Then take a piece of chalk, scrape it with a knife all over the board, sprinkle water on it everywhere, and rub it all over with a cloth. When it has dried, take the measurements, namely, the length and breadth of one section in a window, and draw it on the board with a rule and com-

[1] Dodwell, p. xxvi, takes these to be incense-boats on the authority of Braun (1932) that "a long, boat-shaped form of incense container was a de-velopment of the twelfth century." It is uncertain, however, that such things were made in colored ceramics.

passes with [a point made of] lead or tin.[1] If you want to have a border on it, draw it as wide as you like and with any kind of work you wish. After doing this draw as many figures as you wish, first with [a point made of] lead or tin, then with red or black pigment, making all the lines carefully, because, when you have painted the glass, you will have to fit together the shadows and highlights in accordance with [the design on] the board. Then arrange the different kinds of robes and designate the color of each with a mark in its proper place; and indicate the color of anything else you want to paint with a letter.

After this, take a lead pot and in it put chalk ground with water. Make yourself two or three brushes out of hair from the tail of a marten, badger, squirrel, or cat or from the mane of a donkey. Now take a piece of glass of whatever kind you have chosen, but larger on all sides than the place in which it is to be set, and lay it on the ground for that place. Then you will see the drawing on the board through the intervening glass, and, following it, draw the outlines only on the glass with chalk. If the glass is so opaque that you cannot see the drawing on the board through it, take a piece of the [clear] white glass and draw it on that. As soon as the chalk is dry, lay the opaque glass over the white glass and hold them up to the light; then draw [on the opaque glass] in accordance with the lines that you see through it. Delineate all the kinds of glass in the same way, whether for the face, the robes, the hands, the feet, the border, or any other place where you want to put colors.

Chapter 18. Glass Cutting

Next heat on the fireplace an iron cutting tool, which should be thin everywhere except at the end, where it should be thicker. When the thicker part is red-hot, apply it to the glass that you want to

[1] The use of a metal point for writing, probably a Roman invention, required a surface dressed with a white mild abrasive. It was commonly used in the Middle Ages for laying out the writing space on vellum or parchment manuscripts. Graphite was not used before the sixteenth century (see Voice, 1950).

cut, and soon there will appear the beginning of a crack. If the glass is hard [and does not crack at once], wet it with saliva on your finger in the place where you had applied the tool. It will immediately split and, as soon as it has, draw the tool along the line you want to cut and the split will follow.

When all the pieces have been cut like this, take a grozing iron, a span long and bent back at each end, and trim and fit together all the pieces with it, each in its proper place. When everything has been laid out in this way, take the pigment with which you are to paint the glass and which you will prepare in the following way.

Chapter 19. The Pigment with Which Glass Is Painted

Take copper that has been beaten thin and burn it in a small iron pan, until it has all fallen to a powder. Then take pieces of green glass and Byzantine blue glass and grind them separately between two porphyry stones. Mix these three together in such a way that there is one third of [copper] powder, one third of green, and one third of blue. Then grind them on the same stone very carefully with wine or urine, put them in an iron or lead pot and with the greatest care paint the glass following the lines on the board. If you want to make letters on the glass, completely cover the appropriate parts with this pigment and write the letters with the point of the handle of the brush.

Chapter 20. Three Shades of Color for Highlights on Glass

If you have applied yourself diligently to this work, you will be able to make the shadows and highlights for robes just as you did in colored paintings, as follows. When you have made the painted

areas in robes out of the above-mentioned pigment, smear it about
with the brush in such a way that while the glass is made trans-
parent in the part where you normally make highlights in a paint-
ing, the same area is opaque in one part, light in another, and still
lighter [in a third] and distinguished with such care that there seem
to be, as it were, three pigments placed side by side. You ought also
to do the same under the eyebrows and around the eyes, nostrils,
and chin, around the faces of young men, and around bare feet and
hands and the other limbs of the nude body, and it should look
like a painting composed of a variety of pigments.

Chapter 21. The Enrichment of Painting on Glass

There is also a special enrichment made on glass, namely, on the
robes, the seats, and in the backgrounds in blue, green, white, and
transparent purple color. When you have made the first shadows
in robes of this kind, and they are dry, cover the remainder of the
glass with a light pigment, not so opaque as the second shadow
nor so transparent as the third, but midway between them. When
this is dry, make fine lines with the point of the handle of the brush
on each side close to the first shadow which you made, allowing
narrow strips of the light pigment to remain between these lines
and the first shadows. In the rest [of the surface] also make circles
and branches, with flowers and leaves in them in the same way as
is done in the case of painted letters [in manuscripts]. The grounds,
which are laid in [uniformly] with pigments in the case of letters,
should on glass be painted with very delicate little branches. You
can also occasionally put little animals, birds, vermicular patterns,
and nude figures in the circles themselves.

In the same way make backgrounds out of the clearest white
[glass], and the figures against such grounds should be decked out
with blue, green, purple, and red. But against grounds made of
blue and green color which are painted in the same way, and of red
[glass], which is not painted, make the robes out of the purest
white, for no robes are more resplendent than [those made with]

this. With the above-mentioned three pigments,[1] paint in the borders branches and leaves, flowers and scrollwork, in the way described above. Use the same pigments on the faces of figures, on the hands, on the feet, and on naked limbs everywhere instead of that pigment which in the preceding book is called the shadow pigment [I-3]. Do not use yellow glass much in robes except for halos and in those places where gold should be used in a painting. When everything has been assembled and painted in this way, the glass should be fired and the pigments fixed in a kiln which you should build as follows.

Chapter 22. The Kiln in Which Glass Is Fired

Take some flexible canes and fix them in the ground in a corner of the building with both ends aligned to form a series of arches, a foot and a half high, the same in width, and a little more than two feet long. Then vigorously knead some clay with water and horse-dung in the proportion of three parts of clay to a fourth of dung. After kneading this very well, mix with it some dry hay and make long loaves out of it. Cover the arch of canes inside and out to the thickness of a fist and leave a round hole in the center of the top, big enough to put your hand through. Also make three iron bars a finger thick and long enough to reach through the width of the

[1] Theophilus is referring not to pigments applied to the surface to give color (a much later invention), but rather to the use of the pigment that he mentioned in chapter 20, which was used in varying degrees to obscure the color of the underlying glass. In twelfth-century windows, the color came from the glass itself. Blue, green, and white glasses were decorated with a pattern of lines or scrollwork in order to reduce their dominating brilliance and halation; red glass both needed this treatment less and submitted less well to it. It should be remembered that the design of a stained glass window involved partly the use of rela-tively large pieces of the different colors (each outlined and supported by the lead cames) and partly overpainting on these pieces with decorative scrollwork, crosshatching, lines, or other shading that was applied in an opaque fused-on pigment. This was either applied with a brush to give lines directly, or it was uniformly applied and then locally removed by scraping those lines or areas that were to be transparent. A number of good photographs of twelfth-century German glass can be found in Wentzel (1954). Plates II and III show some contemporary French windows.

kiln. Make three holes for these on each side of the kiln so that you can put them in and take them out whenever you wish. Then put fire and wood into the kiln until it is dried out.

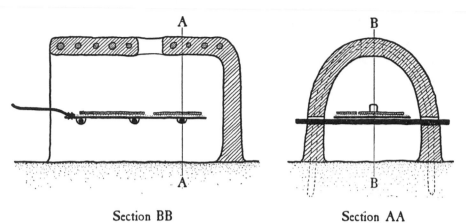

Section BB Section AA

Fig. 5.—The kiln for firing glass. Translators' reconstruction

Chapter 25. How Glass Should Be Fired

Meanwhile, make yourself an iron plate to correspond to the inner dimensions of the kiln but two fingers smaller in both length and width. Sift dry quicklime or ashes onto this to the thickness of a straw and pat it down with a smooth flat piece of wood so that it lies firmly. The plate should also have an iron handle by which it can be carried, put in, and taken out.

Now carefully lay the [pieces of] painted glass on it close together, putting the green and blue glass on the outermost part, close to the handle, and the white, yellow, and purple glass on the inside, because these are more resistant to fire. Insert the bars and lay the plate on them. Now take some beechwood logs that have been well dried in smoke and kindle a moderate fire in the kiln, and then later a bigger one until you see the flame rising at the back and on each side between the kiln [walls] and the plate, and, by passing over the glass and licking it, so to speak, covering it long enough

to make it slightly red-hot. Take the wood out at once and carefully block up the mouth of the kiln and the hole on top through which the smoke was escaping, until the kiln cools by itself. (The lime and ashes on the plate serve to protect the glass from being broken by heat on the bare iron.) Now take out the glass and test it to see if you can scrape off the pigment with your fingernail; if not, it is sufficient; but if you can, put it back again. When all the pieces have been fired in this way, put them back individually on the board, each in its proper place. Then cast cames out of pure lead in this way.

Chapter 24. Molds of Iron

Make yourself two pieces of iron, two fingers wide, a finger thick, and a cubit long. Couple them at one end like hinges so that they stick closely together, and join them together with a bolt so that they can be shut and opened. At the other end, make them a little farther apart, and thinner, so that, when they are shut, there is the beginning of a hole on the inside; and make the outsides continue evenly.[1] Then fit them to each other with a grindstone[2] and a file, so that you cannot see any light between them. After this separate

[1] The construction is not quite clear, but it must have been somewhat as in Figure 6. The notched wooden stick, when used to hold the mold and pressed at a slight angle against the floor (II-25), would hold the two parts tightly together. The fitting together of the parts at the top is simply as a guide. Though the details of the mold are different, the process of casting the cames faintly foreshadows the later casting of type.

[2] "Grindstone" translates *runcina,* a word which apparently is used only by Theophilus. It occurs again as an instrument for producing a carefully finished flat surface in II-24, III-17, and III-27, while in III-80 and III-85 the crank by which a *runcina* is turned is cited as a model for the method of turning a lathe. There can be little doubt that it was a normal rotating cylindrical grindstone. The earliest illustration of such a device is in the Utrecht Psalter of about A.D. 850, where it is twice shown being used to sharpen a sword. It was obviously a commonly known object or else Theophilus would have described it with his other paraphernalia. It is curious, however, that he does not mention its use for sharpening tools, but only for preparing surfaces that are to be flat over a considerable area. For a discussion of the crank, and the possible connection between its late invention and human psychology, see White (1962).

the two pieces from each other and take a rule and draw two narrow
[parallel] lines from top to bottom along the middle of one piece
and two matching lines along the middle of the other. Then en-
grave them as deeply as you wish with the engraving tool with
which candlesticks and other castings are engraved. Scrape a little
off the inside of each iron piece, on the part between the two lines,[3]
so that when you cast lead in them, it will turn out as a single piece.
Arrange the mouth into which the lead is poured in such a way that
one part fits into the other and cannot move while you are casting.

[3] Follows *lineas* (L). At this point the lines have become grooves.

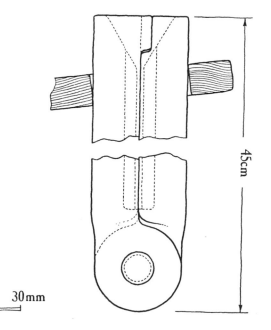

Fig. 6.—The split iron mold for casting lead cames. Translators' reconstruction

Chapter 25. Casting the Cames

After this make a hearth where you can melt the lead, and form a hollow in it in which you put a large earthenware pot (smeared inside and out with clay kneaded with dung to make it firmer) and light a large fire over it. When it is dry, put the lead on the fire inside the pot so that when it has melted it flows down into [the pot]. Meanwhile, open the mold for the cames and put it on the coals to heat. Then you should have a piece of wood, a cubit long, with one end round for holding in the hand, and the other end flat and four fingers wide, where a transverse slot should be cut, of a width equal to that of the mold and reaching to the center. When the mold is hot, shut it and put it into this slot and so hold it at the top end with your hand slightly bent back in such a way that the bottom end rests on the ground. Now taking a small heated iron ladle withdraw some molten lead and pour it into the mold. Put the ladle immediately back on the fire so that it will always be hot. Throw the mold out of the wooden holder onto the ground and open it with a knife. Take out the came, shut the mold again, and replace it in the wooden holder. Should the lead be unable to flow right to the bottom of the mold, heat the mold better and cast again. Make it properly hot like this until it becomes full [on casting], because if it is made properly and uniformly hot you will be able to cast more than forty cames in one heating.

Chapter 26. The Wooden Mold

If you have no iron, look for a piece of fir or other wood which can be split evenly, of the length, breadth, and thickness given above. Split it in two and cut the outside to make it round. Then on each end of each of the pieces make two small marks corresponding to the width you want the center of the cames to have. Now take a thin, twisted linen thread and wet it in red paint; separate the two pieces of wood and place the thread along the inside of one piece, so that it is tightly stretched from the mark which you cut on the

top end down to the mark on the bottom end. Fit the second piece of wood to the first and press them hard together so that when you separate them the paint appears on both pieces. Remove the thread, wet it again with the paint and fix it to the other [pair of] mark[s] and again lay the second piece of wood on the first and press them together. When the paint appears on both pieces of wood, cut the groove for the came with your knife, as wide and deep as you want, but in such a way that it does not run right through to the bottom end, and has an opening at the top end into which the casting will be done.

After doing this fit the two pieces of wood together and bind them with a thong from top to bottom. Hold them in the wooden holder and pour in the lead; then loosen the thong and eject the came. Bind them and pour again, and keep on doing so until the charring reaches into the end of the groove. After this you will easily be able to cast as often and as much as you wish.

When you see that you have enough cames, cut a piece of wood two fingers wide and as thick as the inner width of the came [and somewhat longer]; make a slot down the middle, leaving one end whole and the other open, where the came is to be inserted. Put the came in, cut it down both sides with your knife, make it flat, and scrape it to your satisfaction.

Chapter 27. Assembling Windows and Soldering Them

When you have finished everything in this way, take some pure tin and mix with it a fifth part of lead, and in the above-mentioned iron or wooden mold cast as many sticks[1] as you want for use in soldering your work. You should also have forty nails, a finger long, slender and round at one end and at the other square and

[1] The Latin word is the same as for cames, and the sticks of solder were, apparently, cast in the came mold to avoid making another. The grooves would, however, provide a good hold for the wax (tallow?) flux mentioned later.

bent well outward so that a hole appears in the middle.[2] Then take the painted and fired glass and lay it in its order on the half of the board where there is no drawing. After this take up the head of a figure, wrap a lead came around it, and replace it carefully [on the drawing on the first side of the board]. Then drive in three nails around it with a hammer suited for this work and fit to it the breast, the arms, and the robes that remain. As you set each piece in position, secure it with nails on the outer side so that it cannot move from its place.

Now you should have a soldering iron which is long and thin, with a thick round end drawn out to a slender point and filed and tinned. Put this into the fire. Meanwhile take the tin sticks that you have cast and pour wax on both sides. Scrape the surface of the lead cames at all the places that are to be soldered. Pick up the hot iron and, wherever two pieces of the lead meet, touch the tin to it and smear them with the iron until they stick to each other. When the figures have been firmly set, in the same way arrange the grounds, of whatever color you want, and so assemble the window piece by piece. When the window is finished and soldered on one side, turn it over on its other side, scrape and solder it in the same way, and secure it firmly throughout.

Chapter 28. The Setting of Gems in Painted Glass

If in these window figures you want to set on the painted glass precious stones of another color—hyacinths or emeralds, for example, on crosses, books, or the enrichment of robes—you can do it in this way without using lead [cames]. Wherever in their proper places you made crosses on the head of [Christ in] Majesty, or a book, or an enrichment of the hem of robes, things which in a painting are made of gold or orpiment, these things in windows should be made of clear saffron yellow glass. When painting the goldsmith's work on

[2] *Quadri et recurvi penitus.* We believe that these nails had a square upper shank and a wide, flat, square head made by punching a hole and turning out the sides to make four wings. Others have supposed, with perhaps equal justification, that a simple round loop of square-sectioned iron was meant.

them, leave bare the places where you want to set the stones, and take pieces of clear blue glass and shape from them as many hyacinths as there are places to fill. Shape emeralds out of green glass. Do this so that an emerald always stands between two hyacinths. When they have been carefully fitted and set in position, paint an opaque pigment around them with a brush, in such a way that none of the pigment flows between the two pieces of glass. Fire them in the kiln with the other pieces and they will stick on so well that they never fall off.[3]

Chapter 29. Simple Windows

If you want to assemble simple windows, first mark out the dimensions of their length and breadth on a wooden board, then draw scrollwork or anything else that pleases you, and select the colors that are to be put in. Cut the glass and fit the pieces together with the grozing iron.[1] Enclose them with lead [cames], putting in the nails, and solder on both sides. Surround it with a wooden frame strengthened with nails and set it up in the place where you wish.

Chapter 30. How a Broken Glass Vessel Should Be Repaired

If a glass vessel of any kind happens to fall or be hit so that it breaks or cracks, it may be repaired in this way. Take some ashes, sift them carefully, and knead them with water. Then fill up the broken vessel with them and put it in the sun to dry. When the ashes are entirely dry fit the broken piece to the vessel, taking care that no ash or dirt remains in the join. Now take some blue or green glass that melts very easily in the heat of a flame, grind it carefully

[3] Very few windows containing such "gems" have survived, probably because the composite glass would have cracked as it cooled after firing unless the expansion of the three glasses was carefully matched. In any case the blue and green "gem" colors would be greatly modified by the underlying yellows.

[1] Follows *G*. We take *grosa* (= *grossa*) to be equivalent to *grossarium ferrum* (II-18).

with water on a porphyry stone, and with a brush smear a thin streak of it over the fracture. Then put the vessel on the iron plate, raising it a little on the side where the fracture is so that the flame may pass evenly over it. Put it thus in the window-glass kiln, little by little adding dry beechwood logs and fire underneath until the vessel and the ashes in it become hot. Immediately augment the fire so that the flame grows. When you see that the vessel is barely reddening, throw out the wood and carefully block up the mouth of the kiln and the hole on top until it is completely cold. Take out the vessel, throw out the desiccated ashes, then wash it, and you will have it for whatever purposes you wish.

Chapter 31. Finger Rings

Finger rings[1] are also made of glass in this way. Build a small glass melting furnace in the way described above; then get some ashes, salt, copper powder, and lead.[2] After compounding these, select the colors of glass that you want, build a fire underneath with wood, and frit them. Meanwhile get yourself a piece of wood, a span long and a finger thick. A third of the way down it place a wooden disk a palm in diameter so that you can hold two thirds of the wood in your hand and the disk lies above your hand firmly fastened to the wood, while a third of the wood projects above the disk. The wood should be cut to a point at the end and fitted into a piece of iron just as the shaft is fitted into the head of a lance. The iron should be a foot long and the wood set into it so that they are flush at the join. From here let the iron gradually taper up to the end, where it should be perfectly sharp. Near the window of the furnace on the right side (i.e., on your left) place a wooden post as thick as an arm, set in the ground and reaching up to the top of the window. Near the window on the left of the furnace (i.e., on your right) there should stand a little trough made of clay.

[1] Both the diameter of the spit on which they are made and the suggestion of adding a simulated gem lead us to disagree with Dodwell's deduction that these rings were not meant to be worn on the finger.

[2] This recipe is evidently one of those included in the missing chapters (see II-11, n. 1). The copper and lead powders would, of course, be the oxides.

Then, when the glass is melted, take the wood with the disk and iron, which is called the spit, and dip its end into the pot of glass. Drawing it out with the little blob that will have stuck to it, drive it hard into the wooden post, so that a hole is made through the glass. Immediately heat it in the flame and strike the tool twice on the top of the post in order to stretch [and loosen] the glass, and with all speed rotate your hand together with the tool so that the ring may become more circular;[3] and by rotating it like this, cause

Fig. 7.—Theophilus' hand tool for shaping glass rings. Reconstruction by Theobald (1933). (V.D.I. Verlag.)

the ring to descend to the disk, so that it becomes uniform and smooth. Throw it off at once into the little trough. Work up as much [glass] as you want in the same way.

If you want to give variety to the rings with other colors, when you have picked up the glass blob and pierced it with the pointed iron, take some glass of a different color out of another pot and put a thread of it around the glass of the ring. When it has been in the flame as above, finish it in the same way. You can also put [a small lump of] glass of another kind on the ring, as you would mount a gem, and heat it in the flame so that it sticks fast.

[3] That is, move your hand in a horizontal circle with the spit upright, so as to cause the ring to swing outward and rotate, becoming simultaneously rounder and larger in diameter.

THE THIRD BOOK

The Art of the Metalworker

Prologue

The greatest of the Prophets, David (whom the Lord God in His wisdom predestined before the ages of time, whom He chose "after His own heart"[1] for the simplicity and humility of his mind, whom He appointed prince over His beloved people, whom He strengthened with princely spirit so that he might nobly and wisely establish a regime of such renown), concentrating the whole power of his mind toward love of his Creator, uttered, among others, these words: "Lord, I have loved the beauty[2] of Thy house."

Whether a man of such authority and capacious understanding meant by this house the habitation of the celestial court in which God presides with inestimable brightness over the singing choirs of angels (for which David himself yearned with all his inmost being, saying, "One thing have I desired of the Lord, that I will seek after; that I may dwell in the house of the Lord all the days of my life")[3] or whether he meant the refuge of a devout breast and a most pure heart (in which God truly dwells, a guest ardently desired by David, who prays, "Renew a right spirit within me, O Lord"),[4] nevertheless it is certain that he avidly desired the embellishment of the material house of God, where is the place of prayer. For he entrusted to his son Solomon almost all the materials—gold, silver, brass, and iron—for the Lord's house, to be the founder of which he himself yearned with most ardent desire although he was not worthy because of his frequent shedding of human, albeit enemy, blood.[5] For he had read in Exodus[6] that the Lord had given instructions to Moses to build a tabernacle, had chosen by name the masters for the various kinds of work, and had filled them with the spirits of wisdom, of understanding, and of knowledge in order that they might devise and execute work in gold and in silver and in

[1] Acts 13:22.

[2] This is translated as "habitation" in the Authorized Version (Ps. 26:8). The Vulgate (Ps. 25:8) reads *decorem*, as does Theophilus.

[3] Ps. 27:4 (Vulgate 25:8).

[4] Ps. 51:10 (Vulgate 50:12) which omits *Domine*.

[5] See I Chron. 28 and 29.

[6] Exod. 31:3–5.

brass, in precious stones, in wood, and in universal craftsmanship. He knew from devout reflection that God delights in embellishment of this kind, which he was arranging to be executed under the direction and authority of the Holy Spirit, without whose inspiration he believed no one could attempt anything of this kind.

Therefore, most beloved son, you should not doubt but should believe in full faith that the Spirit of God has filled your heart when you have embellished His house with such great beauty and variety of workmanship. And lest perhaps you are diffident, I shall unfold clearly and systematically that whatever in the arts you can learn, understand, or devise, is bestowed on you by the grace of the seven-fold Spirit.[7]

Through the spirit of wisdom you know that created things proceed from God and that without Him nothing is.

Through the spirit of understanding, you have received the capacity for practical knowledge of the order, the variety, and the measure that you apply to your various kinds of work.

Through the spirit of counsel you do not hide away the talent given you by God, but, working and teaching openly and with humility, you faithfully reveal it to those who desire to learn.

Through the spirit of fortitude you shake off all the apathy of sloth, and whatever you commence with quick enthusiasm you carry through to completion with full vigor.

Through the spirit of knowledge that is given to you, you are the master by virtue of your practical knowledge and you use in public the perfect abundance of your abounding heart with the confidence of a full mind.

Through the spirit of piety you set a limit with pious consideration on what the work is to be, and for whom, as well as on the time, the amount, and the quality of work, and, lest the vice of greed or cupidity should steal in, on the amount of the recompense.

Through the spirit of the fear of the Lord you bear in mind that

[7] In *H,* there is an insert in red, in the same style as the chapter headings, reading "Note the conformity between the Seven Spirits and the seven works of art," and the initial letter of each of the following seven paragraphs is rubricated.

of yourself you are nothing able and you ponder on the fact that you possess and desire nothing that is not given to you by God, but in faith, trust, and thankfulness you ascribe to divine compassion whatever you know or are or can be.[8]

Inspired by these covenants with the virtues, dearest son, you have confidently approached the house of God and decorated it well and gracefully. By setting off the ceiling panels and walls with a variety of kinds of work and a variety of pigments, you have shown the beholders something of the likeness of the paradise of God, burgeoning with all kinds of flowers, verdant with grass and foliage, cherishing the souls of the saints with halos according to their merit. Thus you have caused them to praise God the Creator in this creation and to proclaim Him marvelous in his works. A human eye cannot decide on which work it should first fix its attention; if it looks at the ceiling panels, they bloom like tapestries; if it surveys the walls, the likeness of paradise is there; if it gazes at the abundance of light from the windows, it marvels at the inestimable beauty of the glass and the variety of this most precious workmanship. But if a faithful soul should see the representation of the Lord's crucifixion expressed in the strokes of an artist, it is itself pierced; if it sees how great are the tortures that the saints have endured in their bodies and how great the rewards of eternal life that they have received, it grasps at the observance of a better life; if it contemplates how great are the joys in heaven and how great are the torments in the flames of hell, it is inspired with hope because of its good deeds and shaken with fear on considering its sins.

Therefore, act now, prudent man (happy before God and men in this life, happier still in the future life), by whose labor and zeal so many burnt offerings are being shown to God. Henceforth be fired with greater ingenuity: with all the striving of your mind hasten to complete whatever is still lacking in the house of the Lord and without which the divine mysteries and the administering of the offices cannot continue. These are chalices, candlesticks, censers,

[8] Isa. 11:2, 3. The Vulgate, but not the Authorized Version, includes the "spirit of piety."

cruets, ewers, caskets for holy relics, crosses, missal covers,[9] and all the other things that practical necessity requires for use in ecclesiastical ceremony.

If you wish to make these begin in the following way.

[9] *Plenaria.* These were books containing compilations of ecclesiastical texts, prayers, and other formal writings. The most common in the twelfth and thirteenth centuries were those containing the Masses, *Missalia plenaria* (*Catholic Encyclopedia,* XII, 164).

Chapter 1. The Construction of the Workshop

Build a high, spacious building whose length extends to the east. In the south wall put as many windows as you wish and are able to, provided that there is a space of five feet between any two windows. Then, with a wall rising to the top, divide off half the building for casting operations and for working copper, tin, and lead. With another wall divide the remaining half into two parts, one for working gold, the other for silver. The windows should not be more than a foot above ground level and they should be three feet high and two feet wide.

Chapter 2. The Seat for the Workmen

Then in front of a window, dig a trench, three feet long and two feet wide, a foot and a half from the window wall and at right angles to it. Line the trench all around with wooden boards, of which two in the middle opposite the window should rise half a foot above the trench. On these fasten a table,[1] three feet by two, over the trench to cover the knees of the men sitting in it, and at right angles [to them]. The table should be so flat and smooth that any little bits of gold or silver that fall on it can be carefully swept up.

Chapter 3. The Forge[1] for the Work

Against the wall near the window on the left-hand side of the man sitting, there should be set into the ground a wooden board three

[1] The general arrangement of the work table and its accompanying forge is shown in Figure 8. The table and work pit are essentially as suggested by Theobald. An alternative arrangement, in which the table top is transverse to the pit, is shown in the drawing made by Joseph Durm for Rosenberg (1910).

[1] Although described as a furnace (Latin *fornax*) the arrangement consists simply of a small wall with a hole in it for the nozzle of the bellows and a hearth in front: it is therefore not a true furnace but a forge. In III-4 and often thereafter Theophilus uses the term *ante fornacem*, literally "in front of the furnace [wall]" when he obviously means on the hearth. This phrase we have translated simply as "on the forge."

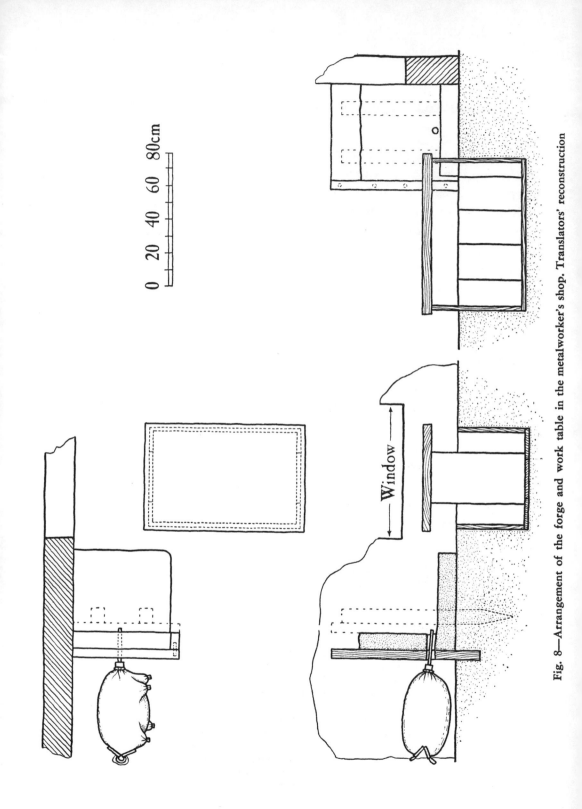

Fig. 8—Arrangement of the forge and work table in the metalworker's shop. Translators' reconstruction

0 20 40 60 80cm

Window

feet long, two feet wide, and almost two fingers thick. When this is firmly in place, it should have a hole in its center, a finger in diameter and four fingers above ground level. There should also be a narrow piece of wood, four fingers wide and as long as the larger board, fitted to it in front and fixed with wooden pegs.[2] In front of this, set in position another board of the same width and length [as the first one], so that between the two there shall be a space of four[3] fingers, and fix it firmly in place from the outside with two or three stakes. Then take some freshly dug clay, neither kneaded nor mixed with water, and start by putting a little of it into this space and compact it well with a round piece of wood; then put in some more and ram it down again. Continue in this way until two thirds of the space is filled, leaving a third empty. Then take away the board in front, and with a long knife trim the front [edge] and the top of the clay flat and smooth. Then strike the clay hard with a slender piece of wood. After this take some clay that has been kneaded and mixed with horse-dung, and build up the forge and a hearth for it. Coat the wall [of the building] also so that it will not be burnt by the fire. Pierce the clay through the hole at the back of the board with a slender piece of wood. Build all smiths' forges in this way.

Chapter 4. The Bellows

Then make bellows out of ram skins in the following way. When the rams are killed, the skins should not be slit under the belly but

[2] This small plank is placed vertically at the front edge of the first board to serve as a lateral retainer for the clay. Since it is pegged in place, supposedly it remains as a protection to the clay in service (Fig. 8). The form is completed by the board in front, held temporarily by stakes, and by the wall of the building. We do not follow Theobald either in his placement of the narrow board on the ground or on his arched superstructure. Although the latter is common in later illustrations of forges for many purposes, Theophilus omits all mention of it in his generally detailed description.

[3] Follows *H*.

opened from the rear and turned inside out so that they can be
stripped off whole. Then they should be filled with straw and dried
out a little. Afterwards they should lie for a day and two nights
in a composition of lees and salt. On the third day they should be
turned right side out and stretched lengthwise and even more in
width. Then they should be greased and stretched again. After this
make a wooden head for the bellows to go through the neck and
be tied there and then make a hole in the head through which an
iron pipe can go. Now, along the width of the bellows at the back,
place four pieces of wood, which should be fitted to each other in
pairs and tied together in the middle.[1] Each pair should be sewn
onto the bellows so that the places where they are joined are at the
top and bottom of the middle [of the opening in the skin]. At these
points also two loops of the same skin should be sewn on, a smaller
one at the top to hold the thumb and a larger one at the bottom for
the four fingers. When this is finished, put the iron pipe into the
hole at the back of the forge, and light a fire of charcoal on the
forge and blow, so that the forge is dried out.

The names of the instruments and iron tools used in smith's
work are these:[2]

Chapter 5. Anvils [and Stakes]

Anvils that are broad, flat, smooth and square.
Also anvils that are flat, smooth, and horn-shaped.

[1] The pieces of wood in a pair are
laid end to end and are tied where they
touch. The outside junctions seem not
to be tied, but depend on the skin to
which they are sewn to hold them flexi-
bly together. The whole forms a loz-
enge-shaped valve which is opened and
closed by the fingers and thumb of one
hand as the bellows are pushed in and
pulled out. Theophilus does not men-
tion the necessary valve in the head of
the bellows to prevent hot gases being
sucked into them during inflation.

[2] We end this chapter with a colon

Also anvils that are rounded on top, like half an apple, one large, one small, and a third short—these are called stakes.

Also anvils that on top are long and narrow, with two horns projecting as from a spear shaft, one of which is round, tapering to a slender tip,[1] while the other is broader and slightly curved back at the tip with a smooth roundness like a thumb.[2] These should be large and medium.

Chapter 6. Hammers

Many types of hammer: large, medium, and small, broad on one face and narrow on the other.

Also hammers that are long and slender, round at the tip, both large and medium.

Also hammers that are horn-shaped at the top, and broad at the bottom.[1]

because the four chapters that follow give a list of tools without any main verb.

[1] A bick iron.

[2] A cow's-tongue stake. A good description of the raising process with illustrations of the various kinds of anvils and stakes is given in Maryon (1954), pp. 87–103. The diversity of shapes is needed for raising vessels of different depths and diameters, and to allow local detail to be formed. Several anvils and stakes, pointed to allow embedding in a heavy wooden block, are to be seen in the 1576 engraving of a workshop by Stephanus (Plates IV and V). Most of the other tools shown here would have been familiar to Theophilus except for the muffle furnace and the implements in which screws were incorporated.

[1] Although Theophilus here refers to the shape alone, these mallets were often made of pieces of actual bullock's horn, about 6 inches long, and fitted with a handle like a hammer. In III-9 and -58 such a horn hammer is used.

Chapter 7. Tongs [and Pliers]

Strong hand pliers having large and small jaws on the end.[1]
Also long slender tongs.[2]

[1] The word translated as either tongs or pliers is *forcipes*. The jaws are literally "knobs." Most of these would be spring tongs made in a single piece, but both the shears and the hand-vice are hinged in the modern way.

[2] LIST OF TOOLS NAMED BY THEOPHILUS

Theophilus' names for the principal tools are given below in Latin with our rendering of them. For particular references see the Index under the English rendering. It should be noted that normally Theophilus uses the medieval masculine form *ferrus* for a tool, always so in the plural, and the classical Latin neuter form *ferrum* for an implement made of iron, but he is not consistent.

clavi ferrei: punches for making the heads of studs

cos: hone

cuprum deauratorium: copper gilding tool

cuprum gracile: slender copper tool

ferrum acutum et latius: turning tool (for use with a lathe)

ferrum aequale: burnishing tool (burnisher); also used in repoussé work

ferrum divisorium: cutting tool (for glass)

ferrum gracile: punch

ferrum grossarium (grosa, grossa): grozing iron

ferrum planatorium: planing tool, drawknife

ferrum solidatorium: soldering iron

ferrum tenue: cutting tool (for wax)

ferrus ad ductile opus: punch

ferrus ad faciendos clavos: tool for making nails

ferrus ductilis: punch

ferrus ductorius: chasing tool (chaser)

ferrus fossorius: engraving tool (graver)

ferrus incisorius: chisel (*meizel,* p. 148)

ferrus obtusus: burnishing tool (burnisher)

ferrus per quae fila trahuntur: drawplate

ferrus pertractorius: drawing tool, scriber

ferrus punctorius: ring punch

ferrus rasorius: scraping tool (scraper)

filum ex auricalco: brass wire brush

forceps (usually in plural, *forcipes*): pliers, shears, tongs, tweezers

incus: anvil

incus longa: bick iron

instrumentum iunctorium: cooper's shaping tool

malleus (dim. *malleolus*): hammer, mallet

malleus rotundus: pestle

mortarium (dim. *mortariolum*): mortar

nodus: stake (anvil)

organarium: tool for swaging beaded wire

pila: pestle

pistillum: pestle

runcina: grindstone

serra: saw

setae porci: hog-bristle brush

sigillum: die

subula: awl, scriber, tracer

terebrum: auger, drill

veru: spit

Also long metal-caster's tongs, slightly curved at the front end.

Also medium-size pliers for holding anything that has to be filed. The end of one of the handles of these should be slender, and from the other a wide thin piece of iron, pierced [with a number of holes][3] should hang, and when you put into [the jaws] anything small that is to be filed, squeeze hard, inserting the slender end of the handle into the desired hole.

Also very small tongs [tweezers] joined together at one end and slender at the other, for arranging beads and any other tiny things.

Also tongs known as coal tongs, both large and medium, which

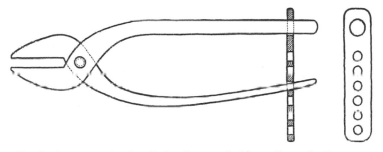

Fig. 9.—Hand vice or spring-handled pliers to hold small work. Reconstruction by translators.

are in one piece, bent around at one end and open and slightly curved at the other.

Also shears, large and medium, made in two parts and held together by a pin.

Chapter 8. Iron [Plates] through Which Wires Are Drawn

Two iron [plates] three fingers wide, narrow at the top and bottom,[1] thin throughout and pierced with three or four rows of holes [of diminishing size] through which wires may be drawn.[2]

[3] As Dodwell suggests (p. 68, n. 1) this is a kind of hand vice. One of the two crossed arms is elastically bent and locked in position in one of the holes to maintain the pressure (Fig. 9).

[1] Perhaps to fit a slot in the bench.

[2] This description of the drawplate provides the first definite record of wire-drawing, although wire of precious metals and bronze was extensively used in jewelry and other applications for at least 3,000 years before Theophilus. It is tempting to believe that

Chapter 9. The Implement Called the "Organarium" [for Swaging Beaded Wire]

There is also an iron implement called the *organarium* which consists of two pieces of iron, a lower and an upper one. The lower one has the width and length of the middle finger and is slightly

the long lengths of wire must have been drawn through a die, but there is no real evidence of this. The cutting of strip followed by rounding under the hammer would not be too difficult an operation, and, indeed, shapes such as the Etruscan safety pins in which the wire is integral with a large body could only have been made this way.

The most famous wire in antiquity is that made by Vulcan by an unspecified technique to catch Venus and her paramour. An early reference is in the Bible (Exod. 39), where "twisted chains like cords" of gold were used on a breastpiece of Aaron's ritual garment and also "gold leaf was hammered out and cut into threads to work into the blue and purple and the scarlet stuff, and into the fine twined linen in skilled design."

Hardwood slabs with holes drilled in them are known from fairly remote antiquity, and these seem to have been intended for scraping soft organic materials. In III-62, Theophilus mentions the use of such a wooden die for smoothing out a braided cable. Such dies may have been used quite early for compacting rolled-up metal sheet and perhaps even for giving a smooth round and uniform surface to hammered wire of soft metal. It is not impossible that this led directly to the use of a sequence of holes of decreasing diameter for the true drawing of soft metals, with considerable reduction in

area and increase in length. Another procedure which was in use in Africa even in comparatively modern times was the reduction of hammered bars by pure tension. A drawing of A.D. 1389 in the Mendel Brothers' *Hausbuch* does show wire being treated apparently by merely winding under tension from one block to another, but this is probably the product of an unobservant artist, and, in any case, the method cannot be used for continued reduction, even with intermediate annealing, because any local thinness becomes exaggerated and leads to local failure.

The existence of mail armor is often said to prove the existence of wire-drawing. Quite to the contrary, however, all early mail and even some of late date is unmistakably made from strip cut from hammered sheet, and a satisfactory technique for drawing wire of a hard metal was obviously slow to develop (Smith, 1959). There are a number of fourteenth-century references to wire-drawers' guilds and the like, and some excellent sixteenth-century drawings of wire-drawing equipment. The earliest illustration in a printed book is in 1530 in Pantheo's *Voarchadumia* (Taylor, 1954), which has a woodcut showing the drawing of a coinage strip through a rectangular die, but the artist seems to have confused the windlass of the draw bench with the hand-operated rolling mill of the competitive process. Biringuccio

thin, with two spikes which fit into a piece of wood below it. On the upper side above these spikes there project two thick pins which hold the upper piece. The latter is the same width and length as the lower one and has two holes, one at each end, through which the upper parts of the two pins should pass so that the two pieces will fit together. They must be fitted exactly to each other with a file, and [a series of] small grooves should be cut out in both pieces in such a way that holes appear right through the middle.[1]

Then, a long [rod] of gold or silver, hammered evenly round, is pushed into the larger hole and the upper part of the tool is struck hard with a horn hammer while the piece of silver or gold is turned

(1540) has woodcuts showing three different hand-operated devices for drawing soft metal wire of different diameters, and a large water powered crank-and-tongs machine. In the course of his detailed description of the operation, Biringuccio remarks that the drawing of heavy iron wire needs water power, from which it may be concluded that drawn wire for mail was indeed impractical prior to the development of the water wheel and its attendant machinery.

The fact that Theophilus describes the drawplate without bothering to describe its use suggests that it was too well known to need details. This is unfortunate, for his specification of a thin plate narrowed at top and bottom does not conform to later convention.

There is no satisfactory history of the origin and development of wiredrawing, despite its central importance among metalworking processes. This note is based partly on a private communication from F. C. Thompson. See also F. C. Thompson (1935, pp. 159–62); Lewis (1942, pp. 15–23, 26–27, 56–60); Feldhaus (1914, pp. 199–203); Theobald (1933, pp. 275–79); and Oddy (1977).

[1] This tool for making beaded wire has been variously interpreted by different authors. Wilson (1951, p. 273)

shows a whole series of hemispherical depressions in each plate running the direction of the wire, while Theobald, whose interpretation is endorsed by Herbert Maryon, favors a single hemispherical cavity in each half, thus working in one bead at a time. This is shown in holes *bbb* in our sketch (Fig. 10). It may be, however, that the grooves merely produced a single circumferential groove and did not fully shape the bead on a single treatment. This is shown in holes *aa*. Such a tool would be much simpler to make and require less force in use although it would require more skill in spacing the grooves to give well-formed beads. An examination of beaded wires of the period does not answer this question completely. For example, in the book cover attributed to Roger of Helmarshausen (see Plate VIII), individual beads differ by as much as 0.5 mm. in length, without any detectable periodicity in the variation. Yet the average spacing is remarkably constant for long distances. An occasional bead has a line around it, indicating a place where a bead had been accidentally hit by the edge of the die. These marks never occur in pairs or groups, which seems to favor a single die line, as in *aa*.

with the other hand. Round beads like beans will then be made; in the second hole they become like peas; in the third, like lentils; and so on smaller.

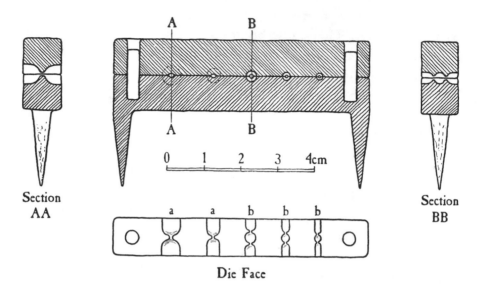

Fig. 10.—The tool for making beaded wire. Translators' reconstruction

Chapter 10. Files Grooved on the Bottom

There are also tools, as thin as a straw, a finger long, and nearly square, but wider on one side. Their tangs, on which handles are put, curve upwards. On the underside a longitudinal strip is dug out and filed like a furrow, and the faces on both sides of this are filed sharp.[1] With these tools both thick and thin wires of gold and silver are filed so that beads appear on them.

[1] Theophilus does not mention cutting file teeth on the groove and its sides. It is possible that, as Herbert Maryon believes, these tools were not files, but rolling swages, which would press wire into a beaded shape by rolling it to and fro on a flat surface. The Latin words for the tool and the operation done with it (III-52) are *lima* and *limo,* which elsewhere seem invariably to refer to filing. A grooved file was certainly used in making beading on the edges of strip, which often appears in contemporary metalwork.

Chapter 11. Engraving Tools

Gravers suitable for engraving are also made in the following way. A tool is made of pure [i.e., solid] steel, as long as the middle finger, as thick as a straw, though thicker in the middle, and square [in section]. The tang is put into a handle. At the other end the upper face should be filed down to the lower one, which is longer, and

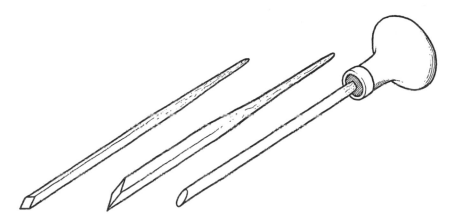

Fig. 11.—The three shapes of engraving tool. Translators' reconstruction

filed thin at the point. It is heated and hardened[1] in water. Several tools are made of this type, both large and small.

Another square tool is also made in the same way. It is broader and thin and its cutting point should lie with the breadth, so that there are two upper faces and two lower ones, which are longer, flat, and smooth. In this way, too, several small and large tools are made.

A tool is also made, as round and as thick as a straw, with its point filed in such a way that the trace it makes is round.

Chapter 12. Scrapers [and Burnishers]

Small and large scrapers are also made, slender, but somewhat wider at the end and sharp on one side. Some of them are curved

[1] See III-18, n. 1.

back, as required by the type of work. Tools are also made, shaped in the same way, but rounded off for burnishing the work.

Chapter 13. Punches

Tools are also made for pushing up figures, birds, animals, or flowers in repoussé in gold, silver, and copper. They are a span long, broad and headed on top, while below they are slender, round, flat, three-cornered, four-cornered, or curved back as required by the diversity of forms in the work. They are to be struck with a hammer.[1] A tool [a ring-punch] is also shaped in the same way but is slender at the end. A hole is impressed in the end of the punch by another even more slender tool and it is filed all around, so that a very delicate circle appears when it is struck on gold or silver or gilded copper.

Chapter 14. Chisels

Also chisels are made, of such a size that they can be grasped by the entire hand and project above the hand broad and even, and below it broad, flat, thin and sharp. Many of these are made, both small and large, and with them gold, silver, or thick copper is cut.

Chapter 15. Tools for Making Nails

There are also tools that are flat and pierced with narrow holes in which large, medium, and small nails may be headed.[1]

[1] This will be done while the sheet metal rests upon some yielding backing such as lead, soft wood, wax, or pitch.

[1] This is well illustrated in a fifteenth-century drawing in the Mendel Brothers' *Hausbuch* (see Plate VI).

Chapter 16. Iron Ingot Molds

There are also iron ingot molds[1] that are long, circular, or square. Molten gold, silver, or copper is cast into them.

There are also iron compasses made in two parts. These are made both large and small, and both straight and curved.

Chapter 17. Files

There are also files made of pure steel, both large and medium-size ones, four-cornered, three-cornered, and round. Others are also made, which should be stronger [i.e., thicker] in the middle. The inside should be made of soft iron; the outside covered with steel. When they have been hammered into the size which their maker wants to give them, they are smoothed on a grindstone and cut with a hammer having a cutting edge at each end [of its head]. Others again are cut with the chisel about which we spoke above [III-14]; with these, work which has previously been filed with other coarser files should be smoothed. And when they have been cut on every side, do the hardening of them in this way.

Chapter 18. The Hardening of Files[1]

Burn the horn of an ox in the fire and scrape it. Mix with it a third part of salt and grind it vigorously. Then put the file into the fire

[1] *Ferri infusorii*. These are open horizontal ingot molds, made of iron and dressed with wax. See III-27 for a description of a different type of mold for casting large disks. The compasses referred to in the next paragraph would be, of course, more like dividers or calipers than modern compasses which mark with pencil or ink. Several can be seen, both straight and curved, in the Stephanus engravings (see Plates IV and V).

[1] Theophilus does not give a general discussion of hardening but rather describes the operations separately for

and, when it is red-hot, sprinkle this composition over it on every
side. When the coals are strongly blazing, open them up and hastily
blow all around so that the hardening does not diminish. Immediate-
ly take out the file and quench it evenly in water. Take it out and dry
it a little over the fire. In this way harden all files made of steel.

Chapter 19. More on the Above

In the same way you will also make very small files—square, round,
half-round, three-cornered, and flat and thin. These are made from
soft iron and you should harden them thus. When they have been cut
with a hammer or a chisel or a small knife, smear them with old pig
fat and wrap them around with leather strips cut from goat skin and
bind them with linen thread. After this cover them individually with

each of the different kinds of tool. The
present chapter deals with files made
of solid steel: the coating of ox-horn
powder and salt which is sprinkled
over the already hot file could serve
little purpose beyond the prevention of
decarburization of the surface. The
blowing that Theophilus mentions
probably was to remove pieces of char-
coal sticking to the tool, which would
prevent uniform quenching. The phrase
sic ut temperamentum non cadat, which
we translate "so that the hardening
does not diminish," has been taken by
other translators as a caution to pre-
vent the falling-off of the hardening
compound. This would be of little use
at this late stage of the process.

In the next chapter very small files
are cut in soft iron, and then case-
hardened in pig fat and leather strips,
in a clay jacket. Although Theophilus
omits instructions to hold the files for
a reasonable length of time after they
had become heated, doing so would
have given deeper hardening. In the

hardening of engraving tools (III-20),
all surface protection is omitted, sup-
posedly because only a small time was
necessary to heat their tips.

It will be noted that Theophilus sim-
ply quenches his tools in plain water
or urine (III-21). Since he does not
mention the tempering process (indeed
no written reference to it prior to the
sixteenth century is known), it must be
assumed that either the steel was of a
low enough carbon content to have
adequate ductility after a full quench,
or, more likely, that the quench was
an interrupted one, carried out dexter-
ously so that the heat of the inner metal
was allowed to flow out and temper
the surface. This would be very diffi-
cult to control and would perhaps be
more reliable in the presence of the
surface deposits left by the various or-
ganic nostrums that were called for in
the early recipes. The true history of
the hardening of steel, perhaps the
most important of all metallurgical
processes, has yet to be written.

kneaded clay, leaving the tangs bare. When they are dried, put them into the fire, blow vigorously, and the goat skin will be burnt. Hastily extract them from the clay and quench them evenly in water. Then take them out and dry them at the fire.

Chapter 20. The Hardening of an [Engraving] Tool

Engraving tools also are hardened, in this way. When they have been filed and fitted to their handles, their tips are put into the fire and as soon as they begin to get red-hot, they are taken out and quenched in water.

Chapter 21. More on the Same

Another method of hardening is also carried out in the following way for those tools with which glass and the softer stones are cut. Take a three-year-old goat and tie it up indoors for three days without food; on the fourth day give it fern to eat and nothing else. When it has eaten this for two days, on the following night shut it up in a very large jar perforated at the bottom, and under the holes put another vessel, intact, in which you can collect its urine. When enough of this has been collected in this way during two or three nights, let the goat out and harden your tools in this urine.[1]

Tools are also made harder by hardening them in the urine of a small red-headed boy than by doing so in plain water.

[1] This, the recipe for Spanish gold (III-49), and the carving of rock crystal in a live goat's heart (III-95) are the only places in the whole work where Theophilus seems to deviate from the simplest workshop practice. It may be, of course, that he really did use urine as a quenching medium because the presence of a certain amount of organic matter in water would be desirable when quenching directly to final hardness without tempering (cf. III-18). One wonders, however, why only goats or red-headed boys can provide the necessary fluid.

Chapter 22. Crucibles for Melting Gold and Silver

With all these things at hand, take white clay and grind it very fine. Then take old pots in which gold or silver has previously been melted and crush them up separately. If you do not have these, take pieces of a white earthenware pot and put them on the fire until they are red-hot, and if they do not crack, allow them to cool, and grind them up separately. Then take two parts of ground clay and a third part of the burned pots and mix them with warm water. Knead it well and make crucibles out of it, both large and small ones, in which you will melt gold and silver. In the meantime, however, while they are drying, take a balance and weigh the gold or silver which you want to work. If the silver is not pure, refine it in this way.

Chapter 23. Refining Silver

Sift some ashes, mix them with water, and take a fire-tested earthenware dish[1] of such a size that you believe the silver which is to be refined can be melted in it without running over. Put ashes in it, thinly in the middle and thickly around the rim, and dry it in front of the fire. When it is dry, remove the coals a little distance from the [wall of the] forge[2] and put the dish with its ashes in front of the wall beneath the [tuyère] hole, so that the blast from the bellows will blow onto it. Then replace the coals on top, and blow until the dish is red-hot. Then put the silver into it, add a little lead on top, heap charcoal over it, and melt it. You should have at hand a stick cut from a hedge and dried in the wind, with which you should carefully uncover the silver and clean away whatever impurity you see on it. Then put on it a brand, that is, a stick burnt in the fire, and

[1] *Testa ollae,* elsewhere *testa: testa* often meant a broken sherd, but here is obviously an earthenware dish, distinguished from an *olla* (a simple pot, normally round) because it is shallow. *Testa* is also used for earthenware pots employed in cementation (III-33). It may be the origin of the word "test" as later used for a large removable cupeling hearth or for small laboratory dishes.

[2] See III-3, n. 1.

blow gently, using a long stroke [of the bellows]. When you have removed the lead by this blowing, if you see that the silver is not yet pure, again add lead, place charcoal on it, and do as you did before. However, if you see the silver boiling and jumping out, know that tin or brass is mixed with it, and finely crush a small piece of glass and throw it on the silver. Then add lead, put charcoal on, and blow vigorously. Then inspect it as before, take away the impurities of glass and lead with the stick, put the brand on it, and do as before. Keep on doing this until it is pure.[3]

Chapter 24. Dividing the Silver for the Work

If you want to make a chalice, divide the silver, when it has been refined, into two equal parts. Keep one part for making the foot and the paten. Make the bowl from the other, adding to it some of the silver assigned to the paten; for example, if there is a mark of silver, add to the one half a weight of twelve pennyweight [of silver], which will later be filed and scraped off [the bowl] so that it can be returned to its own part. But if there is more silver than this, or less, add in the same proportion and later restore to each part its proper weight.[1]

[3] This is the earliest good description of the very ancient art of cupellation, which serves effectively to separate the noble metals, silver and gold, from practically all other materials. Unlike most metallurgical operations which are done in relatively impervious refractories, this is intentionally done on a porous bed made of ashes (the best are bone ash but Theophilus does not specify) to absorb the oxidation products by capillary action. Easily oxidized lead was added to the silver in order to provide a material that would instantly flux the oxides of other impurities and carry them away. As Theophilus points out, the presence in large amounts of tin or brass (containing zinc) will give an oxide that is not dissolved in the litharge, and hence an additional fluxing agent, glass, was added. It was necessary first to melt the silver and then, when it was thoroughly hot, to expose it to an oxidizing blast of air from the bellows. By the fifteenth century this was being done both on a very large scale in furnaces consisting of a bone-ash hearth covered with a large brick dome and in smaller dishes ("tests"), much as Theophilus describes (see Fig. 12).

[1] The proportion of 12 pennyweight to half a mark of silver amounts to an allowance of 8.6 per cent for recoverable scrap. The bowl was finished first, and the filings, scrapings, and other scrap from it were added to the metal being cast for the foot (III-43). When

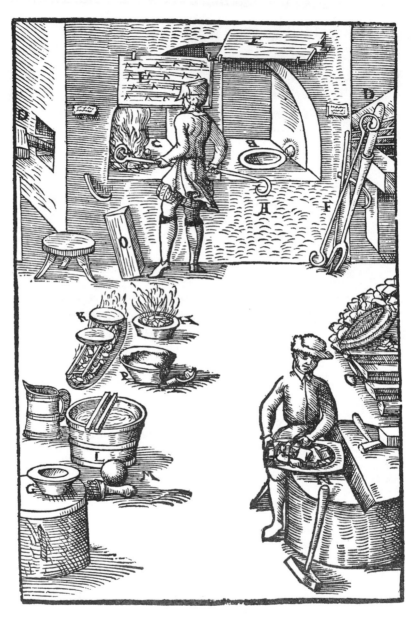

Fig. 12.—Refining silver on the test. (From Ercker, 1574.)

Chapter 25. Casting Silver

After arranging these things put the silver in one of the crucibles, and when it has melted throw a little salt on it and immediately cast it into a circular ingot mold, which should have been heated on the fire and in which there should be [a dressing of] melted wax. If by some carelessness it should happen that the cast silver is not sound, cast it again until it becomes so. Then make a composition out of clear lees and salt, in which you should quench the silver every time you anneal it.

Chapter 26 Making the Smaller Chalice

When you begin to hammer the silver, look for the middle of it and make a center point with the compasses. Around this you are going to make a square projection onto which you will [later] fix the foot. Now when the silver has been made so thin that it can be bent by hand[1] [leaving, however, that which is needed to form the projec-

that was finished everything left was melted to make up the ingot for the paten (III-44).

The above ratio is based on the assumption that Theophilus' mark and pennyweight (*marca* and *nummus*, respectively) correspond to the system in use for precious metals, later well established in Germany, in which the mark was half a pound, made of 16 loths each of 16 *pfennig*, giving 256 *pfennig* (pennyweight) to the mark. On this basis not only is the allowance for scrap here and in III-26 a reasonable one, but also the addition of two pennyweight of brass to half a mark of silver, specified in III-30, would give about the right amount of zinc for deoxidation. One cannot be certain, however, for in northern Europe the mark was at one time equivalent to the pound, but both its monetary value

and the weight of silver represented by it changed between early and late medieval times.

In most places where a definite composition must be given, as, for example, in compounding solders or bell metal, Theophilus states the relative numbers of parts of the components, not their absolute weights. The latter generally appear only where precious metals are dealt with and where the scale of operations is important. The word *libra*, "pound," is used for the base metal, tin, in III-88, together with a curious unit, *quadrans*, which is discussed in III-88, note 2. The common word for pennyweight, *denarius* (also, of course, a monetary unit), occurs only once, in III-37, where it denotes the size of individual lots of niello.

[1] The operations in making the two chalices are practically identical to

tion] draw [concentric] circles with the compasses, from the center to halfway out on the inside, and on the outside from halfway out to the rim. Then, following the circles, hammer on the inside with a round hammer to give depth and, following the circles on the outside up to the rim, hammer with a medium-size hammer on a rounded anvil to make [the bowl] narrower. Continue doing this until you reach a shape and size appropriate to the amount of silver. When this has been done, scrape it smooth with a file on the inside and the outside and around the edge until it is even and smooth all over.

Then divide the remaining half of the silver into two parts as

those described in any modern book on fine metalwork. See, for example, Maryon (1954) or Wilson (1951). The main operation in shaping the hollow bowl or stem from the sheet is known as raising and is done by means of hammer blows on the outside of the bowl resting temporarily upon a stake. The finer details of the embossed design are produced by the use of smaller tools, locally applied on either side of the metal, to push the high parts up and the background down. This calls for extreme skill in balancing the local thickness of the metal at various stages so that the metal will always be thick enough in the extended parts and not (since the metal is precious) too thick in the others. In the final stage of the operation it is necessary to support the work inside, which is done by filling it with wax to prevent buckling. The silver would, of course, need to be frequently annealed during its working operations, though Theophilus often omits mentioning this important step.

The final operations involve the engraving or chasing of fine decorative linear details. It is here sometimes difficult to follow Theophilus. The more common process, chasing, involves making an impression with a tool hammered nearly normal to the surface of the sheet so as to leave an impression by displacement of the metal rather than by excising it. This is clearly referred to in this chapter as the means of decorating the paten. Elsewhere, however, Theophilus' description of his tools and the use of the word *fodio* quite definitely imply a cutting operation: this is true engraving, in which a line of metal is actually removed by the cutting tool. Herbert Maryon has remarked that engraving is very uncommon in surviving objects from the eleventh century or earlier, and that most things so described are actually chased.

Many chalices and patens, which conform approximately to the type which is here being made, will be found illustrated in Braun (1932). Figure 13a is a sectional drawing representing our concept of the actual construction, which differs materially from earlier interpretations. We believe that the square projection, referred to in the second sentence of the chapter, is a boss left at the center of the silver for the bowl while the surrounding metal is thinned out by hammering from the cast disk. This projection, after being slit into four, is inserted into the matching holes in the top of the foot and in the reinforcing ring, and it acts as a rivet when it is spread open and clinched by the punch inside. The parts are given their final polish before assembly and no solder is used.

above, and take from one of the parts a weight of six pennyweight. Add this to the other part from which you are going to make the foot. Later you will remove this by filing and restore it to its own part. Cast it and hammer out the foot as you did the bowl until it is thin, except that you do not make a projection on it. When it is thin, give it depth with a round hammer inside and out. Now start to

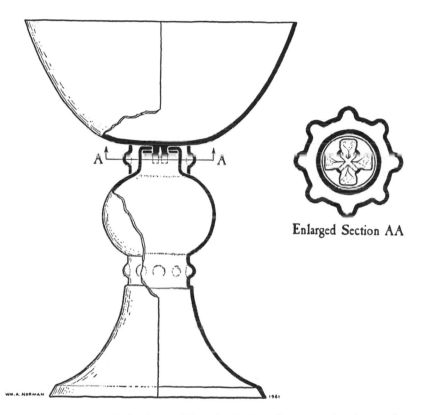

Enlarged Section AA

Fig. 13a.—Theophilus' method of assembling the chalice. Reconstruction by translators

shape the knop using a medium-size hammer on a rounded stake, and then [continue] on the bick iron until you make the neck as slender as you want it. Be careful not to hammer more in one place than another, so that the knop does not incline to one side, but remains in the middle, equally thick and wide on all sides. Then put it on the fire [to anneal it]. Fill it with wax and, when it has cooled, hold the foot in your left hand and a thin punch in your right and

seat a boy next to you with a tiny hammer to strike the punch wher-
ever you put it, and in this way mark out a ring running around be-
tween the knop and the foot. When this has been marked out, pour
out the wax, anneal the foot, and fill it again [with wax], so that you
can hammer the ring more deeply in the same way as before. Con-
tinue doing this until you have equipped it evenly with its beads.
Then file and scrape the knop and all round the foot inside and out,
together with its rim. In the middle of the knop make a square hole
of the same size as the projection on the bowl above, and in the knop
place a round thick piece of silver with a similar hole.

Also, separately, make a ring which is to go between the knop and
the bowl, of the same size and appearance as the ring which you
shaped with the punch below the knop. Then take a burnisher, rub
it on a flat smooth hone and then on a piece of oakwood covered with
ground charcoal, and with it burnish the bowl itself inside and out,
the knop, the foot, and the ring. Then rub the work with a cloth and
finely scraped chalk until it is shining bright all over.

When all this is finished, with a thin file slit the projection of the
bowl into four, right to the center, and turn the bowl upside down
on a rounded stake so that it hangs evenly. Place the ring on it, then
insert the projection into the hole of the knop and [through] the
round piece of silver, which is in it on the top. Holding them firmly
and evenly with your left hand, with your right hand insert a punch
into the knop, and have it struck from above with a medium-size ham-
mer until you have fixed everything firmly.

Afterwards [to make the paten] cast all the silver you have filed
and scraped off together with any that is left over. Hammer out a
disk, maintained circular with the aid of compasses, having a diam-
eter slightly more than the height of the chalice from the foot at the
bottom to the rim at the top. Sink [the center portion of] this with a
hammer until it matches the diameter of the top of the bowl, so that
it can lie evenly upon it. And, if you wish, make two circles on the
inside with compasses; then in the center with a blunt tracer[2] draw
the likeness of the Lamb, or a right hand reaching down from

[2] *Subula.* This word means "awl" in
classical Latin, and it is so used in
III-62. It is a scriber in III-52. The-
ophilus generally uses it, as here, for
a tool with a blunt, chisel-shaped edge,
i.e., a tracer.

heaven, as it were, and making a sign, and letters between the two circles.[3] Engrave it finely with a graver and burnish it for use like the chalice.

Chapter 27. The Larger Chalice and Its Mold

But if you want to make a large silver chalice weighing four, six, or ten marks, first assay all the silver in the fire and refine it. Then divide it in the same way as above. After this take two pieces of iron, a span in both length and width, and as thick as a straw, hammered flat and smooth, sound, and carefully smoothed at the grindstone. Between these put an iron strip, moderately thick and hammered flat and smooth; bend this into the shape of a hoop, large enough in your judgment to hold the amount of silver that you want to cast. When you bend it, do not fit the ends together, but separate them a little so that a hole appears through which you can pour in [the metal]. Fit this hoop evenly between the two iron plates so that its ends project a little outside them, and squeeze them together in three places with three strong curved iron clamps, one at the bottom and one on each side of the hole. Now smear kneaded clay around the hoop between the pieces of iron and thickly around the hole. When the mold has dried, heat it and pour in the molten silver. Unless something happens through great carelessness, any gold and silver that is cast in this way is invariably sound for working whatever you want in it. You should proportion the hoops to the amount that you wish to cast in them, making larger ones and smaller ones.

When you have hammered out the cast silver as described above and given shape to the bowl, fill it with wax and hammer flat or rounded flutes [i.e., godroons] on the body, if you want them, which should radiate like [the fluting of] shells. Either type of work greatly enriches the chalice. If you wish to put niello on the flutes, see that the silver is thicker, and proceed in such a way that one rib is gilt and the next one black, alternately in pairs. When you have hammered

[3] Braun (1932, Fig. 14) has an illustration of a paten with a pointing hand design and inscription. This is, however, the symbol of the apostolic blessing, not Theophilus' hand of God.

them, file them smooth and scrape them. On those that you want to make black, draw Byzantine foliage[1] and engrave them with thick strokes. Engrave graceful circles and fine work in the backgrounds. Then compound niello in this way.

Chapter 28. Niello

Take pure silver[1] and divide it into two parts of equal weight and add to it a third part of pure copper. When you have put the three parts into a small casting crucible, weigh out lead to equal half the weight of the copper that you mixed with the silver. Take yellow sulphur and crush it small; put the lead and some of the sulphur into a small copper pot and put the rest of the sulphur into another casting crucible. When you have melted the silver with the copper, stir them both together with a piece of charcoal and immediately pour into them the lead and the sulphur from the small copper pot. Mix it all again vigorously with a piece of charcoal and hastily pour it into the other casting crucible over the sulphur which you have put therein. Quickly lay aside the crucible you have poured from and pick up the one you have poured into, and put it into the fire until [its contents] melt. Stir it again and cast it into an iron ingot mold. But before it is cold, hammer it a little, then heat it slightly and hammer it again, and so continue until it is completely thinned out. For the nature of niello is such that, if it is hammered when cold, it immediately breaks up and flies into pieces; on the other hand it should not be heated so much as to become red because it immediately melts and runs into the ashes. When the niello is thinned out, put it into a deep, thick pot, pour water over it, and crush it with a pestle until it is extremely fine. Then take it out and dry it. Put the fines in a goose quill and stop it up; put the coarser parts again into the pot and crush them and, when they are dry again, put them in another quill.

[1] Possibly the motif known as "Byzantine blossom." See Dodwell's note (p. xxvii) for a discussion of the significance of this in dating Theophilus.

[1] In III-70 Theophilus suggests that the material (silver sulphide) resulting from the separation of gold and silver by means of sulphur can advantageously be used in place of silver in making niello.

Chapter 29. Applying Niello

When you have filled several quills in this way, take the resin called borax[1] and grind a small piece of it with water in the same pot, so that the water is rendered just turbid from it. Wet the place you want to cover with niello with this water first; next, take the quill and with a light iron rod tap out the ground niello carefully over the place until you have covered it all, and do the same everywhere. Then heap together well-burning coals and put the bowl into them, covering it carefully in such a way that no coal is placed over the niello or can fall on it. When the niello has become liquid, hold the bowl with tongs and turn it everywhere where you see the niello flowing, and in so turning be careful that the niello does not fall to the ground. If it does not become full everywhere at the first heating, wet it again and put niello on as before, and take good care that more is not needed.

Chapter 30. Casting the Handles for the Chalice

If you want to put handles on the chalice, as soon as you have hammered and scraped it and before doing any other work on it, take some wax and shape handles out of it and carve on them snakes, animals, birds, or foliage in any way you wish.[1] On the top of each

[1] *Parabas* in *L, V,* and *H; barabas* in *G.* These are probably Latinizations of the Arabic word *baracha* meaning borax (Theobald, p. 302). Borax is not, of course, a gum or resin, but if fused it does have a glassy, resinous appearance. Gum arabic, which has been suggested by other translators, would not serve as a flux, but would carbonize and have an effect opposite from that intended. The melting point of borax is rather high for use with niello, and today sal ammoniac is commonly used. Theophilus' niello would contain about 56 per cent silver sulphide, 30 per cent copper sulphide, and 14 per cent lead sulphide. It is far from the composition of the eutectic (25 per cent Ag_2S, 35 per cent Cu_2S, 40 per cent PbS, which melts at 440° C.) and actually has a melting range from 440° to 560° C. For the general history of this noble technique for decorating the precious metals see Rosenberg (1908); for its technique, Maryon (1954); and for a technical study of it, Moss (1955).

[1] This and III-61, on the cast censer, together constitute the earliest detailed description of the extremely old and still important method of *cire perdue* casting. It is very versatile, since the pattern does not have to be with-

handle put a small piece of wax, rounded like a slender taper of the length of your little finger, but slightly thicker at the top. This wax is called the gate and you should "solder" it on with a hot iron. Then take some vigorously kneaded clay and carefully cover each handle separately, so that all the holes of the carving are filled. When the handles are dry, carefully cover them again all over except for the top of the gate; and do the same a third time.

Afterwards put these molds near the coals and, when they are heated, pour out the wax. After it has been poured out, put the molds right into[2] the fire, turning downwards the holes through which the wax came out, and leave them until they are red-hot like the coals. Immediately melt the silver and add to it a little Spanish brass, for example, a weight of two pennyweight if there is half a mark of silver, and in proportion if there is more or less.[3] Take the molds away from the fire, stand them up firmly, and pour in [the silver] in the same place from which you poured out the wax.

When they are cold, take away the clay and with a file and gravers fit the handles to the bowl in their proper places. For the underlying joints make two slots [within the thickness of the handles], one above and another below, which should not be visible outside. You will [later] individually fit into these slots two broad pins, which you should make go through each side of the bowl through two slots, one above and one below.[4] Fasten the pins on the inside [of the bowl] and solder them in this way.

drawn from the mold, but is melted and burned out, leaving a cavity that can be of virtually any connected shape into which the molten metal can run. The disadvantage that only a single casting can be obtained from each pattern is offset by the fact that the artist can work directly on the wax, knowing that the resultant shape and surface texture will be well reproduced in the metal. It does not at all follow that every complicated casting was made by the *cire perdue* process: the elaborate

Chinese ceremonial bronzes of the Shang and Chou dynasties owe the main features of their design to the fact that they were made using piece molds (Barnard, 1961).

[2] Reading *in,* following *H.*

[3] This corresponds to an addition of about 1.0 per cent copper and 0.5 per cent zinc, both of which would improve the casting qualities of the metal.

[4] This construction is clearly shown in Figure 13*b*, reproduced from Theobald (1933).

Chapter 31. Soldering Silver

Weigh out two parts of pure silver and a third part of red copper; melt them together and file them fine into a clean pot and put the filings into a quill. Then take argol (the substance that accumulates on the insides of jars in which the best wine has lain for a long time) and wrap pieces of it in a cloth and put it into the fire to burn until

Fig. 13*b*.—The method of attaching the handle to the chalice. Reconstruction by Theobald (1933). (V.D.I. Verlag.)

smoke no longer comes from it. Take it away from the fire and let it cool. Blow away the ashes of the cloth and grind the stuff, now that it is burnt, in a copper pot with a pestle, mixing in water and salt so that it becomes as thick as lees. With a wooden lath, spread it around the pins on the inside and the outside [of the bowl] and with a short iron rod shake the silver filings onto it and so let it dry. Spread the mixture on again more thickly than before and put [the bowl] into the fire and carefully cover it by adding coals and blow gently with long blasts [of the bellows] until the solder is sufficiently melted and then remove the bowl from the fire. When it is fairly cold, wash it and, if the pins are firm, good; but if not, treat them

again as before. When they are firm, file them down on the inside
and scrape them smooth so that no one can detect where they have
been placed. Put the handles against the outside, and again carefully
fit them in place. Then through the middle of the handles opposite
the pins make tiny [transverse] holes and do likewise in the same
place on the other side of the pins. In these holes you will fix [small
golden pins] when the whole work is completed [III-42] in such a
way that no one can see how the handles are held on. After this dili-
gently carve and engrave these handles with files and iron tools and,
if you want to put niello on any part of them, do it in this way.

Chapter 32. More about Applying Niello[1]

When you have mixed and melted the niello, take a piece of it and
hammer it into a thin, rectangular rod. Then pick up a handle with
tongs and heat it in the fire until it becomes red, and with the other
long slender pair of tongs hold the niello and rub it over all the
places you want to niello until every engraved line [of the design] is
full. Take the work away from the fire and level it off carefully with
a flat smooth file until the silver shows just so much that you can
barely see the engraving. Then with a scraping tool, carefully scrape
off the file marks.[2] Gild the remainder [i.e., what is not covered by
niello]. Make the gilding in this way.

Chapter 33. Cementing Gold

Take any kind of gold and hammer it until it becomes a thin flat
sheet, three fingers wide and as long as you can make it. Then cut
pieces as long as they are wide and lay them together exactly and
make a hole through them all with a thin scraper. After this, take
two fire-tested earthenware dishes[1] of such a size that the gold can lie

[1] This is an alternative method to
that described in III-29, in which pow-
dered niello is used.

[2] Reading *limae* with Dodwell, but
omitting the comma.

[1] See III-65, n. 1.

in them; then break into tiny pieces a tile or a piece of burnt and reddened furnace-clay and when it is powdered, divide it into two equal parts by weight and add to it a third part of salt of the same weight. It should then be lightly sprinkled with urine and mixed so that it does not stick together but is just moistened. Put a little of it into one of the dishes [to cover] approximately the area of the gold, then a piece of the gold, then the composition again, and gold a second time. Gold should always be covered with the composition so that it is not touched by other gold. In this way fill the dish up to the top and cover it with the second dish. Lute the dishes carefully all around with mixed and kneaded clay and put them at the fire to dry.

Meanwhile build a furnace of stones and clay, two feet high and one and a half feet wide, broad at the bottom but narrowing at the top. Here there should be a hole in the middle. Inside the furnace there will project three rather long and hard stones which can endure flame for a long time. On these stones place the dishes with the gold and cover them freely with other dishes. Then put fire and wood below and see that a plentiful fire is not lacking for the space of a day and a night. In the morning, however, take out the gold, melt it again, hammer it, and put it into the furnace as before. After another day and night take it out again, mix a little red copper with it, melt as before, and put it back in the furnace. And when you have taken it out for the third time, wash it carefully and dry it. Weigh it, when dried, and see how much has been lost, then fold it up and keep it.

Chapter 34. More on the Above

But if there is only a little gold that you want to cement, hammer it out and lay it in the dishes in the same way as above. After this, take a new pot and break a hole through the bottom and four holes around the side. Then make a low clay tripod with its feet spread apart so that they straddle the hole in the bottom of the pot. When it is dry, put the dishes with the gold on top of it and raise the pot up on three stones of equal size, a little separated from each other. Put blazing coals into the pot, then dead ones and, as they subside, put

fresh ones on top and never allow the dishes to be uncovered by the fire. Occasionally stir the coals with a thin stick inserted through the holes [in the sides] and also from below, so that the ashes may fall out and the draft may find entry. Then do the same using the coals in the pot as you did above with the wood in the furnace.

Chapter 35. Milling Gold [Amalgam]

If you want to mill [amalgam], after the gold is fully cemented, put eight pennyweight of it into a dish[1] and weigh out eight times as much mercury. Immediately add the gold to this and rub it until it becomes white; then break it up into little pieces. Also take one of the small crucibles in which gold or silver is melted, but which for this work ought to be thicker than those, and put it into the fire until it becomes red-hot. Also put into the fire a thin, bent iron rod fitted into a handle at one end and with a round knob on the other. When they are both red-hot, hold the crucible with tongs over a dry wide platter and pour the mercury with the gold into it. Quickly rub it and muddle it with the red-hot bent tool until you feel nothing but liquid in the crucible and at once pour it into water. Now, when the water has been removed, put the gold into your left hand and wash it carefully, testing with your finger to see if it is well milled and, if it is, put it upon a clean linen cloth and toss it to and fro until the water is dried off.

Chapter 36. Another Method for the Same

But if the nature of the gold is such that you cannot mill it in this way, take a flat smooth square piece of sandstone and make a hollow in the middle of it, three fingers wide and the same depth.[1] Then equip yourself with a stone, harder than the one above, but so slender that it can be rotated in the hollow, and so long that it can be

[1] *Testam,* following *H.*

[1] Figure 14 shows this mill, as reconstructed by Theobald. See Figure 1 for a more elaborate design of mill for making gold powder, without mercury, for use as an ink or paint.

fitted and firmly fixed into a piece of wood, which should be three cubits long and whose lower end, into which the stone is to be set, should be as thick as a shinbone. Half a foot above this stone make a hole through the piece of wood and join to it a second thin piece of wood, two palms wide, which should have a projection to go

Fig 14.—The mill for making gold amalgam. Reconstruction by Theobald (1933). (V.D.I. Verlag.) Compare this with Figure 1.

through the hole in the long piece of wood. On this thin piece of wood should be tied a stone, a foot in size and above this the [long piece of] wood should become narrower, cut round and smooth, so that it can be turned between the hands.

When you have constructed all this in this way, put the larger [mortar] stone in a basin or a smooth wooden vessel and see that the

stone lies firmly and the vessel is firmly set. When you have put the gold with the mercury into its hollow and sand and water on top, insert the smaller stone which is set into the wooden [shaft]. Then, holding the shaft at its upper part, turn it a little between your hands and soon, by the impetus of the stone tied on below, it will be made to rotate. Mill for three or four hours by rotating it in this way. Inspect it now and then and test it with your finger and again put in sand and water. Whenever as a result of this turning back and forth the sand begins to foam up and be scattered over the stone, always collect it again with a long, slender, flat, thin stick and put it back in the hollow for fear that accidentally some gold may be carried out with the sand and not be milled. When it has been fully milled, it should be taken out, washed and dried as above, and put on the balance. Now if any gold is missing, the dregs which flow off the stone should be washed and so it will be found. It is for this reason that the stone is set in a vessel. By this method also pure silver, very thinly hammered and mixed with mercury, should be milled, because it cannot be milled in a hot crucible with the hot iron tool. However, it should be so mixed that there are five parts by weight of mercury and the sixth is pure silver.

Chapter 37. More on the Above

You can also mill gold more easily in this way. Take a large fire-tested earthenware dish and put it into the coals until it is completely red-hot. Put in it the gold, mixed with mercury and broken up into very small pieces. Holding the pot with tongs, swing your hand evenly back and forth and soon you will see how the gold melts and mixes with the mercury. As soon as it is completely liquid, pour it into water and wash and dry it as above. (Be very careful that you do not mill or apply gilding when you are hungry, because the fumes of mercury are very dangerous to an empty stomach and give rise to various sicknesses against which you must use zedoary and bayberry, pepper and garlic and wine.)

After this weigh the gilding material in a balance and divide it in

two, again divide each half in two [and keep on so dividing] until you reach single pennyweights [*denarii*]; put these individually into goose quills in order that you may know how much you are to put on each place that is to be gilt. Then hammer a piece of red copper into a shape like an engraving tool and fit it into a handle; file and scrape its end until it is rounded and quite thin. Rub the end with mercury until it becomes white and then you can gild with it. After this, make a composition for amalgamating and gilding the work in this way.

Chapter 38. Amalgamating and Gilding the Handles

Take some argol, about which we spoke above [III-31], and grind it carefully on a dry stone and add to it a third part of salt and put it in a large earthenware dish; pour over it that water into which you put the newly milled gold and add a little mercury. Put it on the coals until it becomes hot and stir it with a stick. You should also have [brushes of] hog-bristles, three or four fingers thick, bound in the middle with iron: two clean ones with which to wash the gold and silver, and two for gilding, one dry and the other wet. When all this has been prepared in this way, take the silver handles in your hands and dip a small, folded linen cloth into the hot composition and with it rub all the places on the handles that you want to gild. When they begin to amalgamate, heat them over the coals and rub them vigorously with a brush that has been wet in the same mixture. Continue, now heating and now rubbing, until all the engravings become white from the mercury. In those places that you cannot reach with the bristles, rub with the copper gilding tool and a thin stick. Do this over a wooden gilding platter, which for small work should be turned on a lathe and capacious, while for large work it should be square, hollow, and smooth.

Then with a small knife cut the gilding material into tiny pieces over this platter and lay it carefully on every place with the copper gilding tool, and spread it evenly with the wet bristles. Pick up [the handle] with long thin tongs, the jaws of which are wrapped in two small pieces of cloth, and put it on the coals until it is hot, and again

spread [the material] with the bristles and keep on doing so until the gold adheres all over. Cut up gold a second time and lay it on with the copper tool and do as before with fire and bristles. Do the same again a third time. When, on the third round, the gold begins to dry, rub it carefully all over with the dry bristles and heat it again and rub it again until it begins to turn pale. If it happens through carelessness that a blemish appears on the silver where the gold is thin and unevenly applied, lay on [more amalgam] with the copper tool and spread it evenly with the dry bristles until it is even all over. When you see this, put it into water and wash it with the clean bristles. Put it on the coals again and heat it until it becomes completely yellow.

Chapter 39. Polishing the Gilding

Take thin brass wires and bend them over so that the distance between the bends is the length of your little finger. When they are quadruple tie them together with a linen thread so that they are like a bundle. Make four, five, or six of these bundles in such a way that one has three bends, another four, a third five, and so on up to eight. When all these have been tied individually, make a small hollow in a piece of wood and put one of these parcels in it and pour in lead, so that when it is cold and you take it out, the bends are stuck together, fixed in a sort of knob of lead. In this way make separate lead knobs on each bundle. Then cut all the bends at the other end and file and scrape the tips so that they become round and smooth. Polish the gilded handles by, so to speak, scratching[1] with these in fresh water in a clean pot. When you have polished them by scratch-brushing with the end of the bundle put them on coals until they are hot and turn a reddish-yellow color and lose the brightness they had acquired by polishing. Then quench them in water and polish them again by scratch-brushing carefully, until they take on a most brilliant lustre. Then color them with the following composition.

[1] Reading *scalpendo* throughout, following *V* and *G*.

Chapter 40. Coloring the Gold

Take green vitriol[1] and put it in a clean fire-tested earthenware dish and set it on the coals until it completely liquefies and begins to turn hard. Then take it out of the dish and put it beneath the coals and cover it carefully and blow with the bellows until it is burnt and turns a reddish color. Remove it from the fire at once and when it is cold grind it on a flat wooden platter with an iron hammer, adding to it a third part of salt. Then temper it with wine or urine and grind it vigorously again until it is as thick as lees. Cover the gilding with this composition with a feather so that no gold remains visible and put it on the coals until it is dried out and a little smoke comes from every part of it. Immediately remove it from the fire, put it in water and wash it carefully with clean hog-bristles. Dry it on the coals again and wrap it in a clean cloth until it is cold.

Chapter 41. Polishing the Niello

Hold the work in the same cloth and with a scraping tool carefully scrape all the places which have been blackened with niello. After this you should have a soft black stone of the kind that can be easily cut and almost scratched with the fingernail. Wet the niello with saliva and rub it all over with the stone, carefully and evenly, until all the engravings are clearly visible and it is completely smooth. You should also have a piece of wood from a linden tree, as thick and as long as the middle finger, dry and cut smooth. On this put the moist powder that comes from the stone and the saliva in the course of rubbing and lightly rub the niello for a very long time with this wood and powder. Continuously add saliva so that it stays moist until it shines brightly all over. Then take some wax from your ear-hole and after wiping the niello smear the wax all over it with a fine linen cloth and gently rub it with a goatskin or a buckskin until it is entirely bright.

[1] *Atramentum.* See I-1, n. 3.

Chapter 42. Ornamenting the Bowl of the Chalice

When the handles have been fully finished in this way, take the bowl of the chalice, half of whose flutes you have already covered with niello, and file smooth and scrape the intervening flutes which you left free from niello. Draw whatever kind of design you want on them, though it should contrast a little with the niello work, and engrave it finely with a slender graver. After this, gild the flutes and also the entire bowl, inside and out, except for the niello, and polish and color it all as you did the handles. Then cover a round stake with smooth parchment and bind it on. Place the bowl over this and have a boy, sitting opposite you, hold it with both hands and align each flute evenly on the stake as you order him. Meanwhile take the slender punch which has a hole in the tip, so that when it is hammered it makes a very fine circle.[1] Fill all the grounds on the gilded flutes with punched ground work by striking the punch gently with a hammer, and fitting each circle successively to the next. When all the grounds are filled, put the bowl on the coals until the punch marks take on a reddish-yellow color on the inside.

File and polish the niello as [that on the handles] above.

Then fit the handles, each in its proper place, and secure them with gold pins through the holes which are in them by striking with a hammer on a slender punch with another tool placed underneath until they hold fast. Scrape these punchmarks carefully and polish them with a burnisher, so that no one can see how the handles are held on.

Chapter 43. The Foot of the Chalice

After this take the fourth part of the silver [which was divided in III-24] and add to it the filings and scrapings from the bowl. Cast it in the same way as above, and out of it make the foot with the knop, just as you made the foot of the smaller chalice, except that in this larger one you should shape flutes rising from the broad base of the foot up to the knop. Cover half of the flutes with niello and engrave

[1] A ring punch. See III-13. Its use in making punched ground work is de- scribed in detail in III-73.

and gild the other flutes and decorate them in every way as on the bowl. When this has been done, you should also gild and fit the ring that is to lie between the bowl and the knop, and fix everything together as in the case of the smaller chalice.

Chapter 44. The Paten

Then cast whatever silver is left and make the paten out of it. When you have thinned it out, make a circle in the center matching the diameter of the chalice. Within this circle measure eight equal segments and on each segment make a semicircle so that there are, as it were, eight arches. Hammer them with a round hammer until they become hollow and by repoussé work from underneath hammer out the angles between the arches, and around them a border as wide as your little fingernail, which should stand up above the level of the whole paten. Engrave it finely and apply niello; then gild the rest of the paten and polish both parts as above.

Chapter 45. The Fistula

You should also make the fistula for the chalice in this way. Make yourself a tapering iron tool a span and four fingers long, extremely thin at one end and from there growing thicker and thicker up to the other end, which should be like a straw. The tool should be round and evenly filed. Thin out some pure silver and wrap it around this tool, fitting the edges together evenly with a file; then take out the tool and put the silver into the fire and solder it. Replace the tool and strike evenly with a hammer all over until the join is no longer visible. Then separately make a round hollow knop, or a square solid one; make a hole in it through which the lower end of the fistula should be inserted almost to the top. Take out the tool again and solder it all over. When it is secure, replace the tool, and hammer on all sides down from the knop until it becomes even and stiff, and then from the knop upwards. In that part where it is wider and thicker, insert a flat thin piece of iron, whose width is equal to that

of the fistula, and hammer it on a stake with a small hammer, so that the opening at the top is rectangular, and flat and thin. This should extend from the knop up above the chalice and is to be held in the mouth, while below it should be round and slender. When this is done, you may, if you wish, variegate the knop with niello and gild the rest of the fistula in the same way as above.

Be extremely careful to scrape vigorously all thick silver that you want to gild, whether on a chalice or goblet, or on a platter or cruet, because, in the course of hammering, it forms a skin out of itself by the agency of the fire and the hammer.[1] If this skin is not scraped off, when the silver is gilded and repeatedly colored over the fire for a long time, tiny blisters will be raised up here and there, and the silver will show through when they break, and disgrace the work, which cannot be restored unless the gilding is completely scraped off and you gild again.

Chapter 46. Gold from the Land of Havilah

There are many kinds of gold, of which the most outstanding is engendered in the land of Havilah, which, according to Genesis, is surrounded by the river Phison.[1] When men skilled in this art find veins of it underground, they dig it out and, when it has been purified in fire and assayed in a furnace, they adapt it to their own uses.

[1] This skin results from the annealing process, which Theophilus does not mention, but which would be essential to soften the metal at intervals during extensive hammering. It would cause oxidation of some of the copper *in situ,* the silver remaining metallic. The formation of blisters on subsequent heating is partly a result of the mechanical weakness of this layer, and partly due to the reduction of the oxide in the reducing atmosphere of the fire with resultant formation of gas.

[1] *Phison* (incorrectly *Gyon,* in *V* and *G*) is one of the rivers running out of the Garden of Eden. The Authorized Version (Gen. 2:10–13) reads: ". . . And a river went out of Eden to water the garden; and from thence it was parted, and became into four heads. (11) The name of the first is Pison: that is it which compasseth the whole land of Havilah, where there is gold; (12) And the gold of that land is good: there is bdellium and the onyx stone. (13) And the name of the second river is Gihon: the same is it that compasseth the whole land of Ethiopia."

The Vulgate says that the gold of Phison is engendered (*nascitur,* as in Theophilus) and that it is the best (*optimum*): the Authorized Version does not quite reflect this. The naming of these rivers provides evidence for the location of the Garden of Eden, a subject beyond our scope.

Chapter 47. Arabian Gold

There is also Arabian gold, which is very precious and of an exceptional red color. The use of it is often found in very ancient vessels. Modern workmen counterfeit its appearance when they add a fifth part of red copper to pale gold and they deceive many unwary people. But this can be guarded against by putting it in the fire: if the gold is pure, it does not lose its lustre, but if it is an alloy, it completely changes color.

Chapter 48. Spanish Gold

There is also a gold named Spanish gold, which is compounded from red copper, basilisk powder, human blood, and vinegar. The heathens, whose skill in this art is commendable, create basilisks for themselves in this way.[1] They have a dungeon walled with stones on the top and the bottom and on all sides, with two tiny windows so small that scarcely anything[2] can be seen through them. Into this they put two cocks, twelve or fifteen years old, and give them plenty of food. When they have been fattened, as a result of the heat of their fatness they copulate and lay eggs. After the eggs are laid, the cocks are removed and toads are put in to hatch the eggs and bread is given to them for food. When the eggs are hatched, male chickens emerge

[1] This chapter, so untypical of Theophilus, has attracted far more attention than it merits. Both Thorndike (1923–58, I, 717), and Stillman (1924, pp. 228–29), select it for full translation and comment! Theophilus would not, of course, have had first-hand contact with mining operations. All of the chapters on gold (III-46 to 49) have a hearsay quality that distinguishes them from his other chapters. He does not mention the mining of silver and has only a cursory report on the mining of copper. Metals to Theophilus were merely raw materials that were obtained by gift or trade. Nevertheless, the description of washing and amalgamating gold sand in III-49 is at least brief and factual and it is astounding that as practical a man as Theophilus should include the present fantastic chapter. It is probably a garbled account of the making of brass that had originally been written in the symbolic and lurid language of alchemy. Alternatively it may be a similarly garbled account of a cementation process for producing a surface layer of pure gold on auriferous copper by superficially oxidizing the base metal and removing it by pickling. Repeated operations would eventually leave a residue entirely of pure gold.

[2] Omitting *luminis*, as *G.*

just like chickens born of hens, and after seven days serpent tails grow on them. They would immediately burrow into the earth if the floor of the dungeon were not of stone. Guarding against this, their masters have round, brazen vessels of great size, perforated all over and with narrow mouths. They put the chickens into these, then they close up the mouth with copper lids and bury them in the ground. The chickens are nourished for six months by the fine soil that falls through the holes. After this their masters uncover the vessels and set a large fire under them until the beasts inside are completely burned. After doing this, when it has cooled, they take out the ashes and carefully grind them, adding to them a third part of the dried and ground blood of a red-headed man. When these two have been compounded, they are tempered with sharp vinegar in a clean pot. Then they take very thin flat plates of the purest red copper and smear this composition on both sides of them and put them in the fire. When they are red-hot they take them out and quench them in the same composition and wash them. They keep on doing this until the composition eats through the copper, which thereby acquires the weight and color of gold. This gold is suitable for all kinds of work.

Chapter 49. Sand Gold

There is another gold, named sand gold, which is found in the banks of the Rhine in this way. The sands are dug up in those places where there is hope of finding gold and are put on wooden boards. Then water is repeatedly and carefully poured over them and as the sands flow off, a very fine gold remains, which is collected separately in a small pot. When the pot is half full, mercury is put in and rubbed vigorously by hand, until it is completely alloyed. Then [the amalgam] is put into a fine cloth, the mercury is wrung out and the residue put into a casting crucible and melted.

Chapter 50. Making the Gold Chalice

Then whatever kind of gold you have, if you want to construct a chalice out of it and to ornament it with stones and enamels and

pearls, begin in this way. First test each piece of gold to see if it can be beaten with a hammer without cracking. Lay on one side whatever is not cracked, and on the other whatever is cracked, in order that it may be refined. Then take a piece of burnt brick and cut a little groove in it big enough to hold the amount of gold that is to be refined. If you do not have brick, make a little groove with an iron tool in a square piece of sandstone and put it in the coals and blow. When it is red-hot, put the gold on it, throw charcoal on top, and blow for a very long time. Take it out and beat it with a hammer. If it does not break, that is enough; but if it does break, put it back again on another stone and keep on doing this until it will not break when it is hammered. If it cracks slightly, melt it with sulphur and in this way it will be restored.

When this is done, melt all the gold together and reduce it to a single mass; then divide it on the balance in the way that you divided the silver above, and in the same way hammer it into the shape you want and also shape the handles according to your fancy. If you want to add work done with gems, hammer out two pieces of gold so flat and thin that the mark of your fingernail can be easily impressed thereon, and cut them to the shape that you want your handles to have. Each of these two pieces belongs to one handle.[1] Then compound the solder in this way.

Chapter 51. The Solder for Gold[1]

Take some beechwood ashes and make a lye out of them. Strain it again through the same ashes so that it becomes thick. Put it again into a small pan and boil it down to a third; then put some soap in and a little fat from an old pig. When it is cold and has settled, strain

[1] These two pieces are mirror images of each other and will be joined at their edges to form a hollow handle.

[1] This process of soldering without using a low-melting-point alloy as a solder is likely to surprise a modern technologist, but it is actually a well-based process of respectable antiquity. Something like it was used to make the Minoan and Etruscan granulation work which stands at the very apex of the goldsmith's art (see Maryon, 1949). Theophilus describes a somewhat complicated way of obtaining a finely divided copper oxide. The oxide is then mixed into a soft paste with an alkaline soap and painted on the parts to be joined. Under the reducing action of

it carefully through a cloth and put it into a copper vessel, which should be solid all over except for a small hole which should project on top and be round so that it can be stopped with the finger. After this take a flat thin piece of copper, wet it in water, and rub salt on both sides of it. Then put it in the fire and when it is red-hot quench it in fresh water in a clean basin, in which whatever is burnt off the copper should be kept. Again rub salt on the copper and do as before and keep on doing so until there is enough. Then pour off the water and dry out the powder in a copper pot and grind it in the same pot with an iron hammer, until it is very fine. Put it on the coals and again burn it and grind as before. Add soap and mix carefully; then put it on live coals, burn it together, and grind again. After this, pour the lye out of the former vessel into the one which contains the powder, mix it and let it boil for a long time. When it is cold, pour it together[2] with the powder back to where it was before, and also put in four small pieces of copper with which the powder should everywhere be mixed whenever you want to stir it. Gold and silver are soldered with this composition; but in soldering gold the powder should be stirred, as was said above, whereas in soldering silver it should not be stirred.[3]

Chapter 52. Applying the Solder to Gold

When all this has been compounded in this way, take the two pieces of gold from which you shaped a handle, place them before you, and lay on them the gems you wish to set and the pearls, each in its proper place.

the fire, the soap and the flour paste that is used as a temporary hold, the oxide powder is converted to metallic copper, and since this is in close contact with the underlying gold or silver surfaces, it immediately forms a low-melting-point alloy which is drawn by capillarity even more closely between the surfaces to be joined. The process is delightfully described by Cellini (1568) in his *Tratate*. He recommends using finely ground verdigris mixed to the consistency of a paint with a little sal ammoniac and borax, and heating the surfaces to which it has been applied under a carefully constructed arch of glowing charcoal until the outer skin of gold begins to glow and then to move. Cellini says that this is hardly to be regarded as soldering but rather as firing into one piece. The method was rediscovered and even awarded an English patent in 1933!

[2] Omitting *fortiter* with *V* and *G*.

[3] No technical reason can be seen for this distinction between gold and silver.

Then hammer out a thin long rod of gold and from it draw thick, medium, and thin wires and file them with the tool mentioned above [III-10], so that beads are shaped upon them. When the wires have been annealed, replace and fasten the gems individually. Then with tweezers fit a piece of the thicker wire around the rim of the handle on the outer surface of each of the two pieces [of gold] and with shears make very narrow slits all around, by which you should secure the wires before they are soldered, so that they do not fall off.

Then take a flat thin piece of gold, beaten even with a wooden mallet, and lay on it side by side a number of medium-size [beaded] wires in such a way that they do not touch each other, but have spaces between them. At their ends there should be narrow slits in the flat thin gold, by which they may be fastened. Pick up the vessel which contains the solder and shake it vigorously to mix the powder and smear the solder carefully with a slender feather all over the gold and the wires. Put the work in the fire and blow with mouth and bellows until you see the solder running around everywhere as if water was being poured over it. Immediately sprinkle a little water over it, take it off and wash it carefully, and again smear solder over it and solder as before until all the wires stand firm.[1]

After this cut [the sheet of gold with the wires soldered to it] into cordlike strips in such a way that each strip has one wire. Immediately bend them and make settings out of them to enclose the stones, smaller and larger according to the size of each stone, and arrange them in their place. You should also have some fine flour of wheat or winter wheat, which you should mix with water in a small vessel and put on the fire to heat a little. Into this dip lightly the underside of each of the settings and so fix them firmly in place. When they are all fixed in place, set on the fire the piece of gold on which you fixed them until the wetness of the flour dries out, and they will immediately stick fast.

Also, pick up the fine [beaded] wires and hammer them lightly on an anvil so that they become somewhat flat and thin, but without the top and bottom of the beads losing their shape. Out of them bend large and small flowers with which you will fill all the grounds be-

[1] Hendrie begins his chapter 53 here, with the title, "De imponendis gemmis et margaritis."

tween the settings. When you have shaped these with the tweezers, dip them in the moistened flour and so set each one in its place. After doing this put them on the coals to dry out the flour and immediately smear solder over them and solder as above.

When [the decoration] has been soldered and firmly fixed on each of the two parts of one handle in this way, fit them together and put between them, running all around inside close to the rim, a reinforcement, namely, a flat thin piece of gold, which should be the width of a straw and everywhere even. When you have fitted this piece between the two parts, bend three flat thin pieces of iron and make clamps out of them to hold the outer pieces of gold in three places outside, so that the third piece which goes around inside the edges cannot be displaced. After doing this, smear solder all over and dry it lightly over the fire. Then arrange pieces of charcoal and light them, making a little trench between them into which you should put the handle. Stack the charcoal around it so that it does not touch the gold but rises around like a wall until it projects above the gold. Lay on top two or three thin iron rods which should reach through, and on them lay charcoal everywhere. Cover them carefully but in such a way that some spaces remain between the charcoal through which you may be able to observe the way in which the solder is flowing around. As soon as you see this happen, sprinkle on a little water, take the handle out, wash it gently, and dry it. Look it over carefully to see if anything has to be corrected, and if so, correct it. Then smear [the solder] on again and solder as before; keep on doing so until it is secure everywhere. In this way shape and solder the matching handle.

When this is completed, fit both handles to the bowl of the chalice in their places and with the scriber draw two lines round them on the bowl itself, by means of which you can observe how well they stay in position during the soldering. Then melt a little gold and mix with it a third part of pure red copper. When this has been melted together and hammered out a little, file it all up and put the filings in a goose quill. After this pile up a large heap of charcoal on the forge and put the bowl of the chalice into it in such a way that half of the bowl is completely buried in charcoal while the part on which a handle is to be put projects above. Immediately

fit the handle to it. Spread solder on that [part of the] bowl with the handle, inside and out, and sprinkle the gold filings that you had put in the quill round the joint where the handle is fitted to the bowl. Surround the handle with fire, heap charcoal all around as you did above, and lay iron rods on top and cover them with plenty of charcoal. In front, now, inside the hollow of the bowl, build up some pieces of charcoal in the shape of a small furnace, so that the charcoal lies closely packed all around and a hole appears in the middle, through which you can blow so that the heat underneath is equal to that on top. When you see the solder flowing and flooding as it were for the third time,[2] sprinkle it carefully with a little water, take it out, wash it and dry it, and again solder it in the same way and [keep on doing so] until it is very firmly fixed. Turn the bowl on the other side and fit and solder the matching handle in the same way.

Chapter 53. Setting the Gems and Pearls

After doing this, take a flat thin piece of gold and fit it to the upper rim of the bowl. Measure this piece so that it extends from one handle around to the other; its width should equal the size of the stones you want to set on it. Now, as you arrange the stones in their place, distribute them in such a way that first there stands a stone with four pearls placed at its corners,[1] then an enamel, next to it another stone with its pearls, then another enamel; arrange it all so that stones will always stand next to the handles. Build up the settings for the stones and the grounds and also the settings in which the enamels are to be placed, and solder as above. Do the same on [the strip for] the other side of the bowl. If you want to put gems and pearls in the middle of the body, do it in the same way. After

[2] The first soldering was of the setting, and the second of the parts of the handle.

[1] Reading *angulis,* following *H.* The general arrangement that Theophilus describes is much like that of the famous chalice at Rheims (see Plate VII).

Similar work was used by Roger in his book cover (see Plate VIII). The small cloisonné enamel plaques, so popular in twelfth-century gold work, were made as described later in this chapter and the next.

doing this fit [the settings and grounds] together and solder them like the handles.

After this in each of the settings in which enamels are to be put you should fit in place a single flat thin piece of gold. When they have been carefully fitted, take them out and with a measure and rule cut up into pieces a strip of somewhat thicker gold and bend them around the rim of each setting, twice, so that there is a narrow space running all around between the small strips.[2] This space is called the border of the enamel. Then using the same measure and rule cut strips of the thinnest possible gold; out of these bend and shape with tweezers whatever work you want to make in enamel, whether circles or scrollwork or little flowers or birds or animals or figures. Arrange the pieces delicately and carefully, each in its proper place, and secure them with moistened flour over the coals. When you have completed one plaque, solder it, taking the greatest care that the delicate work and the thin gold do not become separated or melt. Do this two or three times until each piece firmly adheres.

Chapter 54. Enamel

When you have built up and soldered all the [plaques for] the enamels in this way, take all the kinds of glass you have prepared for this work and breaking off a little from each piece put all the fragments at the same time on a single sheet of copper, each fragment, however, by itself. Then put it into the fire and build up coals around and above it. Then while you are blowing observe carefully whether the fragments melt evenly; if so, use them all; but if any fragment is more resistant, lay aside by itself the stock that it represents. Now take all the pieces of tested glass and put them one at a time in the fire and when each one becomes red-hot throw it into a copper pot containing water and it will immediately burst into tiny fragments. Quickly crush these fragments with a pestle

[2] *Corrigiunculas,* following *H.*

until they are fine. Wash them and put them in a clean shell and cover with a linen cloth. Prepare each color separately in this way.

After doing this, take one of the soldered gold plaques and stick it with wax in two places onto a flat smooth board. Take a goose quill, cut as finely as for writing, but with a longer and unsplit point, and with it draw up [some of] whichever glass color you want, which should be moist. With a long, slender, fine-pointed copper tool scrape the color delicately off the point of the quill and fill in whatever little flower you wish with as much as you want. Replace any of it that is left over in its own little pot and cover it. Do the same with each of the colors until one plaque is filled. Then take away the wax to which it was stuck, and put the plaque on a flat thin iron tray which should have a short handle. Cover this with another piece of iron, which should be concave like a small bowl and should be finely perforated all over with ⌊punched⌋ holes that are smooth and wide on the inside while on the outside they are narrower and jagged and serve to keep off any ashes that happen to fall on it. This cover should also have a small ring in the middle on top, by means of which it may be put on and lifted off.

After doing this, heap up big, long pieces of charcoal and burn them strongly. Make a place among them and smooth it with a wooden mallet so that the iron tray may be lifted into it with tongs by its handle. Cover it and carefully set it in position; then build up charcoal on all sides around and above it, take the bellows with both hands and blow from all sides until the coals blaze evenly. You should also have a whole wing of a goose or some other large bird, which should be fully spread and tied to a stick; fan [the coals] with this and blow vigorously on every side until you see between the coals that the holes in the cover are completely red-hot inside. Then cease blowing. After waiting about half an hour uncover it gradually until you have removed all the coals. Again wait until the holes of the cover grow black inside; then lift the tray out by its handle and, keeping it covered, put it in a corner behind the furnace until it is completely cold. Now open it and take out the enamel and wash it. Fill it again and melt as before. Continue in this way until everything is melted and it is evenly filled throughout. Build up the remaining pieces in the same way.

Chapter 55. Polishing the Enamel

After doing this take a piece of wax the length of half a thumb.
Fit the enamel in this so that on every side there is wax by which
to hold it. Rub the enamel carefully on a flat smooth piece of sand-
stone with water until the gold [cloisons] appear evenly everywhere.
Next, rub it for a very long time on a hard, smooth hone until it
acquires clarity. Moisten the same hone with saliva and rub on it a
potsherd of the kind that are found broken from ancient pots, until
the saliva becomes thick and reddish; then smear it on a flat smooth
lead plate and rub the enamel gently on it until the colors become
translucent and clear. Again rub the sherd on the hone with saliva
and smear it on a goatskin fastened to a flat smooth wooden board.
Polish the enamel on this until it is completely brilliant, so much
so that if half of it becomes wet while the other half remains dry,
no one can tell which is the dry part and which is the wet.

Chapter 56. The Foot of the Chalice, Its Paten, and Its Fistula

Then cast the gold from which you should shape the foot with its
knop [as you did those for the silver chalice (III-26). Then] in the
middle of the knop and round the rim of the foot arrange a border
with stones and enamels as above. Also, when you have shaped the
paten to the size and shape you want, make a border with the same
kind of work round its rim, in the same way. Also make a gold
fistula in the same way and manner as the silver one above. Also
ornament crosses, missal covers, and reliquaries with similar work
using stones, pearls, and enamels.

Chapter 57. The Strainer

You should also make a gold or silver strainer in this way. Hammer
out a small vessel shaped like a little basin with a diameter slightly
more than the palm of a hand. Put on it a handle a cubit long and

the width of a thumb, which should have at one end a cast lion's head very elegantly carved. The head will hold the little basin in its mouth. At the other end the handle will also have a similarly carved head in whose mouth there should hang a ring through which the finger may be inserted for carrying it. The rest of the handle between these two heads should be decorated in places with niello and elsewhere with engraving[1] and punched groundwork and it should be inscribed with letters of verses in the appropriate place. Now the round part of the little basin at the end should be pierced with tiny holes to cover a circle two fingers in diameter in the middle of the bottom. Through these holes should be strained the wine and water that are to be put in the chalice for the celebration of the sacrament of our Lord's blood.

Chapter 58. The Cruet

If you want to make a cruet for pouring the wine, hammer out some silver in the same way as the knop on the foot of the chalice is hammered, except that the body of the cruet should be shaped much wider and its neck should be narrowed on a bick iron with a horn hammer and a medium size iron one.[1] At intervals as the cruet begins to take shape it should be filled with wax and gently hammered with the medium-size hammer, so that the roundness of the body and the outline of the neck may be more elegantly and evenly fashioned. Then take out the wax, anneal the cruet on the coals once more, put wax in again, and hammer as before, until it is completely shaped. After doing this, if you want to put figures or animals or flowers on the cruet in repoussé work, first make a composition of pitch, wax, and [powdered] tile.

Chapter 59. The Composition Called Chaser's Pitch

Grind a piece of brick or tile very small and melt some pitch in an earthenware dish and add a little wax. When these are both melted,

[1] *Fos[s]ili*, following *G*. [1] *Ferreo*, following *H*.

mix in the powdered tile and stir it vigorously and pour it out into water. When it begins to grow cold, dip both your hands into the water and knead it for a long time until you can stretch the composition and draw it out like a skin. Immediately melt this composition and fill the cruet to the top.

When it is cold, draw whatever you wish on the body and the neck. Then take slender chasing tools and a tiny hammer and mark out what you have drawn by hammering gently all around. Then give the hammer to a boy sitting opposite you and, holding the cruet [firmly upon a pad] with your left hand, and in your right the appropriate chasing tool in its proper place, have the boy strike the top [of the tool] gently or hard, as you want, and push down the grounds so that they are depressed and the work pattern is raised. When you have once hammered all over, put the cruet by the fire and remove the composition. Then anneal the cruet, take it off the fire, fill it again, and hammer as before. Continue doing this until you have evenly depressed all the grounds and shaped all the work so that it looks as if it were cast. However be very careful that the silver of the cruet is thick enough so that, when you have shaped the work by hammering, you can chisel, engrave, and scrape it elegantly with engraving tools.

When this is finished, make a cast handle, if you wish, in the same way as you shaped the handles of the silver chalice, and in the front make a spout from which the wine may be poured. You should fix these on with the solder alloyed from silver and copper, as above [III-31]. Then ornament it with niello wherever you want and gild the remainder as above [III-38].

In the same way make silver and gold goblets and platters, pyxes for holding wafers, incense boxes, handles for knives, and figures on crosses and missal covers in gold or silver or else in copper.

Chapter 60. The Repoussé Censer

Now if you want to construct censers of gold, silver or copper in repoussé work, first refine the metal in the way described above and cast in iron ingot molds two, three, or four marks according to

the amount that you want for the upper part of the censer. Then thin it out into a disk in the same way as you did with the larger chalice [III-27], except that this work should be thicker and sunk more deeply inside to make it higher on the outside, the height being one and a half times the diameter. When you have drawn out its height, before narrowing the diameter, portray towers on it, namely, one on top with eight sides, in which there should be the same number of windows; beneath this tower there should be four square towers on each of which three little columns should be put and between these columns two elongated windows; between these over the middle column there should be a little round window. Beneath these [four towers], in the third tier, eight other towers should be shaped, namely, four round ones in line with the square ones above, in which small flowers, birds, animals, or windows should be made and between these round towers, four square ones, still wider, in which should be made half-figures of angels, as if sitting in them, with their wings. Beneath these, at the widest circumference of the vessel, there should be made four arches, slightly elongated at the top, in which the four evangelists should be represented either as angels or in the form of animals.[1] Between these arches extending over the very edge of the circumference there should be fixed four cast heads of lions or men, through which the chains are to pass. When all these have been drawn in this way, they should be beaten inside and out with chasing tools and hammers, until they are completely shaped, and then they should be filed and scraped and engraved with gravers. This is the upper part of the censer.

Then the lower part with its foot should be hammered out. On this you should make four [inverted] arches answering to those above, in which should be seated the four rivers of Paradise in human form with their urns, from which running water should appear to flow. Now at the corners where the circles [in top and bottom] are fitted together[2] you should fix the lions' heads or the men's faces about which we spoke above, in such a way that the

[1] The symbols were an angel for Matthew, a lion for Mark, an ox for Luke, and an eagle for John.

[2] The semicircular arches on the top half meet each other at the rim and match their counterparts in the bottom.

faces in which the chains are to be anchored are attached to the
lower part, while the manes or hair through which the chains are to
pass are on the upper part.

Now if the foot cannot be hammered out integrally with the lower
part, it should be made separately, of repoussé or cast work, and
should be attached with the solder alloyed from silver and copper,
about which we spoke above. The lily onto which the ring is to be
attached and into which the chains are to be fixed at the top should
be similarly made of repoussé or cast work. On it there should be
shaped flowers or small birds or animals of the same type as the
work below. If this censer is made of silver or copper, it can be
gilded in the way described above [III-38]. Now if anyone wants
to devote his labor to making a censer of more costly work, he may
execute in the following way a representation of the city which the
prophet saw upon the mount.[3]

Chapter 61. The Cast Censer

Take some clay, mixed with dung and well kneaded, and let it dry
in the sun. When it is dry, break it up small and carefully sift it.
After it has been sifted, mix it with water and knead it vigorously
and build up two lumps out of it of the size that you want the
censer to be, one for the lower part, the other for the upper part,
which will be higher. These lumps are called the cores. Then pierce
these cores with a piece of wood, which has been evenly cut along
the length of its four sides, and dry them in the sun. After this push
through them a piece of iron which is called the spindle, long and
moderately slender, but thicker at one end, hammered evenly on all
four sides and tapering gradually smaller to the other end. Onto
the thicker end of it fix another short bent piece of iron or wood
[as a crank] by which it can be turned. Then you should have two
small wooden posts fixed on the bench and separated from each other
by a distance corresponding to the length of the spindle. Each of
these posts should have on the front a chock, also of wood, a span
long and cut in steps. On the chocks lay another piece of wood,

[3] Rev. 21:10.

which is round, in such a way that it can be moved nearer or farther away so that the turner's hand may rest on it.[1]

After constructing this, put the spindle holding the cores between the two posts and have an assistant, who is to turn the spindle, seated facing you on your left hand. Then, with sharp and rather wide tools turn the cores to evenness on every side and so shape them that they match each other with equal width and thickness at the middle. Now cut away the lower core from the halfway point down to the bottom, so that the upper diameter is twice that of the lower, on which you will also shape the foot. Cut the upper core in the same proportion, although its height will be great enough for it to be cut three times, into the shape of a wooden belfry, with each successive tier progressively narrower.

When it has been turned in this way, take out the spindle, and, on the broadest band of the upper core, cut out four segments with a knife up to the next tier, so that the band takes the shape of a cross. The three sides of each arm of the cross should be equally wide but the height should be one and a half times the width and on it you should also shape gables like roofs. Now, in the next tower [i.e., tier] you should make eight sides, four broad and four narrow, making the latter also rounded, so that the corners of the broad sides project, while those of the narrow sides are dug out, so that thus[2] a roundness emerges. Shape roofs on these also proportionate to their size. Now shape the penultimate tower in the same way, but [oriented] so that the round sides are shaped over the broad sides of the tower below and the round sides of the tower below fit beneath broad sides of the [two] towers above. Then the topmost tower should be shaped with eight equally broad sides and with no roofs. This will be the upper part of the censer.

Next shape the wider band of the lower part [of the censer] with segments cut similarly into the form of a cross, so that it matches the upper part. The lower band should be finished into roundness.

[1] This core-lathe is identical with the pewterer's lathe illustrated in III-88 except for being turned by a crank instead of by a strap.

[2] Reading *sic*, following most manuscripts, for Dodwell's *sicut*. The successive tiers of the tower must have been shaped somewhat as in Figure 15. The famous censer at Trier (Plates IX and X) is similar in spirit but not in architectural detail. Compare also Plate XI. For a somewhat different interpretation of the shape of the censer see Thompson (1967).

After matching the cores in this way, take two pieces of wood a foot long and a finger wide, and thin them down to the thickness that you want the wax to have. Take another piece of wood of the same length, round and as thick as the shaft of a lance, and have a board a foot wide and two cubits long and very flat and smooth. On this fasten the above-mentioned two pieces of wood so that they lie exactly parallel to each other half a foot apart. Then take some pure wax, put it in front of the fire and knead it vigorously, and when it is hot lay it between the two pieces of wood on the board, after first sprinkling water there to prevent its sticking. Now wet

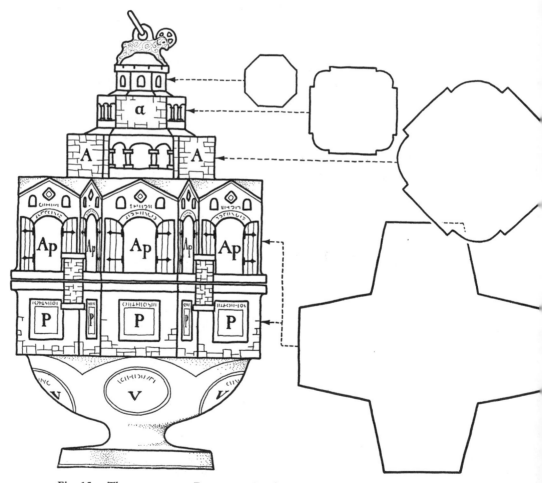

Fig. 15.—The cast censer. Reconstruction by translators, based on Theophilus' description. *a*, angel (half-figure); *A*, angel; *Ap*, apostle; *P*, prophet; *V*, virtue.

the round piece of wood and, rolling it hard with both hands, thin down [the wax] to the thickness of the two pieces of wood. When you have prepared a number of smooth wax slabs, sit near the fire and cut them up into pieces corresponding to the spaces you have cut on the clay [cores] of the censer, and in each space fit its proper piece of slightly heated wax and join it all around with a heated iron, suitable for this work. When you have covered the whole core on the outside in this way, take a thin tool sharpened on each side like a slender arrow and with a small tang fitted into a wooden handle, and with it cut around [the wax] on every side. Then even it up with a piece of boxwood of similar shape and see that the wax is not thicker or thinner in one place than in another. Then draw arches, one on each face [of the lowest tower] and also on the side walls, and a double door beneath the arches at each side, so that each door fills up a quarter of the space and two quarters remain in the center. In these spaces beneath each arch draw the figure of an apostle, each one holding an inscription in his hand and repre-sented as you wish. Write their names in the border round the arches. Now in the triangular spaces which support the roof gables shape representations of the twelve stones, assigning to each apostle the appropriate stone according to the significance of his name[3] and writing these names on the lower border of the same space. Make a little window in each corner next to the stone. This will be the representation about which the prophet says: *On the East three gates, and on the West three gates, and on the South three gates, and on the North three gates.*[4] Further, in each of the four corners separating the gates shape in wax a round turret through which the chains will pass. After arranging this in this way, on the next higher tower in each of the rectangular spaces make full figures of angels with their shields and spears, as if they were standing guard on the walls, and in the round turrets shape little columns with their small capitals and bases. In the same way on the penultimate tower, which is shorter, make half-length figures of angels and little columns to match. Now on the uppermost tower, which will be more slender, make long rounded windows and battlements encircling the top of

[3] Rev. 21: 19–20. [4] Misquoted from Rev. 21:13—where the order is E, N, S, W.

the tower. In the middle of these you should shape a lamb with the halo and cross on its head and a small arch around its back, with a ring on top into which the center chain should be inserted. This is the upper part of the censer with its work.

Now cover the lower part with wax in the same way and shape in each of its spaces the figure of a prophet with his inscription. Give each apostle an appropriate prophet so that the testimonies which are to be written in their inscriptions correspond. Now do not make gates surrounding the prophets, but let their spaces be merely rectangular and let their names be written in the borders above their heads. In the corners also make four [little] towers for securing the chains, in such a way that they match the towers in the upper part. Then on the rounded space below make as many circles as you can or wish and in each of them shape a half-length female figure representing one of the Virtues, and write their names in the circles. Finally shape the foot on the bottom and turn it [on the lathe]. All the spaces round the figures in the upper and lower parts are to be pierced.

Next, put gates and air vents onto each part and carefully smear thin clay all over them both and dry them in the sun. Do the same a second and a third time. These parts are now called the molds. When they are completely dry, put them near the fire; and when they have become hot, pour the melting wax into water and again put them near the fire and continue until you have completely removed the wax.

After this put large pieces of fresh charcoal in a suitable level place and stand the molds steadily on them with their openings turned downward. Surround them with stones which will endure the fire's heat without spalling, laid stone upon stone, like a wall, dry, without mortar, so that many very small openings remain between the stones. Build them up like this half a foot higher than the molds and pour blazing coals around and then fresh charcoal up to the top. Take care that there is enough space between the molds and the stones to hold the coals. When all the coals are red-hot, they should be raked from time to time with a thin stick through the openings all around between the stones, so that the coals pack well and the heat is everywhere uniform. When they settle to the

point where you can see the molds, fill up to the top again with fresh charcoal and do the same a third time.

When you see that the molds are growing red-hot on the outside put into the [forge] fire a crucible containing the brass you want to melt, and blow, at first gently, and then more and more until it is completely liquid. After doing this, stir it carefully with a bent iron tool with a wooden handle and turn the crucible to another side [facing the blast] and fill it up again with brass and melt it, and keep on doing this until the crucible is full. When this is done, stir it again with the bent iron, clean the coals off it and as the bellows-man blows vigorously cover it with large pieces of charcoal. Next, move the stones away, take the molds from the fire, and with a cloth carefully smear them all around with clay drenched with water until it is as thin as lees. Now dig a trench close to the forge on which you are melting [the brass], put the molds in it and heap up earth all around and carefully press it down by repeatedly ramming it with a flat-ended piece of wood. Have at hand a small cloth folded over many times and held in a cleft stick. Immediately take the crucible off the fire with bent-nosed tongs, hold the cloth against it to keep back the dirt and ashes, and pour [the metal] carefully into [the molds].

When both of the molds have been cast in this way, let them stand as they are until the top of the gate grows black. Then take away the earth, remove them from the trench, and lay them aside in a safe place until they are completely cold, taking very great care that you do not spill water on the molds when they are hot because the inside cores immediately swell if they sense dampness and the whole work bursts asunder.[5] When they have cooled by themselves, take off the clay and inspect them carefully. If a piece is missing through negligence or accident, thin that place by filing around it, put some wax on it [in the shape that you want the repair to be] and pile clay up around it. When [this casting-on mold] is dry, heat it and pour brass through it until, as the stream runs down into that part, the brass that you are pouring joins [with the other]. When you examine it again, if it is not secure, solder it with burnt argol

[5] Such cracking would be due, of course, to the shrinkage of the metal, not, as Theophilus suggests, to the expansion of the core (cf. p. 175).

and filings of the alloy of silver and copper, as we described above
[III-31]. After this, first file across all the grounds, using various
files, square, triangular, and round, then engrave them with en-
graving tools and scrape them with scrapers. Finally clean the work
all over with sand and sticks whose ends are slightly shredded, and
gild it.

Chapter 62. The Chains

When you are going to make the chains,[1] first draw thin or thicker
wires of copper or silver and intertwine them, using an awl, in
three braids, or in four, five, or six, depending on the thickness you
want for the size of each censer, the smaller or the larger. When you
have plaited all the chain for one censer, in a single length, take a
flat thin piece of oak or beechwood and make a series of holes in it
with a slender, round iron that is hot. After annealing the chain in
the fire and cooling it, draw it through [one of] these holes; then
anneal it again and draw it again through another hole; and anneal
it once more and keep on doing this [through successively smaller
holes] until it is everywhere evenly thick and round. Then cut the
chain into lengths appropriate to the size of the censer, making the
center length shorter and the others longer. Make loops in each end
of the chains and secure the longer ones in the lower part of the
censer by driving pins firmly through the loops. Run the chains
through the upper part and put little rings on them, with which
you will adjust them and secure them to the bottom of the lily. With
a large ring fitted to the top of this lily the censer should be carried
about in the hand. Then secure one end of the middle chain which
is shorter to the upper part of the censer with a pin, and fit the
other end with a ring placed on it below the lily. Take care that
the censer hangs evenly on every side.

[1] This is a woven cable, not a chain
as the word *catena* suggests and as pre-
vious editors have supposed. There is a
scepter in the British Museum which
shows this type of work. The compos-
ite "bronze" wire rope described by
Feldhaus (1914, p. 206) as coming from
Pompeii is actually of brass and is
probably modern. Braided gold wires
were commonly used in jewelry.

In the same manner and way that we described above, censers of different shape and different kinds of work can be hammered and cast in gold and silver and also in brass. But you must take very great care that if brass is to be gilded it should be completely pure and purged of lead because of the various accidents that are wont to happen to men when they are gilding. Now if you want to make this brass, first learn the nature of copper, from which it is prepared.

Chapter 63. Copper

Copper is engendered in the earth. When a vein of it is found, it is recovered by digging and breaking with extreme effort. For it is a stone, colored green, that is very hard and in its natural state mixed with lead.[1] When a great quantity of this stone has been dug out,

[1] There are some confusing statements in this chapter on copper as with all of Theophilus' sections describing the preparation of raw materials with which he had no direct contact. The roasting and smelting are well enough reported (although the lack of change of color of the ore on roasting is surprising), but the reference to lead running out through the cavities while the copper remains behind is hard to relate to the smelting of an ore. Theophilus may be recording a garbled account of a report of the process for removing silver from copper by melting it with lead and subsequently liquating the alloy. This process is generally supposed to be a fifteenth-century development, but the first descriptions of it show such a degree of sophistication, with a series of special furnaces each so well designed for its function that there was no significant change until the abandonment of the process in the nineteenth century. In the fifteenth century the process involved the making of an alloy containing approximately 75 per cent of lead in the blast furnace, and casting cakes which were then heated in a separate hearth to a dull red heat to melt the lead, which drained off carrying most of the silver while porous copper remained. The silver-bearing lead was cupeled, and the copper had to be refined.

Liquation was introduced into Japan in 1591 by the "southern barbarians"—the Portuguese—and the method continued supposedly unchanged until the nineteenth century when the description was written (Gowland, 1894). The Japanese operation, quite different from the European, involved manually squeezing a pasty alloy (containing only about 25 per cent lead) to remove the lower-melting lead. It is conceivable that this represents a survival of an early method that had been supplanted in Europe by the labor-saving large hearths. Theophilus is on safer ground when he describes the refining of copper in III-67, and he may have been an eyewitness. This is done in a small hearth with bellows, the copper being melted with charcoal and then uncovered to expose it to oxidation. Theophilus says that the copper should be stirred with a slender dry stick, for the purpose of collecting the burned lead mixed with charcoal ashes, but it would

it is put on a pyre and burned like lime. The stone does not change color, but loses its hardness, so that it can be broken up. After being broken up into small pieces, it is put in a furnace, the bellows and charcoal are applied, and the bellows are blown unceasingly day and night. This must be done with care and caution, i.e., charcoal is first put in, then small pieces of the stone are spread over it, and again charcoal and then stone once more, continuing until the furnace is filled to capacity. When the stone begins to soften, lead flows out through certain small cavities and copper is left inside. When the bellows have been blown for a very long time, the copper is cooled and taken out, and again more is put in, in the same way. To this copper, smelted in this way, a fifth part of tin may be added and the alloy is produced from which bells are cast.

There is also found a kind of stone of a yellowish color, sometimes reddish, which is called calamine. This is not broken up but, just as it is dug out, it is put on closely stacked, thoroughly blazing wooden logs and is burned until it is completely red-hot. After this the stone is cooled and broken up very small and mixed with charcoal dust. Then it is alloyed with the aforesaid copper in a furnace built in this way.

Chapter 64. The Furnace

Four stones are stood up to form a cross, a foot apart from each other, partly fixed in the earth but rising equally a foot above it, and they are all level on top. On these stones are placed four square iron bars, a finger thick and long enough to reach from one stone to the next. Other iron bars of the same size are placed in between these at equal intervals, namely, spaced three fingers apart. Cross-

also undoubtedly serve to reduce the excess amount of oxygen that was needed for refining, exactly in the manner that fire-refined copper is "poled" today. The hot ductility test would be quite sensitive to lead and would well serve to indicate the end of the operation. Theophilus names the final copper, *cuprum "torridum,"* a term reminiscent of the German *Darrkupfer,* which also means dried copper. This, however, was the copper residue from the liquation operation, before refining, not after. Liquation is described by Biringuccio and Agricola, but the best early description is that of Lazarus Ercker (1574; 1951, pp. 224–53).

wise on these, more iron bars of the same shape and size as those beneath them are placed in such a way that the openings appear to be square. When these bars have been spaced like this, put on them well-kneaded clay mixed with horse-dung, to a thickness of three fingers, so that it sticks everywhere to the bars and the stones, and it is as if a round hearth were lying on top of the stones. Then with a round stick, in all the spaces between the iron bars, make holes as large as possible, and carefully let it dry out.

Rising from this hearth a wall in the shape of an earthenware pot should next be built of tiny stones and the same clay. From halfway up it should narrow a little and its height should be greater than its diameter. Bind it with five or four iron bands, and carefully plaster it with the same clay inside and out. When this is done, blazing coals mixed with dead ones should be put in, and at once the draft entering through the holes below draws out the flames without using the blowing of bellows.[1] Any kind of metal that is put in immediately melts by itself. Then the crucibles needed for this work should be made in this way.

[1] Figure 16 shows Theobald's reconstruction of this brass-making furnace, modified, however, by the omission of the window that he gratuitously placed on the side and which would have spoiled the draft. It will be noticed that Theophilus was fully aware of the effect of draft in the furnace though he does not specifically relate it to height. Although iron-smelting furnaces quite often depended on natural draft, early metallurgists generally used bellows when they needed moderately high temperatures (Goldsmith and Hulme, 1942). The principle of the separate chimney was not realized until the middle of the sixteenth century, and it took time to spread. Biringuccio (1540), who is even more vague than is Theophilus about the nature of draft in his wind furnaces, describes a two-hole brass furnace in use at Milan. He supposed that the two work holes both led to a single, more or less rectangular, space, but it is more likely that there were two separate furnaces, shaped like those of Theophilus but set into a large block of masonry, an arrangement so well described in eighteenth-century France by Galon (1764) and others.

Metallic zinc was known in classical antiquity, (probably as an accidental condensate in furnace crevices), but it was little used until the seventeenth century and was not extensively employed in making brass until the nineteenth century. Zinc is easily reduced from its ores, but it boils at 930° C. and so escapes to burn above the furnace fire unless it is kept out of contact with air and condensed, or unless, as in making brass, it is absorbed in copper where it has a lower vapor pressure. The process goes best when the copper is not melted until the end, for a large surface is desirable to absorb the zinc. The resulting alloy after two heatings could have as much as 30 to 40 per cent zinc.

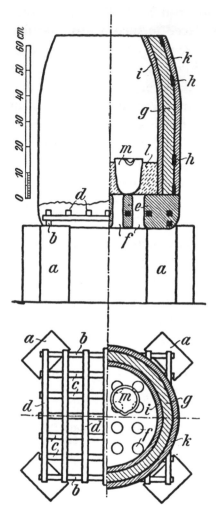

Fig. 16.—Wind furnace for making brass. Reconstruction by Theobald (1933), modified. (V.D.I. Verlag.)

Chapter 65. Making the Crucibles

Take fragments of old crucibles that have previously been used for melting copper or brass and crush them into tiny pieces on a stone. Then take clay from which earthenware pots are made—there are two kinds of this, one white, the other gray: the white is good for

coloring gold,[1] the other for making these crucibles. When you have ground it for a very long time, mix the raw clay in with the other (i.e., the burnt clay that you first ground) in proportion like this. Take any small pot and fill it twice with the raw clay and three times with the burnt clay so that there are two parts of raw and three of burnt. Put them together into a large pot and pour warm water over them; then knead them vigorously with hammers and with your hands until the mixture is completely tenacious. Then take a round piece of wood and cut it to the size that you want the crucible to have [inside], according to the capacity of the furnace. Shape a crucible upon this and, after it has been shaped, coat it at once with dry ashes and so put it close to the fire until it is dried. Make as many crucibles as you wish in this way. When they have been carefully dried, put three, four, or five of them into the furnace, up to the number it can hold, and heap charcoal around them.

Chapter 66. Making Coarse Brass[1]

And when the crucibles are red-hot take some calamine, about which I spoke above [III-63], that has been [calcined and] ground up very

[1] The white clay is probably used for making crucibles in coloring gold or in cementation. See III-40 and 33, respectively.

[1] The word that we translate as "coarse brass" is *aes*. Although the process so well described here is unmistakably that for making a copper-zinc alloy, *aes* in classical Latin, particularly in Pliny, meant bronze, that is, a copper-tin alloy, perhaps containing a minor amount of lead. The word which was later to become the common term for brass is *auricalcum* (normally spelled *aurichalcum*). This is frequently used by Theophilus, mostly for metal which is to be made into sheet or fine gilded castings. He describes (III-67) how *auricalcum* is made in the same way as *aes*, but from copper that has been refined so as to remove the lead content. He gives a caution that the impurities in *aes* make gilding impossible. Dodwell, believing that the ability to take gilding was the only distinction between brass and bronze in Theophilus' mind, generally translates *auricalcum* as bronze and *aes* as brass, although he is not consistent. We admit the uncertainty and are aware that bronze would take gilding better than brass and was probably commoner in the twelfth century, but we have preferred to translate *auricalcum* always as brass. We call *aes* "coarse brass" in the present chapter, where no other term could conceivably fit the process. In III-85, where the context clearly calls for it, we have rendered *aes* as bell metal. The Spanish brass, *auricalcum Hispanicum*, used to deoxidize molten silver in III-30, must have been a true brass, for zinc would be necessary for this purpose.

fine with charcoal, and put it into each of the crucibles until they are about one-sixth full, then fill them up completely with the above-mentioned [crude] copper [III-63], and cover them with charcoal. From time to time poke the holes below with a slender hooked stick, so that they may not become blocked and also so that the ashes may come out and more draft may enter. Now, when the copper is completely melted, take a slender, long, bent iron rod with a wooden handle and stir carefully so that the calamine is alloyed with the copper.[2] Then with long tongs raise each crucible slightly and move them a little from their position so that they may not stick to the hearth. Put calamine in them all again as before and fill them with copper and cover them with charcoal. When it is once more completely melted, stir again very carefully and remove one crucible with the tongs and pour out everything into [little] furrows cut in the ground. Then put the crucible back in its place. Immediately take calamine as before and put it in, and on top as much of the copper that you have [just] cast as it can hold. When this is melted as before, stir it and add calamine again and fill it again with the copper you have [just] cast and allow it to melt. Do the same with each crucible. When it is all thoroughly melted and has been stirred for a very long time pour it out as before and keep it until you need it. This alloy is called coarse brass and out of it are cast cauldrons, kettles, and basins. It cannot be gilded, since the copper had not been completely purged of lead before the alloying. If you are going to make brass which can be gilded, begin in this way.

Chapter 67. The Refining of Copper

Take an iron pan of whatever size you wish, plaster it inside and out with well-kneaded and mixed clay and carefully dry it out. Then put it on the coals on a blacksmith's forge in such a way that when the bellows blow, the draft passes partly into it and partly above it, but not below it. Place small pieces of charcoal around it, lay the

[2] Stirring at this stage would help very little, for the copper would already have absorbed all of the zinc vapor that it could.

copper evenly in it and add a heap of charcoal on top. When the copper has been melted by blowing for a long time, uncover it and at once throw on it very fine charcoal ashes and stir it with a slender, dry stick as though mixing, and you will at once see the burnt lead sticking like glue to the ashes. Take this out, again put charcoal on top and blow for a long time as at first, uncover it again and then do as you did before. Keep on doing this until you remove the lead completely by cooking it out. Then pour the copper into an ingot mold that you have prepared for this purpose and test it thus to see if it is well purified. Hold it with the tongs before it is cooled, while it is still red-hot, and strike it hard on an anvil with a large hammer and, if it breaks or splits, it will have to be melted again as before. But if it remains sound, cool it in water and refine more copper in the same way. This copper is called *torridum*.[1]

From this copper you can work for gilding whatever you wish to make in repoussé—figures, animals, and birds on censers and different kinds of vessels or the borders of tablets as well as wires and chains. Out of it, also, you make brass by adding calamine in the same way as you made the coarse brass for cauldrons above. When you have reheated it four or five times [with calamine] in crucibles in the furnace, you will be able to gild very well any kind of varied work that you have cast from it.

Chapter 68. How Brass Is Gilded

If you are going to gild a brass censer do it in the same way that you gilded the handles of the silver chalice above [III-38], but taking greater care, because silver and unalloyed copper can be gilded more easily than brass. The amalgamation of brass must be done more scrupulously and carefully and it must be gilded more thickly and washed more often and dried for a longer time. When it begins to take on a yellow color, if you see white spots emerging on it so that it refuses to dry evenly, this is the fault of the calamine, because it

[1] Literally "heat-dried." This is similar to tough-pitch copper and has no relation to the dried copper (German *Darrkupfer*) from the later liquation process. See III-63, n. 1.

was not evenly alloyed, or of lead, because the copper was not purged and refined free of it. You can amend this in the following way. Take some soap and put it in a clean pot and pour water over it; mix it carefully with your fingers as if you were washing until it is like the dregs of beer. Smear it evenly everywhere with hog-bristles over the gilt censer. Then put it on the coals and heat it until the mixture begins to grow black and then, lifting it with the tongs, sprinkle it carefully all over with water. Wash it and polish it with brushes of brass wire as was described above. After doing this, rub it all over again with the argol composition and with mercury and gild it once more for fear that the gold itself, if it had been thinly gilded, may be burnt off because of the heat of the coals which are so very frequently put on. Polish it again with the wire brushes and put it once more on the coals and heat it for a longer time, until it takes on a reddish color. Immediately cool it in water and polish it with the appropriate burnishers and then color it with burnt green vitriol, as aforesaid [III-40].

Chapter 69. How To Separate Gold from Copper

Now if you ever break gilded copper or silver vessels or any other kind of gilded work, you can recover the gold in this way. Take the bones of any kind of animal that you may have found in the street and burn them; when they are cold, grind them very fine and mix with them a third part of beechwood ashes and make dishes, as we described above in the refining of silver [III-23]. Dry these by the fire or in the sun. Then carefully scrape the gold off the copper and wrap the scrapings in lead that has been hammered flat and thin. Set one of these dishes into live coals on the forge, put the lead packet with the scrapings into the dish as soon as it is red-hot, heap charcoal over it and blow. When it has melted, burn it in the same way that silver is normally refined, sometimes removing the live coals and adding lead and sometimes uncovering it and blowing carefully, until the copper is completely consumed and pure gold appears.

Chapter 70. How To Separate Gold from Silver

When you have scraped the gold off the silver put the scrapings in one of the small crucibles in which gold or silver is normally melted, and press down a small linen cloth on top to prevent any of them being blown out by the blast from the bellows. Then put it on the forge and melt them. At once put in bits of sulphur proportionate to the amount of the scrapings and stir carefully with a thin piece of charcoal until the fumes cease. Immediately pour it into an iron ingot mold. Then hammer it on an anvil, doing this gently so that none of that black which has been burnt by the sulphur may spall off, because it is itself silver. For the sulphur does not consume any of the gold, but only the silver, which it thus separates from the gold. Carefully save the silver, and again melt the gold in the same crucible as before and add sulphur. Stir it, pour it out, and break off whatever has become black and save it. Continue doing so until pure gold appears.

Then put all the black that you have carefully saved into the dish made of [burnt] bone and ashes and add lead, and so burn it in order to recover your silver. If you want to keep it to use as niello, rather than burning it, add copper and lead to it in the proportions mentioned above [III-28] and melt them together with sulphur.

Chapter 71. How To Put a Black Coating on Copper

From the above-mentioned copper, which is called red copper, have sheets thinned out to whatever length and width you wish. When you have cut them and prepared them for your work, draw on them little flowers or animals or anything else you like, and engrave them with a slender engraving tool. Then take some linseed oil and with your finger smear it thinly all over and spread it evenly with a

goose feather. Hold the work with tongs and put it on blazing coals. When it is fairly hot and the oil is liquefied, spread it evenly again with the feather, put it on the coals again, and continue doing so until it is dried out. When you see that it is evenly dried out everywhere, put it on strongly burning coals and let it lie there until it completely ceases to smoke. If it is sufficiently black, good; if not, smear a very little oil on it with a feather while it is hot, spread it evenly again, blow the coals, and put it on them and do as before. When it has been cooled, not in water but by itself, scrape the little flowers carefully with very sharp scrapers in such a way that the grounds remain black. If there are letters, it rests with you to decide whether you want them to be black or gilded. Now, when the sheet has been carefully scraped, immediately amalgamate it with the argol composition and with mercury, and gild it at once. When it is gilt do not quench it in water, but let it cool by itself and polish it as described above and color it in the same way.

Chapter 72. Openwork

From the same copper as above, thin out plates, but make them thicker. Draw on them whatever work you wish and engrave it as above. Then you should have tools, narrow and broader according to the size of the grounds. They should be flat and thin and sharp at one end and rounded at the other. These are called *meizel*.[1] Put a plate on an anvil and cut through all the grounds with the above-mentioned tools, striking them with a hammer. When all the grounds have been cut through in this way, smooth them everywhere with very small files going right up to the lines of the design. After doing this, gild and polish the plate as above.

In the same way silver plaques and plates for book covers are made

[1] Note that Theophilus uses a German word here. The tool in question is simply a special small chisel for cutting sheet metal. Elsewhere chisels are always called *ferri incisorii*. They are de- scribed in III-14. A good example of openwork (*opus interrasile*) is in the portable altar of Roger of Helmarshausen (see Plate XII).

with figures, flowers, small animals, and birds. Parts of these are gilded, namely, the halos of the figures, the hair, and, in places, the robes, and parts remain silver. Copper plates are also made and engraved and coated with black and scraped. These are then put in a pan containing molten tin so that the scraped places become white, as if they had been silvered. Painted chairs, stools, and beds are bound with these plates and the Books of the Poor are also ornamented with them.

Chapter 73. Punched Ground Work

Plates are also made of copper in the above way and are engraved with delicate designs of figures, flowers or animals. The work is so arranged that the grounds should be very small; the plates are then cleansed with fine sand and polished with the appropriate tools, then gilded and again polished and colored. After this, [the grounds] are punched with a ring punch[1] that is made in this way.

A tool is made of steel, a finger long, slender at one end, thicker at the other. When it has been evenly filed at the slender end, a fine hole is struck in the center of the end with a very fine punch and a small hammer. Then you carefully file around this hole until its edge is uniformly sharp all around, so that a very small circle appears wherever it is struck. After this heat the tool a little until it is just red-hot, and harden it in water. Now hold this tool in your left hand and a small hammer in your right, and let a boy sit opposite you to hold the plate and adjust it on the anvil to those places where you are going to strike. Now strike lightly on the punch with the small hammer and fill one of the grounds with very fine circles, fitting them as closely one to the other as you can. When all the grounds are filled in this way, put the plate on red-hot coals until the punch marks take on a reddish-yellow color.

[1] *Ferrus punctorius.* The same tool was also described in III-13 and its use in III-42 and elsewhere. The effect of using it on a flat metal ground is illustrated in Plate XII, which shows a detail of one of Roger's portable altars.

Chapter 74. Repoussé Work[1]

For raising figures in relief hammer out a gold or silver plate as long and broad as you wish. When you have first cast this gold or silver, inspect it by carefully scraping it all over or gouging it to see if there is a blowhole or crack in it, things which often happen when the metal is cast too hot or too cold, or too fast or too slowly through the carelessness, negligence, ignorance, or inexperience of the caster. After casting it with attention and care, if you find a fault of this kind in it, carefully dig it out with an appropriate tool if you can, but if the blowhole or crack is so deep that you cannot dig it out, you must cast the metal again and keep on doing so until it is sound. When it is, see that the anvils and hammers with which you are to work are completely flat and polished, and take the utmost care that the gold or silver plate is thinned out so evenly everywhere that it is no thicker in one place than another. When it has been so thinned out that the impression of the fingernail is just visible on the other side, and when it is completely sound, then draw on it as many figures as you wish according to your fancy. Draw them on the side that appears sounder and more appropriate, gently, however, and in such a way that the drawing barely appears on the other side.

Then with a well-polished, bent tool, gently rub [the metal from the under side] forming the head [of the figure] first, for it must stand higher, then turn the plate over and rub around the head on the front side with a smooth, polished tool so that the ground is depressed and the head is raised. Next, hammer lightly around the head itself with a medium-size hammer on an anvil, and then heap

[1] *De opere ductili.* An example, again from Roger's own hand, is shown in Plate XIII. It will be noticed that this work is not done mainly with punches as in modern repoussé, but is begun by rubbing the metal (which is very thin) with a hand tool, followed by hammering on both sides to shape the main convexities: punches are used only for shaping the final details (chas-ing). The hand tool with its bent, smooth, rounded end must have been rather like a modern spinning tool in its appearance and action. Theophilus does not mention any backing, but the work was supposedly done against a surface of chaser's pitch (III-59). True repoussé work on thicker metal is described in III-78 and elsewhere.

charcoal on that very place and anneal it on the forge until it is red-hot. When this has been done and the plate has cooled by itself, again [working] on the under side, rub the inside of the hollow of the head gently and carefully with the bent tool. Then turn the plate over and rub once more with the smooth tool on the upper side and depress the ground so that the head is elevated like a little mountain. Again hammer gently round it with a medium-size hammer, put charcoal on it and anneal it. Do this repeatedly, carefully raising it from inside and outside, hammering it many times and as often annealing it, until the elevation reaches a height of three or four fingers, more or less, depending on the size of the figures.

Now, if the gold or silver is still a little too thick, you can hammer it on the inside with a long, slender hammer and thin it out, if need be. If there are to be two, three, or more heads on the plate, you should do as I said round each one of them until they reach the height you want.

Then with a drawing tool mark out the body or bodies of the figures and so by depressing and hammering from time to time raise them as much as you wish, though take care that the head is always higher. After this mark out the nostrils and eyebrows, the mouth and ears, the hair and eyes, the hands and arms, and, in addition, the shadings of the robes, and the footstools and the feet. With smaller bent tools raise these gently and carefully from the inside, taking very great care that the work is not broken or pierced. If this should happen through ignorance or carelessness, it should be soldered in this way.

Take a little of the same gold or silver, mix a third part of copper with it, melt them together, and file them fine. Now burn some argol and add salt and mix them with water. Thinly smear the fracture with some of this mixture and sprinkle the filings over it. When it is dry, once more smear on the mixture more thickly, put charcoal above and below it and blow gently until you see the solder flowing. When you see this, immediately sprinkle it lightly with water and if it is solid, good; but if it is not, do the same again until it does become solid. If, however, the fracture is a wide one, carefully fit into it a thin piece of the same gold or silver so that it lies evenly and solder it in the same way, until it sticks fast everywhere.

When the raising of the figures has reached the point where the work is ready for chasing,[2] if it is gold, do it now. Then carefully polish the work and color it with green vitriol that has been burnt red, and salt, as above in the work on the chalice [III-40]. But if the plate is silver and you want to gild the halos, hair, and beards and parts of the robes on the figures, this must be done before the chasing in this way.

Put together two parts of finely ground common clay and a third part of salt, and mix them in a pot with fairly thick beer dregs. With this mixture cover all the [parts of] silver that you want to remain white, and leave whatever is to be gilded uncovered. When you have dried it on live coals, gild each place carefully without using water. When it has been gilded, wash it and polish it and color it. Then with thin and rather thicker pieces of wood rub it carefully with finely ground charcoal until it is uniformly bright all over. After this do the chasing in both the gold and the silver and, at the same time as you are doing it, also polish the work until you have brought it to perfection.

Next, when, after fully raising and polishing these gold or silver plates, you want to attach them, take some wax and melt it in an earthenware or copper pot and mix with it finely ground tile or sand in the proportion of two parts of this to a third of wax. When these have been melted together, stir the mixture vigorously with a wooden spoon, and with it fill all the figures, or whatever other raised work in gold, silver, or copper there is.[3] When it is cold, attach it where you wish.

Similar work is done on copper plates, thinned out in the same way, but with the application of greater force and with more care because of its harder nature. When this work has reached the stage of chasing, it should be cleaned on the outside with a woolen cloth and sand until the black skin is removed. Then it should be gilded and polished and, when the chasing has been finished, it should be colored and filled with the above-mentioned composition.

[2] *Subtiles tractus*—fine lines and details made with chasing or engraving tools or otherwise.

[3] This filling is to provide support against injury by accidental blows, for the metal is very thin. The plates were to be attached to boxes, altars, and flat surfaces generally.

Chapter 75. Work Pressed on Dies

Tools should be made a finger thick, three or four fingers wide, and a foot long. These should be very sound, so that there is no imperfection in them and no crack on their upper side. On these, to look like seals, should be carved narrow and wider borders within which there should be flowers, animals, and small birds, or dragons linked together by their necks and tails. They should not be carved too deeply, but moderately and with care.[1]

Then thin out some silver much more thinly than for raised work, of whatever length you wish. Clean it with a cloth with finely ground charcoal, scrape chalk onto it and polish it. After doing this, cut a piece of this silver to fit a border, place the die on an anvil so that the carving is uppermost, and lay the silver on it. Then put some thick lead on top and strike it hard with a hammer so that the lead forces the thin silver into the carving so strongly that all the detail appears fully on it. Now if the silver sheet is longer [than the die] move it from place to place and when it is in line with the die hold it evenly with tongs and so make one impression after another, continuing until the whole sheet is filled. This work is very useful around borders when you are making altar panels and on pulpits, caskets for the bodies of saints, and books, and elsewhere where it is needed, since embossing is beautiful and delicate and is easily done. Work of this kind is also done in copper, which should be thinned out, cleaned, gilded, and polished in the same way. It is then laid on the die with the gilding turned to the die, the lead is put on top and it is hammered until the detail appears.

A representation of the crucified Lord is also carved on a die in the

[1] This process of putting repetitive designs on thin sheet metal by pressing it against a carved form of a harder metal or stone is of great antiquity and ubiquity. It has been employed particularly to make small decorations out of extremely thin gold, and such objects may be seen among artifacts from ancient Mesopotamia, Egypt, Mycenae, and Etruria, as well as from the pre-Columbian New World. The product, though sparing of the precious metal and labor, looks flashy but cheap and is easily subject to damage. A small die like those described by Theophilus, but dating from the fourteenth century, is shown in Plate XIV*a*. Plate XIV*b* is a photograph of a twelfth-century strip of gilded copper sheet with a die-stamped design.

way described above, and silver or gilded copper impressed on it. From this are made phylacteries, i.e., reliquaries, and small caskets for the saints. A carving representing the Lamb of God is likewise made on a die, and representations of the four evangelists; gold or silver is impressed on these and used to ornament cups of precious wood. A circle with the Lamb stands in the center of the cup, and the four evangelists around it in the form of a cross with four bands stretching from the Lamb to the four evangelists. Figures of little fishes, birds, and animals are made which are fastened over the remaining ground of the cup, affording much ornament. The representation of Divine Majesty is also made in the same way, and other figures of any shape and sex. When these are impressed on gold, silver, or gilded copper, they provide the greatest embellishment to the places where they are affixed because of their delicacy and fine workmanship. Figures of kings and knights are also made on dies in the same way. These, impressed on Spanish brass, ornament basins (for use in pouring water over the hands) in the same way as gold and silver cups are ornamented with borders of the same metal. On these borders small animals, birds, or flowers stand; these, however, are not integral, but are [pressed separately and] soldered on with tin.

Chapter 76. Studs

Iron [punches for the heads of] studs are also made, a finger long, thicker at one end and thinner at the other end, where steel should be welded on. One of these punches should be filed square, one triangular, and a third round, all of an appropriate size. Then you should carve little flowers on them in the same way as described above, and make the edge of the tool round the little flower sharp. Now, after hammering out some silver, gilded copper, or brass very thin, polish it on the upper side, as above; and on the under side cover it very thinly with tin, using the iron with which windows are soldered. Then put a thick piece of lead on an anvil and lay the silver or gilded copper on top of it, so that the gilding is uppermost and the tin beneath. Now take whichever one of the punches you want and

put the carving in position on the silver and strike it with a hammer so that the impression of the carving appears on the silver and it is cut out all around by the sharp edge of the tool. When you have done this over all the silver, keep all the little flowers, because they are to be the heads of studs, whose shanks you should make in this way.

Alloy two parts of tin and a third part of lead, and hammer it out thin and long; then draw it through the holes in the drawplate [III-8] so that it becomes a very long wire, not too thin but medium. After this, make yourself a slender iron tool, half a foot long and moderately wide at one end (the width of your fingernail) and slightly concave, while its other end is fixed into a wooden handle. Then sit next to an appropriate furnace in front of which should stand a little copper vessel with molten wax. In your left hand hold the handle of this slender tool, which you should have heated at its wider end, and in your right hand hold the tin wire rolled up like a ball. [Unroll] the end, dip it into the molten wax and put it on the tinned side of one of the little flowers so that it sticks. Then lift it up and put it into the hollow of the tool when it is red-hot and hold it there until it melts. Immediately take both [the flower and wire] off the fire and cut the wire with shears to the length which you want the shank of the stud to have. Continue doing this until you have used up the silver and gilded copper in studs of this kind.

When you have a sufficient quantity of studs, if you want to fix them on the stirrup leathers of a horse saddle or around the head piece of a bridle, first make holes with an awl, then insert the studs in such an order that there are three of gold, three of silver, and again three of gold, and so on. Now, if you want to have two or three rows of studs, always place one of silver, and the next one of gold throughout. Then put the leather with the heads on a flat smooth wooden board and make the shanks fast with a medium-size hammer. Studs of brass are also made by the same procedure, but they should be thicker. Their copper shanks[1] are soldered on the

[1] On the silver or gilded copper studs described earlier in this chapter Theophilus apparently leaves a bit of solder wire to serve as a precarious stem, but these brass studs are to be more sturdy and have copper wire shanks soldered to them. Common soft solder as used on the first studs would also do better on brass than the specified pure tin.

inside with pure tin in the same way. These studs are used to make fast the sheaves of knives, leather bindings on books, and many other things of this kind.

Chapter 77. Soldering Gold and Silver Together

Silver, weighing twelve pennyweight, is refined and hammered out into a narrow piece the length of half the little finger. Then cemented gold, weighing one pennyweight, is hammered out to the same width and length, and these two are soldered with the gold solder mentioned above [p. 151] until they stick completely fast to each other. Stuck together like this they should be hammered out until a very thin flat sheet is made. This work has the appearance of silver that has been gilded on one side, although a sheet of such a length could not be so brilliantly gilded with two or three pennyweight of gold. Borders are made out of this sheet and are impressed with a die in the above way. Narrow strips are also cut from this sheet and they are twisted around silk in spinning. Gold fringes are woven from them in the homes of the poor just as among the rich they are woven of pure gold.

Chapter 78. Repoussé Work Which Is Chased

Hammer out a copper plate as wide and long as you wish and so thick that it can hardly be bent. It should be completely free from any crack or imperfection. Draw on it the figure that you want. Then hammer with a medium-size round hammer from the under side [to form] a hollow in the place for the head and hammer all around on the upper side with a narrow straight-peen hammer. Anneal it on live coals. When it has cooled by itself, work over the whole figure with hammers (just as you did with bent, smooth tools on the thin copper sheet [III-74]), always carefully depressing [the grounds] on each side and repeatedly annealing it. When you have raised the figure to the height you want, take narrow, rounded, pointed punches which you have made for this work, a span long, thicker at one end, where they can be struck with a hammer, and thinner at the other end.

Now seat a boy skilled in this art in front of you, hold the plate in your left hand and the tools in your right, and as the boy strikes on top with a medium-size hammer, mark out the eyes and nostrils, the hair and the fingers, the toes and all the lines of the robes. This is done on the upper surface in such a way that they appear through on the inside, where you should also strike with the same punches, so that the design is raised on the outside. When you have done this long enough to shape the figure completely, engrave with engraving and scraping tools around the eyes and nostrils, the mouth and the chin and the ears, and mark out the hair and all the fine lines of the robes and the nails of the fingers and toes.

After doing this, if you want to ornament the halos of the figures with gems, enamel, and pearls, fashion individual settings in gold with wires and solder, as above in the work of the chalice [III-53]. Then fit each setting in its proper place and make holes through which they can be fastened, that is [in the setting] beneath the larger gems and in the copper to match. Now gild the plate and polish it first with brass wire brushes, as above [III-39], and then with burnishing tools. Color it, fasten the gold settings, each one in its place, insert the gems, and bind the pearls round them.[1]

In the same way you can, if your inventory allows, make figures in gold and silver on the books of the gospels and on missals; also animals, small birds, and flowers on the outside of the riding saddles of Matrons. Also made in the same work, in the center of gold or silver cups and platters, are knights fighting against dragons or else lions or griffins fighting, the figure of Samson or David breaking the jaws of lions, also lions and griffins by themselves or each one strangling a sheep, or anything else you like, that is also appropriate or fit to the size of the work.

Chapter 79. Cleaning Old Gilding

Take some soap and put it in a basin or another clean vessel, pour water over it and mix it with your fingers until it is as thick as lees,

[1] It is not clear how the small stones and pearls were to be attached; perhaps cells for them were made integrally with the setting for the larger stone, which was riveted in place.

so that wherever it is put it cannot flow off. Then with hog-bristles smear it carefully over old gilding on copper or silver which has lost its brilliance, so as to cover it completely and let it stay thus for a day and a night. On the second day, however, wash it with water with the same bristles once and again; the third time drench it with clear water and you will see it become brilliant so that it delights the eye.

Chapter 80. Cleaning Gold and Silver

If gold or silver that has been made into thin sheets and fastened anywhere with studs has become blackened with age, take some black charcoal, grind it very fine, and sift it through a cloth. Take a linen or woolen cloth that has been wet in water and put it on the charcoal. Lift it up and rub the gold or silver all over until you remove all the black stain. Then wash it with water and dry it in the sun or by a fire or with a cloth. Then take white chalk and scrape it very fine into a pot and, dry as it is, rub it with a linen cloth over the gold or silver, until it recovers its pristine brilliance. In the same way [ecclesiastical] vessels are cleaned.

Chapter 81. The Organ

A man who is going to make an organ should first have a table of dimensions[1] giving the measurements for the bass pipes, the alto, and the treble. Then he should make a long, thick iron [mandrel] of the dimensions that he wants the pipes to be. It should be round in circumference, filed and polished with the greatest care, thicker at one end and slightly flattened so that it can be inserted into a bent iron [crank], like the wooden handle of a grindstone, by means of which it can be turned. At the other end it should be slender, corresponding

[1] *Lectio mensurae.* This table was probably like the one referred to in making bells (III-86), based on Pythag- orean theory but adapted to the reali- ties of organ-pipe making.

in size to the pipe at the lower end which is to be put into the wind chest.[2]

Then some pure and very sound copper should be thinned out so that the impression of the fingernail shows through on the other side. When the copper has been marked out and cut to the size of the iron for the longer pipes known as bass, following the directions in the table, he should make in it a hole in which the languet is to be placed. The copper should then be slightly scraped around [the

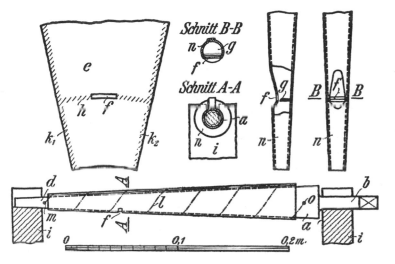

Fig. 17.—The mandrel for assembling and smoothing organ pipes, and details of the languet. Reconstruction by Theobald (1933). (V.D.I. Verlag.)

hole] to the width of a straw and tin spread on it with the soldering iron. It should then be scraped along its length on the inside of one edge and on the outside of the other, to the same width, and thinly tinned. Before being tinned, the copper should be slightly heated and the strips which have just been scraped should be smeared with fir resin so that the tin may adhere more easily and quickly.

After this has been done, the copper should be wrapped around the mandrel, so that the tinned strips meet each other, and bound firmly with fairly thick iron wire. This wire should first be inserted into a

[2] Figure 17 shows Theobald's reconstruction of the pipe-maker's setup. The lathe is not used for turning, but for a kind of internal ironing operation to give full rotational symmetry to the pipe.

tiny hole in the thin end of the mandrel and there twisted twice around it. Then it should be wound around and down to the other end and secured there in a similar way. Then with the joints [of the strips] matched to each other and carefully fitted together, the bound assembly with its mandrel is placed on the forge on blazing coals. A boy should sit there and blow moderately hard. In the right hand a thin stick should be held, the end of which is split and has stuck in it a little cloth with resin. In the left hand a long strip of thinly hammered tin should be held, so that, as soon as the pipe heats up, the joint may be smeared with the resin-impregnated cloth, the tin applied and melted, and the joint carefully soldered. When this has been done and the pipe has cooled, the mandrel should be put in a device made like a lathe, the crank fitted, and the wire loosened. Then one man should turn the crank while another should hold the pipe firmly with both hands now gloved, so that the mandrel turns while the pipe remains stationary, until it looks completely pleasing to the eye, as if it had been turned.

Then the mandrel should be taken out and with a medium-size hammer the pipe itself should be struck close to the hole, both above and below it, so that the roundness is depressed almost to the center for a distance of two fingers. Now the languet should be made of somewhat thicker copper, in the shape of a half disk. It should be tinned around its circumference like the pipe above. Then it should be inserted in the lower part of the hole so that it stands evenly beneath the rim of the hole and cannot move either down or up.

The organ maker should also have a soldering iron of the same width and curvature as the languet. After heating this, he should put small pieces of tin on the languet with a little resin and carefully move the hot iron around it so that the languet is not shifted but is stuck fast by the molten tin, so that no wind can escape around it except only through the hole at the top. After doing this he should put the pipe to his mouth and blow, at first gently, then more, and then strongly, and he should adjust the voice according to what he distinguishes by ear, so that if he wants it to be strong the hole should be wider; if, however, he wants it weaker, it should be made narrower. All the pipes should be made in this way. He should make the size of

each pipe above the languet according to the directions in the book, but below the languet all the pipes should be of one size and the same diameter.

Chapter 82. The Wind Chest of the Organ

When you are going to make the wind chest on which the pipes are to be placed, see whether you want to have it of wood or copper [i.e., cast copper alloy]. If of wood, get yourself two planks of well-dried plane tree wood, two and a half feet long and a little more than a foot wide, one of them four fingers thick and the other two. These should be free from knots and smooth. Fit the [flat sides] very carefully together. In the center of the under side of the thicker plank there should be a square hole four fingers wide and around this there should be left a rim of the same wood, a finger wide and a finger high, in which the wind conductor is to be placed. In the upper part at the side [of the hole] you should make grooves through which the wind can reach the pipes.[1]

The other plank, which is to be the upper piece, should be measured out into equal parts on the inside and seven or eight [transverse] grooves made there. In these the slides are to be carefully fitted so that they can run easily when pulled out and pushed in, but are so well fitted that no wind can escape through the joins. In the upper side cut grooves opposite those on the lower side but a little wider and fitted with an equal number of pieces of wood so that between them and the plank the groove remains empty to let the wind rise through it to the pipes. Holes should be made in these pieces of wood in which the pipes are to be fixed. The grooves in which the slides are fitted should continue through to the front, like horizontal

[1] Figure 18 shows the supposed construction of the organ, based largely on Theobald's drawing, but with the shape of the air channels above the slides modified to conform better to the text. A contemporary drawing of an organ rather like the one described by Theophilus is reproduced in Plate XV. It will be noted that two pipes are activated with a single slide. Compare the illustration from the Dijon Bible, shown in *Speculum*, 1948, *23*, 208 (article by W. Apel). In the cast brass organ (III-84) the description allows for, though it does not require, pipes to be sounded one, two, or three at a time on a single slide. For a history of the organ, see Sumner (1952).

window-frames, through which the slides can be pushed in and pulled
out. At the back, beneath the end of the slides, there should be holes,
equally wide and long, and two fingers in size, through which the
wind can rise from below to above in such a way that, when the
slides are pushed right in, the holes are blocked by them, and, when
they are pulled out, [the holes] are again open. Now, in the pieces of

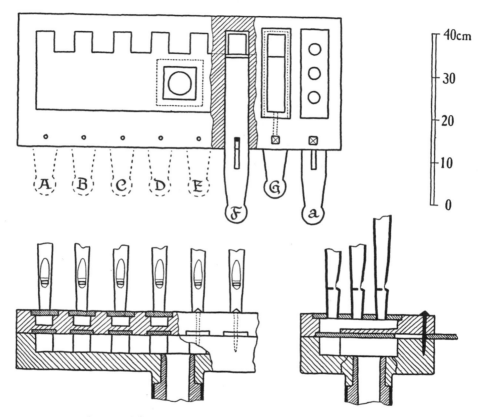

Fig. 18.—The organ mechanism. Reconstruction by translators

wood which are fitted above the slides, holes corresponding to the
number of pipes for each note should be made carefully in a row. In
these holes the pipes are to be inserted so that they will stand firmly
and receive the wind from below.

Letters also should be written on the handles of the slides, corre-
sponding to the rise and fall of the scale, from which it can be seen
which is this or that note. In each of the slides there should be a

single narrow slit, the length of half the little finger, running length-
wise, in the front part close to the handle. In each slit there should
be put a copper pin with a head; these pins should pass through the
center of the little windows in which the slides are inserted, from
the top of the upper plank of the chest into the bottom, the heads
of the pins being visible on top. They prevent the slides being com-
pletely drawn out when they are pulled during the playing of the
organ.

When everything has been so arranged, the two planks which
compose the wind chest of the organ should be glued together with
cheese glue, as well as those pieces which are fitted above the slides
and which carry the holes [for the pipes]. Then everything should
be carefully trimmed and scraped.

Chapter 83. The Wind Conductor

When you are going to make the wind conductor, fit together two
pieces of plane tree wood in the same way as above, one foot long,
one of them a palm thick and the other three fingers. They should be
curved like a shield at the front and a foot and a half wide there; at
the back they should be a span wide and obtuse. When these have
been carefully fitted together, cut as many holes as you want to
correspond to the number of bellows in the curved front of the
thicker plank, and in its obtuse end cut a single, larger hole. Then
from each hole cut a channel leading to the larger hole through
which the wind can find its way when the bellows are blowing. Now
glue the pieces of wood together with cheese glue and surround them
with a new strong linen cloth, coated with the same glue so that it
sticks fast. You should also make strong iron bindings, tinned inside
and out so that they cannot be destroyed by rust,[1] and fasten them on
with long tinned headed nails, using one binding between any two
holes to grip the two pieces of wood from the upper side down to the
lower. Then procure a sound, strong bent piece of oak wood with

[1] Follows Dodwell's unannotated emendation of *aerugine* for *tignea*, **H**, and
tigine, **G**.

one end one foot long from the bend, and the other two feet. Bore a hole through each end with a large auger of the type with which naves are bored in plow wheels. Now, since the holes cannot meet together because of the bend, make an iron tool with a head rounded like an egg and a long, slender shank which should be fitted into a handle. It should be slightly curved close to the head. After heating it, burn the holes inside the bend with it until they join smoothly into each other. After doing this, cut [the short end of] the wood to a

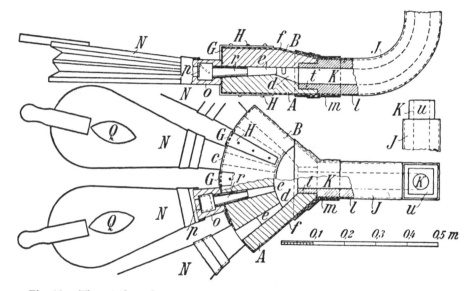

Fig. 19.—The wind conductor. Reconstruction by Theobald (1933). (V.D.I. Verlag.)

square shape, a span wide on each side to match the dimensions of the obtuse end of the wind conductor. Then fit the longer end of the wood to the hole on the under side of the wind chest with a projection the length of a thumb cut in the same wood. This projection should then be put or forced into the hole, the join being so close that no wind can escape through it. Now fit the other end in the same way into the wind conductor, and secure the wood with cheese glue. Wrap the whole wooden structure in cloth together with the join, around which you should also nail a wide strip of copper to hold the edges of both pieces of wood.

When this is finished, if you want the organ to stand on the other side of the masonry of the wall, so that nothing is visible inside the

monastery except the wind chest with its pipes, and the bellows lie on the other side of the wall, you must turn the wind chest so that the slides will be drawn out in the direction of the bellows. A niche should then be made in the wall itself in which the player can sit on a seat so arranged that his feet straddle the wind conductor. There is also a square opening in the middle of the niche running through the masonry, through which the wind chest and its pipes are exposed to view. The wind chest rests on the join at the neck of the conductor, which is anchored with stones in the wall beneath the opening and is supported by two long iron bolts fixed squarely in the wall. A wooden shutter hangs at this opening and when it is shut and protected by lock and key, no stranger coming upon it can learn what is contained inside.

Outside, above the organ, in order to keep off dust, a thick cloth, stretched on the inside with pieces of wood into the shape of a little housing, should be suspended on a rope from the ceiling. This rope, skillfully fitted around a wheel that is above the ceiling, is pulled when the organ is to be played, and it raises the housing. When the playing is over, it is again lowered over the organ. The housing also has a spire of the same cloth, stretched with four pieces of wood into triangular shape, and on top of it there should be a small wooden ball to which the rope is attached. The bellows and the structure on which they are to lie should be arranged as you wish according to the character of the site.[2]

Chapter 84. The Copper Wind Chest and Its Conductor

Lay out the length and width of the wind chest according to the number of pipes and make a mold core of kneaded clay.[1] When it is dry, cut it carefully to whatever size you wish, and cover it with wax

[2] The only manuscript to contain the following chapters in entirety is *H*. Six of them, not all complete, are contained in *C* (Dodwell, p. lxvi).

[1] The completed organ is shown in Figure 20, taken from Theobald. The technique of casting a block of lead to fit the slides and hold the pipes is ingenious and simple, but it would probably have worn rapidly in use.

that has been carefully thinned out with a wooden roller between two equally thick boards [cf. III-61]. Then in this wax cut the holes for the slides and the lower hole through which the wind is to enter. Add vents and a gate and cover it with the same clay once, twice, and a third time. When the mold is dry, cast it [in brass] in the same way that you cast the mold for the censer described above.

Also shape the wind conductor in clay, with the wind ducts underneath extending in all directions like the roots of a tree and meeting together at the top in a single opening. When it has been laid out according to measure and cut with the knife, cover it with wax and do as above.

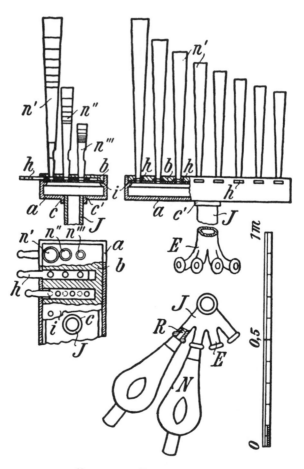

Fig. 20.—The cast copper alloy organ. Reconstruction by Theobald (1933). (V.D.I. Verlag.)

When you have cast the wind chest, fit a hammered copper plate inside, a finger's height from the bottom, level with the bottoms of the holes for the slides, so that the slides lie on it and can be smoothly drawn out and pushed in. Then smear the slides with a thin coat of clay and pour in molten lead to fill up the rest of the chest all over the slides themselves and up to the top. After doing this, take out the lead carefully and mark out the holes for the pipes on the slides and then on the lead itself. Make the holes very carefully with a slender tool or drill. Beneath the slides [in the copper plate] make the entrance holes for the winds, then push each slide into its proper place and replace the lead. By striking with a hammer fit the lead into the chest so that no air can escape except through the holes in which the pipes are to be placed.

Now when the wind conductor has been cast and filed and the pipe of each bellows has been fitted into its inlet, the conductor should be fitted and firmly attached to the under side of the wind chest, so that the wind may find its proper entrance holes and cannot escape at all through the other joins. Also make careful provision that a flat thin piece of copper should hang in the head of each bellows, in front of its pipe hole, to close up the entrance hole for the air, so that the copper rises up and all the wind goes out when the bellows are depressed in blowing, but, when the bellows are raised to receive air again through their own intake, the copper completely closes the mouth and does not allow the wind that was sent out to return.

Chapter 85. Casting Bells

When you are going to make a bell,[1] first cut a dry piece of oak, as long as you want the bell to be, but projecting a span beyond the mold at each end. It should be square and thicker at one end, while the other should be slenderer and rounded so that it can be turned in a hole. It should become gradually thicker and thicker, so that,

[1] Theophilus was concerned with two kinds of bells, the large church bells (*campanae*, or *cloccae* as they were also called by other medieval writers) which had clappers and were swung (described in this chapter), and the smaller bells, *cymbala*, referred to in III-86. Theophilus' description of making the latter is cursory; of the former, magnificent. It is interesting to com-

when the work is finished, it can easily be drawn out. One palm from the thicker end this spindle should be cut to make a circumferential groove two fingers wide, and there the spindle should be made round. The end of the spindle next to this groove should be made flat, so that it can be fitted into a wooden crank by means of which it can be turned, as is done in the case of the grindstone. Also make two boards, equally long and wide, fitted opposite each other and braced with four wooden [crossbars] wide enough to provide a space between them corresponding to the length of the above-mentioned spindle. Make a hole in one board in which the rounded end may rotate, and in exact line with this in the other make a groove two fingers deep in which the journal may turn.[2]

After doing this take the spindle and surround it with well-kneaded clay two fingers thick at first, and when that has been carefully dried put another layer on it and keep on doing so until the core is filled out as much as you want it to be. Take care that you never put on more clay until the layer beneath is completely dry. Now put the core in place between the boards described above. Seat a boy to

pare this description with that of Biringuccio some four centuries later (1540). Biringuccio describes the laying-out of the bell contours in detail; he uses a strickle in making the mold for large bells and melts the metal in a reverberatory furnace. He uses removable clay instead of meltable tallow for the pattern and in general has more detail than Theophilus, but there is little difference in principle. Biringuccio gives an actual bell scale which must be much like the "table of dimensions" used by Theophilus for the *cymbala* (III-86), although it was clearly based on practice, not mathematical rule alone. Biringuccio remarks, "It has been discovered by skilled bell founders, more through experience than from geometrical calculations (although calculation does enter), that a certain relationship of dimensions in both large and small bells makes the tone and the weight almost certainly what is desired. This is in addition to the customary shape which is, according to the historians, perhaps that found by the first discoverers of bells. Among themselves bell founders have made a rule of these measurements and have called it the bell scale [*la scala campanaria*]. Beginning with the small ones weighing ten pounds, it increases by degrees to a point where, as I have seen, they are able to make them even twenty-five and thirty thousand pounds. This scale is of great enlightenment if one does not have a bell already made for comparison" (Biringuccio, 1540; English trans., 1942, p. 260). Starting from the actual dimensions given for the thickness of the sound bow, Biringuccio builds up the shape of the bell by geometric construction. Theophilus, however, gives no such rules for his large bell, and one must assume that he worked by eye and had no thought of making a tuned set.

[2] See Figure 21.

work the handle and, using appropriate tools, turn it just as you want and smooth it by holding a wet cloth against it.

After this take some tallow, cut it up finely in a pot, and knead it with your hands. Then nail two flat smooth pieces of wood, of the thickness that you want [the metal to be], onto a flat smooth board, put the tallow in between them, thin it out and even it with a wooden roller as you did the wax above [III-61 and 84], after putting water beneath to prevent it sticking. Next lift it up and rapidly

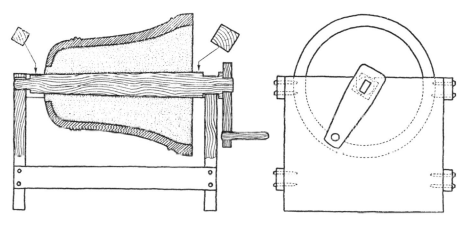

Fig. 21.—The lathe for turning heavy bell cores. Translators' reconstruction

lay it on the core and join it on around with a hot iron. Thin out another piece of tallow again in the same way, lay it next to the former piece and go on doing so until you have entirely covered the core. Make the rim of the bell as thick as you want. When the tallow is completely cold, turn it with sharp tools. If you want any fancy work in flowers or letters round the side of the bell, inscribe it in the tallow. Also shape four triangular holes close to the neck so that the bell will sound better.[3]

Then put on it sifted and carefully mixed clay and, when it is dry,

[3] The acoustic effect of these holes could hardly be significant. They were probably intended to provide bridges of clay to steady the core. Similar perforations occur in Chou dynasty Chinese bells and in the (pre-Buddhist) Japanese bell-like *dōtaku*. In the casting of guns (where of course the un- supported length of the core was much greater than in bells) iron chaplets were used (see Biringuccio, 1540, VI, 8a). These rods were left embedded in the guns, and can be seen today in the breeches of most surviving guns of the sixteenth century or earlier.

add another layer on top. When this also is completely dry, turn the mold on its side and extract the spindle by hammering gently. Lift the mold up again and fill up the upper part of the hole with soft clay, and press into it along the axis a bent [U-shaped] piece of iron for the clapper to hang on, with its ends projecting outside. When this clay is dry, level it off in line with the rest of the core and cover it with tallow so that the ends of the bent iron are deeply embedded in it. After this shape [out of tallow] the neck[4] and the canons and a vent and gate on the top and cover them with clay. When the clay has dried all over for the third time, bind [the whole mold] with iron hoops so close together that there is no more than a hand's width between any two hoops and then apply two layers of clay over them all. When these are dry, turn the mold on its side and cut a large, deep, cylindrical hole inside the clay [core] so that the remaining clay is nowhere more than a foot thick, since if the mold were solid inside, it could not be lifted because of the excessive weight and it could not be baked throughout because of its thickness.

Then dig a pit in the place where you want to set the mold for baking, of a depth corresponding to the height of the mold [and of appropriate] width. Now build a strong base with stones and clay, like a foundation, a foot high, on which the mold will stand. In a straight line running through[5] the center of this base there should remain a space like an alley, a foot and a half wide, where a fire is to burn beneath the mold. After doing this, fix close to the base four wooden posts which reach up to the level of the ground and then fill the pit with earth. Next, bring the mold over and set it squarely between these four posts and begin to dig out the earth under the mold on one side. When it tilts, dig on the other side until it tilts again on that side and continue doing this on each side until the mold sits squarely on the stone base. Now take out the posts, which were put in merely for the purpose of leading the mold straight down. Take some stones that can withstand flame, and some clay and build an

[4] The neck (Latin: *collum*) is in reality a heavy ring through which passes one of the wooden crossbars for hanging. The canons (*aures,* literally "ears") are loops of bronze through which

iron bands pass to secure the bell (see Fig. 24).
[5] *Ultra indirectum.* The meaning is uncertain.

arch[6] for the furnace on each side in front of the alley space that you left in the center of the base. Build the furnace all the way around at a distance of half a foot from the mold. Now, when in building it you have reached halfway up the mold, clean out the arches of the furnace and make a hole in the rim of the mold on each side through which the tallow can run out, and put pots beneath. Apply fire and dry wood. While the mold is heating and the tallow begins to escape, gradually finish the furnace right to the top of the mold. Place a

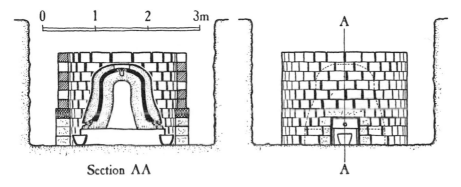

Fig. 22.—The bell mold in its pit, surrounded by a temporary furnace for melting out the tallow pattern and baking the mold. Reconstruction by translators.

little cover made of clay or iron over the mouth [of the mold]. When the tallow has completely run out, block up both the holes with kneaded clay, using just the right amount so as not to infringe upon the rim of the bell. Put plenty of wood around the mold so that the fire does not fail for a whole day and the following night.

Meanwhile take a round-bottomed iron pot, made for this work only, with two iron handles on each side.[7] If the bell is going to be

[6] *Oram,* literally a border, edge, or brim. The description of the mold-baking furnace is somewhat obscure. We believe that the intent was to surround the mold with a cylindrical wall of stones loosely laid with air spaces between them, the pit being large enough to leave space for a man to work and for air to circulate outside the wall. A possible design is shown in Figure 22. The arches in the bottom of the furnace wall were to allow wood to be placed in the "alley" under the mold, to provide access to the rim of the mold for making and closing the holes for the tallow to run out, and for inserting and removing pots to catch the tallow. The main fire, of wood, was placed in the space between the mold and the wall, receiving air through the spaces in the stonework.

[7] The cupola-like melting furnaces and the bellows are well depicted by Theobald (see **Fig. 23**).

very large, take two or three pots. Plaster them inside and out with
well-kneaded clay once, twice, and a third time, until it is two fingers
thick. Set them down opposite and facing each other in such a way
that you can walk between them. Pack ordinary earth underneath
them and fix wooden stakes around them. Now, in two or, if need be,
three places where the bellows are to be applied, fix firmly two
equally wide stakes leaving a space between them opposite the rim

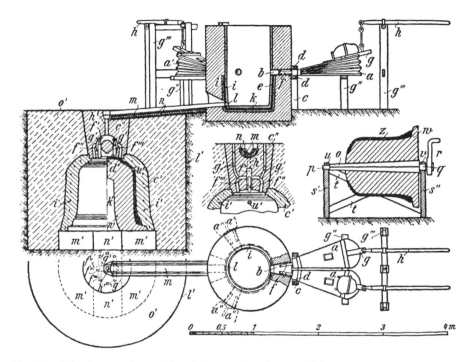

Fig. 23.—The furnace for melting bell metal, with a mold for casting a large bell. Re-
construction by Theobald (1933). (V.D.I. Verlag.)

of the pot, so that the blast can enter it. Put into each space a piece of
sheet iron bent round so that the pipes of the bellows can be fixed
securely in them. Then build up your furnace with stones and clay
around the pot, and extending a foot and a half above it. Plaster it
smoothly inside with the same clay and put in lighted coals. When
you have done the same with each pot, set up the bellows, two to
each hole, with their supporting structures on which they should lie
securely. Assign two strong men to each bellows. When the pots are

thoroughly red-hot inside, cut a pair of thick, dry pieces of oak for each pot, so shaped that [together] they cover the bottom inside; between them make a hole through which the bell metal can flow. On top of this pair, put another pair of the same size and lay on them a kind of ring of little stakes of the same wood, projecting from these pieces of wood up above the brim of the furnace.

After doing this, weigh all that you have of the components[8] of bell metal in the proportions of four parts of copper and a fifth of tin and place the right amount into each pot according to its capacity. Then go to the mold furnace, lift up the cover at the top, and see how the mold is behaving. If it is completely red-hot inside, run back to the pots and first put in some large pieces of charcoal, then put in the copper, piece by piece, without the tin and intermix charcoal, throwing plenty of it lavishly on top. When lighted coals have been thrown in, start the bellows blowing, at first gently, then more and more. When you see a green flame rising, the copper is now beginning to melt. Immediately pile on plenty of charcoal and run back to the mold furnace and, using long tongs, begin to rip out the stones from the top and throw them away. At this point the work requires not lazy workmen, but agile and eager ones, lest someone's carelessness should lead to a mold being broken or one workman getting in the way of another or hurting him or provoking him to anger, contingencies which must be avoided at all costs.

When the stones and the fire have been completely removed, the earth should be replaced with alacrity, so that the whole pit around the mold is carefully filled up again. Workmen should keep going around ramming fairly lightly with blunt wooden poles and stamping their feet hard so that, as the earth is being put in, it presses against the mold and will prevent it from breaking in any way when the weight of the bell metal is poured in.

When you have filled the pit right up to the top in this way, run back to the pots and stir the copper with a long, scorched stick and, if you feel that it is completely melted, put in the tin and stir it again carefully so that it mixes well. Break down the furnace all around and put two long, stout poles through the handles of the pot and,

[8] *Aeramentum.* See III-66, n. 1 (on copper alloys). Throughout this chap- ter Theophilus refers to bell metal as *aes.*

assigning strong experienced men, have them lift it up very carefully and carry it to the mold. Throw off the coals and ashes, put a skimming cloth in place, and see that the metal is carefully poured into the mold. While this is going on lie down close to the mouth of the mold and listen carefully to find out how things are progressing inside. If you hear a light thunderlike rumbling, tell them to stop for a moment and then pour again; and have it done like this, now stopping, now pouring, so that the bell metal settles evenly, until that pot is empty. Then take it away and immediately bring another, put it in the same place and do the same with it as you did with the first, and likewise with a third one until the bell metal can be seen in the gate. The [last] pot should not be taken away at once, but should be kept for a short time, so that if the bell metal sinks, more can be poured on top.

Now, if you want to avoid this effort of carrying and repeatedly pouring, get a very large pot with a flat bottom and make a hole in its side at the bottom and cover it inside and out with clay, as above. After doing this, place it close to the mold at a distance of not more than five feet, fix stakes round it, and put fire and charcoal in it. When it is red-hot, take some clay and seal the hole, which should have been turned to face the mold. Put the four pieces of wood and the little stakes inside, and build a furnace all around it as above. Then put in the copper with charcoal and fire, place three sets of bellows in position, and have them blown with all the men's strength. Meanwhile you should have a dry piece of wood long enough to reach from the hole in the pot to the mouth of the mold and with a deep channel in it. Cover this with clay all over, particularly on top, bury it flush with the ground but a little higher near the pot, and heap lighted coals over it. As soon as the tin has been put in and stirred with the copper, as above, open the hole with an iron hook firmly set into a wooden handle. With men standing by to hold two skimming cloths, let the bell metal flow out, but stop [its flow] from time to time as above. If any bell metal remains in the pot when the mold is full, put a lump of clay on the end of a thick wooden pole and drive it hard against the front of the hole so as to seal it.

Smaller bells can also be cast by either of these methods of casting and pots should be made according to the size of the bells.

When the bell metal has hardened in the gate, have the earth quickly thrown out of the pit and let the mold cool a little on the outside. After the earth has been removed, tilt the mold to one side and pack earth under it and keep on doing this until the mold is brought out of the pit in the same way as it was put in. After doing this, lay the mold right over on one side and with axes and other sharp tools with long wooden handles quickly take out the clay that is inside, since if it were allowed to cool there it would swell because of the dampness of the earth and the bell would undoubtedly be cracked.[9] After the clay has been taken out, set the mold upright again on the ground and leave it standing until it is completely cold on the outside. Break away the clay and remove the hoops. Whatever unevenness there is on the outside should be cut off with sharp-edged hammers. Next, put a piece of wood in the bell along its axis, like the one on which the core was originally turned,[10] and brace the rim of the bell with four other pieces of wood arranged in the shape of a cross. The gate should rest on one board and the wooden spindle on the board at the other [end of the lathe], so that after a wooden crank has been attached, the bell can be turned and smoothed all over with a sandstone.

After this, the gate should be filed on both sides and carefully broken off. Two pieces of wood should be fitted together round the neck, the smaller piece below, running through the middle of the neck, and the larger piece surrounding it on top. These pieces of wood should be firmly clamped together with two hoops and bound on every side with iron ties going around the canons. Now the larger piece of wood should be slightly longer than the bell is wide and it should be a little narrower at its ends than in the center. In these ends it should have two thick round iron pins extending half a foot into the wood and a span outside it.

Arrange two beams to support the bell and make two grooves in

9 See III-61, n. 5.

10 This wooden spindle would be shorter than the original one used for the core, and notched at one end to fit around the clapper iron inside the upper part of the bell. It is braced against the bell mouth and extends to provide a journal for turning. The other journal is provided by the gate, which would therefore have to be axial and cylindrical. The whole rests on two heavy boards forming an arrangement like the core lathe in Figure 21.

them two fingers deep in which these large pins may turn; and under the pins also put two curved iron [bearing blocks] to protect the beams. The larger piece of wood from which the bell is hanging should also have a hole in each side into which you should put two wooden bars looking upwards.[11] The ropes for tolling the bell should be tied to these bars. Also put a thick piece of leather from the neck of a stag around the bent iron which is embedded in the center of the bell, and hang the clapper on this. The clapper should be long enough to project a hand's width below the bell. It should be thicker at the end for the length of a palm and thinner above.

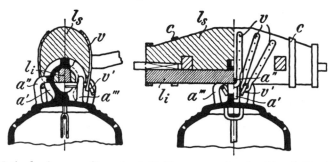

Fig. 24.—Method of suspending the bell. Reconstruction by Theobald (1933). (V.D.I. Verlag.)

Chapter 86. The Scale of Sizes for Small Bells

Whoever wants to make small bells sound in tune for playing should divide the wax for each one by weight.[1] He should start from the higher tones and descend until he reaches the lower ones, marking each with its proper letter, so that he can distinguish them in the course of the division. First, using the balance, he should make two equal pieces of wax, one for the letter *a,* the other for *G.* He should divide the wax of letter *a* into eight equal parts and add to the wax for letter *G* as much as there is in an eighth part of the wax of letter *a.* In the same way he should divide the wax of *G* into eight

[11] Figure 24, from Theobald, shows the manner of hanging the bell. Theophilus' suspension seems to be identical with that in common use on large bells until the introduction of the crown staple bolt in the nineteenth century.

[1] These small bells (*cymbala,* distinct from the larger *campanae* or tolling bells) were made in sets of eight or nine and were intended to be struck with a wooden bar or hammer as shown in the nearly contemporary illustration in Plate XV. They were used in teaching music and to accompany singing, frequently with the organ. The principal authority on these little bells, J. Smits van Waesberghe (1951), believes that the proportioning of the wax was more a discussion of musical theory than an actual guide to the bell-maker, who would use his own skill

and ingenuity in sizing and shaping the bell. Nevertheless, although the necessary details of shape of the bells are not given, and the factors are derived from Pythagorean theory, this chapter does read as if it were meant to be a reminder to the founder of the quantitative side of his operations. It is, in fact, the equivalent of the manual of measurements referred to by Theophilus in the previous chapter. Smits van Waesberghe reproduces and collates the texts of some thirty-eight manuscripts containing quantitative bell scales, twenty-two of which are more or less independent. He found the scales to fall into two classes, (a) those in which the bells have the same height, with the thickness and mass increasing as the pitch increases, with factors usually of 9/8 for a full tone difference and (b) those in which the thickness remains constant, the mass decreasing as the pitch increases by adjustment of the height and diameter. The latter scales sometimes start from the largest bell and work down in weight of wax; sometimes, as in Theophilus, start from the smallest and work up. Smits van Waesberghe noted that in over three hundred manuscripts on the theory of music that he has studied, none that contained these scales were of French or Italian origin

and so concluded that they were the scholarly work of some abbey or chapter in Germany, although there was no evidence that one area was ahead of another in the actual founding of the bells.

The derivations of the weights of wax for the individual bells are tabulated below. They are directly based on Pythagorean theory, with the ratio of weights inversely proportional to the frequency ratios. A whole tone interval is a fifth minus a fourth, i.e. $3/2 \times 3/4 = 9/8$, and a semitone is a fourth less two tones, i.e. $4/3 \times 8/9 \times 8/9 = 256/243$. Theophilus follows the standard diatonic scale with two semitone intervals ($B-C$ and $E-F$ respectively) and five whole tones ($A-B$, $C-D$, $D-E$, $F-G$, $G-A$) with an additional sharp (based on the ratio 243/128, a fifth less two semitones) between A and B. The theoretical frequencies are plotted in Figure 25. The actual frequencies of the bells as they came from the mold would not scale so exactly except in the case of simple geometric shapes such as plates (see Thompson, 1967), which were not used in medieval Europe and the bells would certainly have needed the adjustment that Theophilus describes at the end of this chapter.

Bell designation	Theophilus' derivation of the weight of wax	Relative weight W/W_a	Pythagorean Frequency $f/f_a = W_a/W$ adjusted to base $C = 1.0$
a	a	1.0000	1.6875
G	9/8 a	1.1250	1.5000
F	9/8 G	1.2656	1.3333
E	4/3 a	1.3333	1.2656
D	9/8 a [in error for 9/8 E]	1.1250 [1.5000]	1.5000 [1.1250]
C	3/2 G	1.6875	1.0000
B	4/3 F [in error for 4/3 E]	1.6875 [1.7778]	1.1250 [0.9492]
[S]	3/2 F	1.8984	0.8889
A	2 a	2.0000	0.8438

parts and make letter *F* out of the total of *G* plus an eighth. Thus he
will have two consecutive tones. At this point there ought to be a
semitone and he should get it like this: he should divide the total
wax of letter *a* into three parts and should make letter *E* out of it all
plus a third of it. Then he should make the letter *D* out of the total
of *E* plus an eighth.[2] Next he should make *C* out of the total of *G*

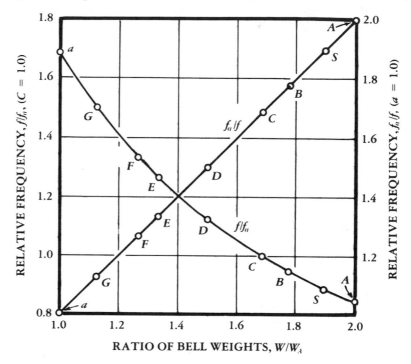

Fig. 25.—The tones of the *cymbala.* Diatonic scale, based on Pythagorean theory that
frequency is inversely proportional to mass.

plus a half, and so he will have two tones after the semitone. Then
he should make *B* out of the total of *E* plus a third. He will again
have a semitone, and should find[3] that he has a chime of seven bells
from letter *a* through *B*. But he will not yet have the octave without
the eighth bell. Therefore he should take double the total wax of
letter *a* and give it to letter *A* and nothing will be lacking for the

[2] *H* reads *a, et octavam;* Dodwell
emends to *a, et mediam.* The correct
weight was either *E* plus ⅛ of *E* or *a*
plus ½ of *a*, which are equivalent.

There is a similar error later where *B*
is made from *F* + ⅓; this should be,
as we read, *E* + ⅓.

[3] *Inveniat,* following *H.*

fourth, the octave, and the fifth. Now he should find the minor second like this: he should take away all the wax for letter [A], and establish the [new] letter between A and B by taking all of F plus a half of it.

The man who has to mold and cast small bells should be extremely careful that none of the above-mentioned wax, which has been so carefully weighed out and divided, is used for the yokes and the vents, but he should make these out of other wax. He should take great precautions that, before any small bell is cast, the tin is mixed with the copper so as to give the right sound, for if he does otherwise they will not be in tune. A fifth or sixth part should be tin and each metal should be refined well before being alloyed so that they sound clearly. If, after being cast, the bells do not have quite the right sound, this should be corrected with a file or a stone.

Chapter 87. Small Musical Bells

When you are going to make the small bells, first get a table [of dimensions]¹ and make the molds according to its directions, weighing out the wax carefully. When you have cast them in the way described above, if the tones are imperfectly matched through negligence or carelessness, correct them. If you want to have a bell with a higher tone, file the bottom of the rim; if lower, file round the rim on the outside.

Chapter 88. Tin Cruets

Make yourself two iron spindles, the length of a hand and slightly thinner than the little finger; they should be thicker at one end and taper gradually to the other end, so that they can be drawn out of the core. At the thicker end they should have flat tangs so that they can

¹ This table (*lectio*) must have contained quantitative information much like that in the previous chapter. A similar table of dimensions was used in making a series of organ pipes in III-81.

be fixed into round pulleys[1] which should have short, round pins on their other ends on which they can be turned. Put clay round the spindles, at first a little, then more, according to the size you wish. When the clay is dry, set up your lathe in the same way as the one on which platters and other wooden vessels are turned with one post fixed firmly and the other movable. When the latter is in place, it should be secured by a flat key [wedge] at the bottom.

Set a core between posts [i.e., the headstock and the tailstock] and the pins in their holes and put a strap around the wooden pulley.

[1] *Manubria,* literally handles. Figure 26 shows a reconstruction of the pewterer's lathe, based somewhat upon Theobald's second hypothesis. The text is not unambiguous. We assume that the two spindles of the first paragraph are simply to enable two cruet bodies to be in process at the same time, and not, as Theobald prefers, two halves of a single spindle which would be mechanically unsound. Note that Theophilus leaves the spindle in place during the baking and casting of the mold so as to have the cruet axially mounted for turning. For general information on the history of the lathe see Woodbury (1961). The spring-pole-and-treadle drive had begun to replace the simple crank before the end of the twelfth century.

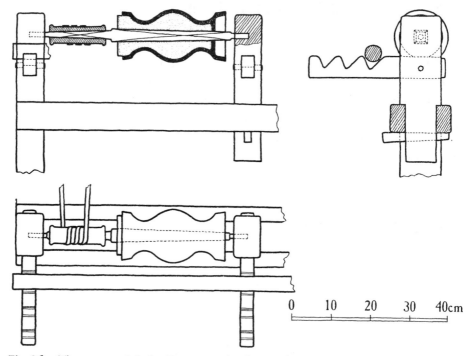

Fig. 26.—The pewterer's lathe. Reconstruction by translators. (The tool rest is taken from the description of the core lathe in III-61.)

Seat a boy to pull it [to and fro] and turn as you please; then cover it with wax. When the wax has been similarly turned, withdraw the mold with the spindle from the pulley, attach the vents [and a gate], put clay over it, and let it dry; remove the wax [by melting] and put the mold into the furnace to bake it, in the way described above [III-61 and 84]. When it is completely red-hot inside, take it off the fire and let it lie until it is cool enough to be held for a short time in your hand. Immediately melt some tin in an iron pan or in a dish and when it is time for casting add a little mercury to it in such proportions that if there is a pound of tin, there should be a quarter [of a pennyweight] of mercury.[2]

[2] *Si est libra stagni, quadrans sit vivi argenti.* The quantitative meaning is uncertain. Dodwell translates, "a quarter of a pint of quicksilver to a pound of tin," and Theobald, "zwar ein Viertelpfund Quecksilber auf ein Pfund Zinn." This is the only passage where Theophilus uses the word *libra* as a unit of measurement or the term *quad rans.* The latter literally meant a fourth part (here apparently a quarter of a pound), but in matters of usury it could mean 4 per cent and monetarily a fourth of a penny, or a farthing. Being the smallest coin known to the Middle Ages, the farthing became a symbol for a thing of slight or negligible value. Our rendering (a quarter [of a pennyweight]) is based on the conversion of the monetary value to one of weight. (See III-24, n. 1 for the weights used by Theophilus.) Only thus is the proportion metallurgically sensible. The formula corresponds to 1 part of mercury in 960 parts of tin, about 0.1 per cent, which would have a useful hardening effect. The larger amounts of 4 per cent, a quarter of a pound or of a pint, to a pound of tin, would give alloys with 3.9, 20, or 80 per cent mercury, respectively, by weight. The last two would contain liquid mercury at room temperatures and would be quite useless.

It may be that Theophilus meant that a little mercury should be added and a quarter of a pound of lead, for lead was a common alloy for tin even in Roman times. Small additions of various metals were usually added to tin to harden it. Bismuth, which has the double effect of hardening the metal and lowering its melting point, was used at least as early as the fifteenth century by pewterers, and copper, brass, and, later, zinc were also used. Fine tin, as defined by the 1348 ordinance of the London Pewterers Company (Welsh, 1902, I, 3), was hardened by brass "as moche as it wol receive of his nature of the same," while pots were to be cast from an alloy of 26 pounds of lead to 100 of tin, almost exactly the composition called for by Theophilus if for mercury one reads lead. Could there have been a confusion of the alchemical symbols of the two metals at some time?

The alloy which was used for soldering tin was commonly 1 lead to 2 tin, a close approximation to the true eutectic at 62 per cent tin which melts at 183° C. compared with 232° for pure tin. In the next chapter Theophilus prescribes 1 lead to 3 tin (25 per cent Pb) for use as a solder on the seams of a wrought tin pot, and it is odd that he does not recommend use of it for soldering the hole left by the core iron in the bottom of the cast pot.

Pour it into the mold without delay. When the mold is entirely cold, break the clay off the outside and when the pulley has been replaced mount the work on the lathe and turn it evenly all over. Finally polish it with shave-grass. After this take some of the scrapings of the tin, mix a little mercury with them, and rub them together with your fingers until they become completely liquid. Then, with a small cloth, smear this around the cruet while turning it until it is left dry and shining. Now extráct the spindle and the clay inside and dig a small groove in the center of the [thickness of the] tin around the hole at the bottom where the spindle had been, and fit into it a small piece of the same tin slightly thicker than the cruet is to be. Put inside [the cruet] a round piece of wood to support the tin so that it will not be bent, and hammer it on the outside with a medium-size hammer, until the tin is forced into the groove and stays firmly there. You can also seal up the hole in another way. Put a piece of wood inside the cruet, as above, with its end wrapped in a cloth; now scrape the hole and smear it with wax, melt some plain lead and pour it in and then quickly even it out with a small hammer.

Chapter 89. How Tin Should Be Soldered

Hammer out of tin two matching cups and fit them together in the middle so that the rim of one goes inside the other. Put the one which holds the other in hot ashes. Then hammer very thin a piece of the same tin, mixed with a third part of lead, and cut it up in little pieces. Place these around [the joint], apply a few lighted coals and as soon as [the work] warms up, smear it around with resin from a fir tree and immediately you will see the pieces melt and flow about. Take away the coals at once and when it is cool it will be firm. Any kind of work in straight tin can be soldered by this method, namely, spouts and handles on pots and the hinges for lids; also any hole that occurs in a cast pot as a result of negligence.

Chapter 90. Casting the Spout

The spout can be easily made also in this way. Cut a piece of cleavable wood to a round shape and make a longitudinal hole in it with

a drill but not right to the end. Split it down the middle and make a hole in the end that has not been drilled. Through this hole fit into place a round piece of iron [to form the core], thinly coated with clay, to correspond to the inside dimensions of the spout.[1] Then bind the mold firmly around on the outside, warm it, and pour in the tin. When it is cold, loosen the wood, take out the piece of iron, file the spout, finish it off smoothly, and solder it to the vessel in the way described above.

Chapter 91. Iron [and Overlaying and Inlaying with Gold and Silver]

Iron is engendered in the earth in the form of stones. When it has been dug out, it is broken up in the same way as copper above [III-63] and smelted down into lumps. Then it is melted [sic] on an iron-worker's forge and hammered, so that it becomes suitable for any kind of work.[1] Steel is named after the mountain Chalybs where the greatest use of it is found. It is prepared in the same way as iron so that it becomes suitable for work.

[1] Following Theobald's emendation, *effusorii.*

[1] *In massas confunditur, deinde in furnace ferrarii liquatur et percutitur, ut aptum fiat unicuique operi.* Dodwell literally, reasonably, but, we believe, improperly, translates: "melted down into pigs, then it is smelted in the iron foundry and hammered so that it becomes fit for any work." Certainly the words *confunditur* and *liquatur* imply actual liquefaction, but there is no shred of evidence that cast iron was actually intentionally produced from the ore in Europe until the fifteenth century (see Schubert, 1957). Iron was made by reducing the ore in rather small furnaces which operated below the melting point, to give blooms of a spongy product which had to be worked by hammering at a white heat to consolidate the metal and make it fit for use.

It is generally supposed that the various passages in classical authors (including Aristotle *Meteorologica* IV. 6) which imply the liquidity of iron at some stage of its processing were written in ignorance of the distinction between the smelting of iron and that of the fusible non-ferrous metals, or that they simply referred to the extreme softness of the metal when it is hot. Cast iron was certainly not (in Europe) regarded as a useful material in the arts, and the few fragments of cast iron that have been found in ancient smelting sites are most probably the result of accidental overheating, but it cannot be stated with certainty that the metal was never intentionally partially melted to provide a bath for the rapid carburization of iron in making steel. Theophilus obviously had no first-hand connection with iron smelting.

Therefore, when you have prepared iron and made spurs or other riding gear out of it and you wish to decorate them with gold or silver, take the purest silver and hammer it out very thin.[2] Then you should have a turned disk made of oak a foot in diameter. It

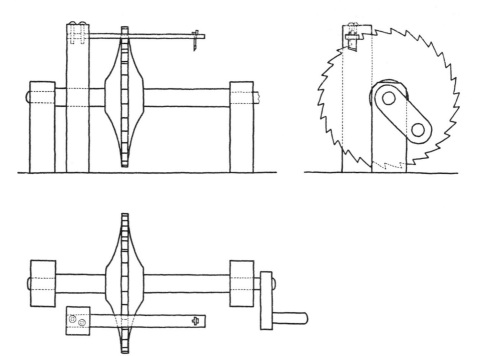

Fig. 27.—Theophilus' machine for cutting grounds on iron for overlaying with gold and silver. Reconstruction by translators.

should be thin at the circumference and thick on both sides of the center, through which you should fix a round piece of wood on which it can turn. Then put on one end of this [axle] a wooden

[2] True inlay is described at the end of this chapter. The first method of overlaying, or damascening as it is frequently misleadingly called, depends on the formation of a fine cross-cut series of tiny grooves, like those on a file but finer, on top of which soft gold or silver is laid in appropriate patterns and hammered or rubbed until it firmly adheres as a result of the interlocking deformation of the steel and non-ferrous metal. The ingenious little machine that Theophilus describes for cutting the ground is illustrated in Figure 27. It is not a sound design mechanically and cannot have worked well in practice, for even today craftsmen usually produce the crosshatched ground with a sharp chisel held in the hand. Somewhat similar machines were later used, however, for cutting the coarser grooves on files.

crank by which it can be turned. Fit the wheel between two small
posts and on the outside of its rim make cuts like steps, looking
backwards. The posts between which the disk rotates should be
firmly fixed crosswise onto a bench, with the crank on the right-
hand side. Also set up another post on the left side in front and
close to the wheel, and fix a thin piece of wood on it, so that it rests
on the wheel. It should have a piece of steel on its end, as long and
wide as the nail of the large finger. This should be firmly fixed [to
the wooden arm] through a hole and should be very sharp. When
the wheel is turned, the piece of wood keeps on falling from one
step to the next so that the steel is thereby vibrated and it cuts any-
thing that is held against it.

When you have smoothly filed a spur, put it on blazing coals
until it begins to turn black and allow it to cool. Now turn the
wheel with your right hand and in your left hold the spur against
the steel and all over the outside make fine cuts lengthwise and a
double set of cuts crosswise. After doing this, with small shears rub
off little pieces of silver as you want and lay them on [over the
hatchings]. Then using the same shears rub the edges of the silver
so that they will stick fast. When you have worked over the whole
of the spur, put it back on burning coals, until it again becomes black;
then lift it off with the tongs and polish it carefully with a long, ex-
tremely smooth, steel [burnishing] tool fitted into a handle. Put it
back on the coals and heat it again; then polish it vigorously again
with the same tool. If you want to gild it, partly or all over, it should
be in your power.

Cut bits and the other horse trappings or anything else you want
in iron, in the way described above, but more deeply. You should
also have very fine silver and gold wires, from which you can shape
tiny flowers and circles or anything else you like. Lay these on the
iron with fine tweezers in any way you wish, but always alternate
gold flowers and silver ones. Strike them gently with a small ham-
mer, so that they stick fast. When the whole surface has been filled
up in this way, put the iron on live coals until it begins to turn
black and strike it carefully with a medium-size hammer until,
wherever iron appears, the cuts are evened out and so the work
looks as if it were niello.

If you wish to have letters on knives or other things made of iron, engrave them first with an engraving tool, then from a thick silver wire that you have made, shape the letters with fine tweezers, lay them in the grooves and embed them by striking them on top with a hammer. In this way you can also make little flowers and circles in iron [things], inlaying them with copper and brass wire.

If any of this work is broken through age or neglect and you want to recover the silver that is on it, put it in the fire until it is red-hot, then hold it with tongs in your left hand and with your right hand rub a long piece of lead over all the places where the silver can be seen. As soon as the lead melts, the silver will melt and alloy with it. Then you cupel the lead and recover the silver.

Chapter 92. Brazing Iron [and Surface Finishes for It]

Thin rings are also made out of iron to be put on the handles of iron tools. Since these cannot be welded, a thin strip of copper is wrapped around them at the join and a little clay is put around it. When this is dry, put it beneath coals on the forge and blow. As soon as it is red-hot, the copper will melt and flow around and braze it. In this way also tinned keys, if broken, or anything else of iron can be brazed.

If you want to make locks for locking clothes chests, hammer out a flat thin piece of iron and bend it around another circular piece of iron and fit a support to it above and below. Then put little strips of the same iron around it and between them little flowers or circles, as you wish, in such a way, however, that one piece always presses against the next, so that it holds fast and cannot fall out. Now make an alloy of two parts of copper and a third of tin and crush it to a powder with a hammer in an iron pot; then burn some argol, add a little salt to it, mix it with water, smear it all around, and sprinkle the powder around it. When it is dry, smear the mixture around it again more thickly and put it on live coals. Then carefully cover it all around [with charcoal] as in the case of the silver above [III-31],

and braze it in the same way; let it cool by itself and wash it. In this way you can braze anything of iron that you want, but it can not be gilded in any way.

If you want to coat an iron object with tin, first file it and, before touching it with your hand, while it is freshly filed, throw it into a pot of melted tin with tallow and stir it about with tongs until it becomes white. Then take it out, shake it vigorously, and clean it with bran and with a linen cloth.

When you have made iron locks and hinges for small chests and for doors, finally heat them and smear them with pitch.[1] The nails, however, should be tinned. When you have made spurs, bits and saddle furniture for humble clerics and monks, and have filed them smooth, heat them a little and rub them with ox horn or with goose feathers. For when these are slightly melted by the heat and stick to the iron, they will provide a black color which is somehow appropriate to it.

Chapter 93. Carving Ivory

When you are going to carve ivory,[1] first shape a tablet of the size you want, put chalk on it and draw figures with a piece of lead according to your fancy. Then mark out the lines with a slender tool so that they are clearly visible. Next cut the grounds with various tools as deeply as you wish and carve figures or anything else you like according to your skill and knowledge. If you want to ornament your work with gold leaf, put an undercoat of glue from the bladder of the fish called the sturgeon, cut the leaf into pieces and lay them on as you wish.

Now fashion ivory handles, round or ribbed, and make a hole down the axis. Enlarge the hole with various appropriate files so

[1] To give a protective black finish.

[1] Latin: *os*. In this chapter Theophilus uses this word interchangeably with *ebur* for ivory. In the next, however, *os* is used for the material of an elephant tusk, a fish bone (walrus tusk?), or a stag's horn. Plate XVI shows a detail of a twelfth-century reliquary in which carved openwork in ivory is backed with gilded bronze, the latter, alas, now heavily tarnished. The carving of ivory was a very important medieval art and no one but a metal-worker could have dismissed it with so brief a treatment as does Theophilus.

that the inside is the same shape as the outside and the ivory is even throughout and moderately thin and flat. Around the outside delicately draw little flowers or animals, or birds, or dragons linked by their necks and tails, pierce the grounds with fine tools and carve with the best and finest workmanship that you can. After doing this, fill the hole inside with a piece of oak covered with gilded copper sheet so that the gold can be seen through all the [pierced] grounds. Then seal up the front and back of the hole by fitting in two pieces of the same ivory and secure them with ivory pegs so cunningly that no one can see how the gold was inserted. After this make a hole in the piece in front through which the blade can be put. Since it is wood inside, the tang can easily be inserted when it is hot and it will stay firmly.

Also make a plain handle of any kind you want and make a hole of appropriate size in it, into which the knife is to be put. Then carefully fit a piece of wood into the hole and shape the tang of the knife to match the piece of wood. Now grind some clear frankincense into the finest powder and fill the hole in the handle with it. Wrap a damp linen cloth three times around the knife close to the tang, put it on the forge, heat the tang until it is slightly red-hot, and immediately fix it carefully into the handle, so that it fits well and it will stay firmly.

If at any time a knife is broken through age or carelessness in such a way that a piece is left projecting out of the handle, heat a blacksmith's tongs, grip the tang, and hold it long enough for it to grow hot and immediately draw it out. A knife can be fixed firmly with ground sulphur in the same way, not only in ivory but also in hard wood.

Chapter 94. Staining Bone Red

There is also a plant called madder, whose root is long, thin, and reddish. After it is dug up, it is dried in the sun and pounded in a mortar with a ball. Then lye is poured over it and it is cooked in a

raw pot. When it has been boiled well, if the bone[1] of an elephant or a fish or a stag is put in it, it will become red. From these bones or horns knops can also be made on the lathe for the staves of bishops and abbots and smaller knops for various useful objects. When you have turned these with sharp tools, smooth them with shavegrass. Collect the shavings on a linen cloth and, still turning the lathe, rub them vigorously on the knops which will then become completely shining. You can also polish horn-handles, huntsmen's horns, and [horn] windows in lanterns with sifted ashes on a woolen cloth. But do not forget to smear them finally with walnut oil.

Chapter 95. Polishing Gems

Rock crystal is water hardened into ice, which is then hardened through many years into stone. It is cut and polished in this way. Take some chaser's pitch, about which we spoke above [III-59], and put it on the fire until it melts. Then cement the crystal with it to a long piece of wood of comparable thickness. When it is cold, rub it with both hands on a piece of hard sandstone, adding water, until it takes on the shape you want to give it.[1] Then [rub it] on another stone of the same kind but finer and smoother until it becomes completely smooth. Now take a flat, smooth lead plate and on it put moistened tile (which has been abraded [to dust] with saliva on a hard hone) and polish the crystal on it until it becomes brilliant. Lastly, put some tile dust moistened with saliva on a goat skin that is neither blackened [i.e., tanned?] nor greased, stretched on a piece of wood and fastened on the underside with nails. Rub [the crystal] on this until it is completely clear.

If you want to carve a piece of rock crystal, take a two- or three-year-old goat and bind its feet together and cut a hole between its breast and stomach, in the place where the heart is, and put the

[1] See III-93, n. 1.

[1] It will be noticed with some surprise that Theophilus mentions no machines for use in cutting or polishing gems. Such devices were well developed by the fifteenth century (see Schroeder, 1931). A range of good small machines is described in a Swedish manuscript of the early sixteenth century (Johånnsen, 1941, pp. 139–62).

crystal in there, so that it lies in its blood until it is hot. At once take it out and engrave whatever you want on it, while this heat lasts. When it begins to cool and become hard, put it back in the goat's blood, take it out again when it is hot, and engrave it. Keep on doing so until you finish the carving. Finally, heat it again, take it out and rub it with a woolen cloth so that you may render it brilliant with the same blood.

If you want to make knops out of rock crystal to put on bishops' staves or on candlesticks, you should pierce them in this way. Make yourself two hammers as thick as your little finger, almost a span long, very slender and well steeled at each end. After shaping the knop cut a hollow in a piece of wood so that the knop lies in it half-way. Fix it firmly with wax in the wood, so that it sticks fast. Now take one of the small hammers and strike gently in one place in the middle of the knop, until you make a small hole. Then enlarge the hole by striking in the middle and by carefully chipping around. Keep working in this way until you reach the midpoint of the knop; then turn it over and do the same on the other side until you have pierced it through. Then hammer out a copper rod, a foot long, so that it can go through the hole, take some sharp sand mixed with water, put it in the hole and file with the copper rod. When you have widened the hole a little, hammer out another thicker copper rod and file with it in the same way. If need be, use a third copper rod, still thicker. After enlarging the hole as much as you want, crush some sandstone very finely, put it in [the hole], and file with a new copper rod until it becomes smooth. Then take some lead, similarly round, add tile dust with saliva, and polish the inside of the hole and the outside of the knop as above.

Take a very pure piece of crystal shaped into a perfectly round form and polished, wet it with water or saliva, and expose it to the bright sun. Place underneath it a piece of the tinder called *centura*, so that the sun's brilliance vibrates onto it, and it will very quickly draw fire.

If you want to cut up a piece of crystal, fix four wooden pegs on a bench so that the crystal lies firmly between them. They should

be spaced so that each of the pairs is so closely fitted above and below that a saw can just be drawn between them and cannot be deflected anywhere. Then insert an iron saw and throw on sharp sand mixed with water. Have two men stand there to draw the saw and to throw on sand mixed with water unceasingly. This should be continued until the crystal is cut into two parts; then rub and polish them as above.

In the same way onyx, beryl, emerald, jasper, chalcedony, and the other precious stones are cut, ground, and polished. A very fine powder is also made from fragments of crystal. This is mixed with water and put on a smooth flat piece of lime wood and the same stones are rubbed on it and polished. Hyacinth, which is harder, is polished in the following way. There is a stone called emery, which is crushed until it is like sand, then placed on a smooth copper plate and mixed with water and the hyacinth is shaped by rubbing on this. The washings which run off should be carefully collected in a clean basin and allowed to stand overnight. On the following day the water should be entirely removed and the powder dried. Afterwards put it on a smooth flat limewood board, wet it with saliva, and polish the hyacinth on it. Gems made of glass are also ground and polished in the same way as rock crystal.

Chapter 96. Pearls

Pearls are found in shells from the sea and other rivers. They are pierced with a fine steeled drill fixed into a wooden spindle having on it a small lead wheel and another piece of wood in which it can turn. A strap is attached by means of which it can be rotated.[1] If it is necessary to enlarge the hole in any pearl, a wire with a little fine sand should be put through the hole and one end of the wire held

[1] This is a pump drill of the more elegant form in which the shaft passes through, and is guided by, the cross-bar. Two of these are shown on the rear wall of the Stephanus workshop (Plate IV).

in the teeth and the other with the left hand; then the pearl is drawn up and down the wire with the right hand, while [more] sand is added, so that the hole becomes larger.

Sea shells are also cut into pieces and from them pearls are filed [i.e., pieces of mother-of-pearl] and polished as above. These are satisfactory to use on gold.[2]

[2] The Harley manuscript contains after this point sixteen chapters, numbered 96 to 111, all of which are taken from Eraclius, and thirteen unnumbered ones, five of which are from the *Mappae clavicula*. The earlier manuscripts do not contain them and they are obviously later copyists' additions. They deal mostly with the making of pigments (including metal powders) with a little on coloring of glass and on the hardening of tools for cutting it. R. P. Johnson (1939, pp. 104–5) quite improperly cites these as evidence to support his view that Theophilus had Eraclius before him when he wrote Book III.

Bibliography

Bibliography

Note: An asterisk (*) indicates items listed in "Printed Editions of the Treatise," pages xxii–xxiv.

Amman, Jost. *Eigentliche Beschreibung aller Stände auf Erden. . . . Durch den weitberumpten Hans Sachsen.* (Woodcuts by Jost Amman.) Frankfurt, 1568.

Barnard, Noel. *Bronze Casting and Bronze Alloys in Ancient China.* Monumenta Serica, Monograph XIV. Tokyo, 1961.

Berger, Ernst. *Quellen und Technik der Fresko-, Oel-, und Tempera-Malerei des Mittelalters. . . .* Munich, 1897. This and the following are parts of the author's *Beitrage zur Entwicklungs-Geschichte der Maltechnik.*

————. *Die Maltechnik des Altertums nach den Quellen, Funden, chemischen Analysen und eigenen Versuchen.* Munich, 1904.

Berthelot, Marcellin Pierre Eugène. *Les origines de l'alchimie.* Paris, 1885.

————. *Introduction à l'étude de la chimie des anciens et du moyen âge.* Paris, 1889.

Biringuccio, Vannoccio. *De la pirotechnia.* Venice, 1540. English translation by Cyril S. Smith and M. T. Gnudi. New York, 1942.

Bischoff, Bernhard. "Die Überlieferung des Theophilus—Rugerus nach den ältesten Handschriften," *Münchner Jahrbuch der bildenden Kunst,* ser. 3, 3–4 (1952–53), 145–49.

*Bontemps, Georges, 1876.

*Bourassé, Jean Jacques, 1851.

Braun, Joseph. *Das christliche altargerät in seinem Sein und in seiner Entwicklung.* Munich, 1932.

Burnam, John M. *A Classical Technology Edited from Codex Lucensis 490.* Boston, 1920.

Caley, E. R. "The Leyden Papyrus X—an English Translation with Brief Notes," *Journal of Chemical Education,* 3 (1926), 1149–66.

————. "The Stockholm Papyrus—an English Translation with Brief Notes," *ibid.,* 4 (1927), 979–1002.

Carswell, John. *Romantic Rogue; Being the Singular Life and Adventures of Rudolph Erich Raspe, Creator of Baron Munchausen.* London, 1950.

Carter, Thomas F., and Goodrich, L. C. *The Invention of Printing in China and Its Spread Westward.* 2d ed. New York, 1955.

Cellini, Benvenuto. *Due trattati, uno intorno alle otto principali arti dell'oreficeria. L'altro in materia dell'arte della scultura.* Florence, 1568. English

translation by C. R. Ashbee (from the Italian edition edited by Milanesi, 1857). London, 1898.

Cennini, Cennino. *Il libro dell'arte* [1437]. Edited and translated by D. V. Thompson, Jr. 2 vols. New Haven, 1932–33.

Chambon, Raymond. "Esquisse de l'évolution morphologique des creusets de verrerie, de l'antiquité à la Renaissance," *Annales du 1er Congrès des Journées Internationales du Verre"* (Liége), August, 1958, pp. 115–17.

Clemens, Paul. *Die romanische monumental Malerei in den Rheinländen,* Düsseldorf, 1916, pp. 528 ff.

Coglan, H. H. *Notes on Prehistoric and Early Iron in the Old World.* Oxford, 1956.

Compositiones variae (Lucca Manuscript). See Hedfors, 1932, and Burnam, 1920.

Deckert, Hermann; Freyhan, R.; and Steinbart, K. *Religiöse Kunst aus Hessen und Nassau.* 1 vol. text, 2 vols. plates. Marburg, 1932.

Degering, Hermann. "Theophilus Presbiter qui et Rugerus," *Westfälische Studien . . . Alois Bömer gewidmet,* Leipzig, 1928, pp. 248–62.

Deutsches Handwerk im Mittelalter, Bilder aus dem Hausbuch der Mendelschen Zwölfbrüderstiftung in Nürnberg, mit einem Geleitwort von Friedrich Bock. (Insel-Bucherei Nr. 477.) Leipzig, 1935.

*Dodwell, C. R., 1961.

Eraclius. *De coloribus et artibus Romanorum.* For text of this see Merrifield, 1849; Ilg, 1874; and Richards, 1940.

Ercker, Lazarus. *Beschreibung allerfürnemisten mineralischen Ertzt und Berckswercksarten.* Prague, 1574. English translation from the German edition of 1580 by Anneliese G. Sisco and Cyril S. Smith. Chicago, 1951.

*Escalopier, Comte Charles de l', 1843.

Feldhaus, Franz Maria. *Die Technik der Vorzeit, der geschichtlichen Zeit und der Naturvölker.* Leipzig and Berlin, 1914.

Fowler, James. "On the Process of Decay in Glass and on the Composition and History of Its Manufacture," *Archaeologia, 46* (1880), 65–162.

Fuchs, Alois. *Die Tragaltäre des Rogerus in Paderborn.* Paderborn, 1916.

Galon. *L'art de convertir le cuivre rouge ou cuivre de rosette en laiton ou cuivre jaune.* Paris, 1764.

Goldsmith, J. N., and Hulme, E. W. "History of the Grated Hearth, the Chimney and the Air Furnace," *Transactions of the Newcomen Society, 23* (1942–43; pub. 1948), 1–12.

Gowland, W. "A Japanese Pseudo-Speiss (Shiromé) . . . ," *Journal of the Society of Chemical Industry, 13* (1894), 463 ff.

Grodecki, Louis. "Fragments de vitraux provenant de Saint Denis," *Bulletin Monumentale, 110* (1952), 51–62.

———. "Les Vitraux allégoriques de St. Denis," *L'Art de France, 1* (1960), 26.

Hedfors, H. (ed. and trans.). *Compositiones ad tingenda musiva. . . .* Uppsala, 1932.

*Hendrie, Robert, 1847.

Hunter, H. L., and Whiley, C. *Leaves of Gold.* London, 1951.

*Ilg, Albert, 1874.

Jansen, Franz. *Die Helmarshausener Buchmalerei zur Zeit Heinrichs des Löwen.* Hildersheim, 1933.

Johannsen, Otto (ed.). *Peder Månssons Schriften über technische Chemie und Hüttenwesen . . . übersetzt und erläutert von Otto Johannsen.* Berlin, 1941.

Johnson, R. P. "Note on Some Manuscripts of the *Mappae Clavicula,*" *Speculum, 10* (1935), 72–81.

———. "The Manuscripts of the *Schedula* of Theophilus Presbyter," *ibid., 13* (1938), 86–103.

———. *Compositiones variae. . . . An Introductory Study.* ("Illinois Studies in Language and Literature," Vol. XXIII, No. 3.) Urbana, 1939.

Karp, A. "Colour Image Synthesis with Two Unorthodox Primaries," *Nature, 184* (1959), 710–12.

Knowles, J. A. "Processes and Methods of Medieval Glass Making and Painting," *Journal of the Society of Glass Technology, 6* (1922), 255–74.

*Lessing, Gottholt Ephraim, 1781.

Lewis, Kenneth B. "The Shape of Things To Come," *Wire and Wire Products, 17* (1942), 3–9, 49–57.

Månsson, Peder. See Johannsen, 1941.

Mappae clavicula (ninth century). See Phillipps, 1847.

Maryon, Herbert. "Metal Working in the Ancient World," *American Journal of Archaeology, 53* (1949), 93–125.

———. *Metalworking and Enamelling: A Practical Treatise.* 3d ed. London, 1954.

Mendel Brothers. *Hausbuch.* Manuscript in Stadtbibliothek, Nuremberg. For heavily retouched reproductions of many of the illustrations see *Deutsches Handwerk im Mittelalter . . .* (1935).

Merrifield, Mary Philadelphia. *Original Treatises, Dating from the XIIth to the XVIIIth Centuries on the Arts of Painting in Oil.* 2 vols. London, 1849.

Meyer, E. "Die Hildesheimer Rogerwerkstatt," *Pantheon, 32* (1940), 1–11.

———. "Neue Beiträge zu Kenntnis der Kunst des Roger von Helmarshausen und seines Kreises," *Westfalen, Hefte für Geschichte Kunst und Volkskunde, 25* (1940), 6–17.

Morelli, Jacopo. *I codici manoscritti volgare della Libreria Naniana.* Venice, 1776.

Moss, A. A. "Niello," *Studies in Conservation, 1* (1955), 49–62.

Phillipps, Thomas. "Letter . . . communicating a transcript of a MS Treatise on the preparation of Pigments, and on various processes of the Decorative

Arts practiced in the Middle Ages, written in the twelfth century, and en-
titled *Mappae clavicula,*" *Archaeologia, 32* (1847), 183–244.

*Raspe, Rudolf Erich, 1781.

Richards, J. C. "A New Manuscript of Heraclius," *Speculum, 15* (1940),
255–71.

Roosen-Runge, Heinz. "Die Buchmalereirezepte des Theophilus," *Münchner
Jahrbuch der bildenden Kunst,* ser. 3, 3–4 (1952–53), 159–71.

Rosenberg, Marc. *Geschichte der Goldschmiedekunst auf technischer Grund-
lage.* [Vol. I], *Einführung,* 1910. [Vol. II], *Niello,* 1908. [Vol. III], *Zellen-
schmelz* (3 parts), 1921, 1922. Frankfurt a. M.

Schnitzler, Hermann. *Rheinische Schatzkammer. Die Romanik.* Düsseldorf,
1959.

Schroeder, Alf. *Entwicklung der Schleiftechnik bis zur Mitte des 19. Jahr-
hunderts.* Hoya(weser), 1931.

Schubert, H. R. *History of the British Iron and Steel Industry from c. 450
B.C. to A.D. 1775.* London, 1957.

Smith, C. S. "Methods of Making Chain Mail," *Technology and Culture, 1*
(1959), 60–67, 151–53, 289–91.

*Smits van Waesberghe, 1951.

Stillman, John M. *The Story of Early Chemistry.* New York, 1924.

Sumner, William L. *The Organ: Its Evolution, Principles of Construction and
Use.* London, 1952.

Swarzenski, Hanns. *Monuments of Romanesque Art: The Art of Church Treas-
uries in North-Western Europe.* London and Chicago, 1954.

Taylor, F. S. "Pantheo's *Voarchadumia,*" *Transactions of the Newcomen So-
ciety, 29* (1954), 93–101.

*Theobald, Wilhelm, 1933.

———. "Die Herstellung des Blattmetalls in Altertum und Neuzeit," *Glasers
Annalen für Gewerbe und Bauwesen* (Berlin), 70 (1912), 91–99; 71 (1912),
28–37, 41–48, 73–76, 90–96, 112–14.

Thompson, Daniel V. "The Schedula of Theophilus Presbyter," *Speculum,*
7 (1932), 199–220.

———. *The Materials of Medieval Painting.* London, 1936.

Thompson, F. C. "The Early History of Wire," *Wire Industry, 2* (1935),
159–62.

Thompson, Reginald Campbell. *On the Chemistry of the Ancient Assyrians.*
London, 1925.

———. *A Dictionary of Assyrian Chemistry and Geology.* Oxford, 1936.

Thorndike, Lynn. *A History of Magic and Experimental Science.* 8 vols. New
York, 1923–58.

Turner, W. E. S. "Studies in Ancient Glass and Glass-making Procedures,"
Journal of the Society of Glass Technology, 40 (1956), 39–52, 162–86, 276–
99.

Voice, E. H. "The History of the Manufacture of Pencils," *Transactions of the Newcomen Society,* 27 (1950), 131–41.

Waetzoldt, S. "Systematische Verzeichnis der Farbnamen," *Münchner Jahrbuch der bildenen Kunst,* 3–4 (1952–53), 6–14.

Welsh, Charles. *A History of the Worshipful Company of Pewterers of the City of London.* 2 vols. London, 1902.

Wentzel, Hans. *Meisterwerke des Glasmalerei.* 2d ed. Berlin, 1954.

Werner, A. E. A. "A Commentary on Eikelenberg's Varnish Recipes," *Studies in Conservation,* 3 (1958), 132–34.

Weyl, Woldemar A. *Coloured Glasses.* Sheffield, 1951.

White, Lynn. "Technology and Invention in the Middle Ages," *Speculum,* 15 (1940), 141–59.

———. *Medieval Technology and Social Change.* Oxford, 1962.

Wilson, H. *Silverwork and Jewellery.* London, 1951.

Winbolt, S. E. *Wealden Glass.* Hove, England, 1933.

*Winston, Charles S., 1847.

Woodbury, Robert S. *A History of the Lathe to 1850.* (Society for the History of Technology, Monograph 1.) Cleveland, 1961.

*Zebrawski, Teophil, 1880.

ADDITIONS TO BIBLIOGRAPHY, 1978

Aitchison, Leslie. *A History of Metals.* 2 vols. London, 1960.

Anderson, E. W. "The Development of the Organ," *Trans. Newcomen Society,* 8 (1937–38), 1–18.

Frinta, M. S. "A Note on Theophilus, Maker of Many Wonderful Things," *Art Bulletin,* 46 (1964), 524–29.

Haedeke, Hanns-Ulrich. *Metalwork.* London and New York, 1970.

Laurie, A. P. *Materials of the Painter's Craft.* London, 1911. (Contains a careful translation of the Preface to Theophilus' Book III.)

Lins, P. A., and Oddy, W. A. "The Origins of Mercury Gilding," *Journal of Archeological Science,* 2 (1975), 365–73.

Oddy, [W.] A. "The Production of Gold Wire in Antiquity," *Gold Bulletin,* 10 (1977), 79–87.

Roosen-Runge, Heinz. *Farbgebung und Technik frümittelalterlicher Buchmalerei. Studien zu den Traktaten "Mappae Clavicula" und "Heraclius."* 2 vols. Munich, 1967.

———. "Farben und Malrezepte in frühmittelalterlichen technologischen Handschriften," in Ploss, E. E., *et al. Alchimia, Ideologie und Technologie.* Munich, 1970, 47–66.

———. "Die Tinte des Theophilus," in *Festschrift Luitpold Dussler,* Munich, 1972, 87–112.

Smith, C. S., and Hawthorne, J. G. *Mappae Clavicula, A Little Key to the World of Medieval Techniques.* Philadelphia, 1974.

Smith, C. S. "Metallurgical Footnotes to the History of Art," *Proceedings of the American Philosophical Society, 116* (1972), 97–125.

Thompson, Daniel V. "Theophilus Presbyter. Words and Meanings in Technical Translation," *Speculum, 62* (1967), 313–39.

Thorndike, Lynn. "Words in Theophilus," *Technology and Culture*, 6 (1965), 442–43.

Untracht, Oppi. *Metal Techniques for Craftsmen.* Garden City, N.Y., 1968.

Weiss, Gustav. *The Book of Glass.* New York and London, 1971.

White, Lynn, "Theophilus Redivivus," *Technology and Culture,* 5 (1964), 224–33.

————. *Medieval Religion and Technology: Collected Essays.* Los Angeles, etc., 1978.

Index